OUTRAGE

THE ARTS AND THE CREATION OF MODERNITY

OUTRAGE

Katherine Giuffre

STANFORD UNIVERSITY PRESS
Stanford, California

Stanford University Press
Stanford, California

Library of Congress Cataloging-in-Publication Data
Names: Giuffre, Katherine, 1962- author.
Title: Outrage : the arts and the creation of modernity / Katherine Giuffre.
Identifiers: LCCN 2022041088 (print) | LCCN 2022041089 (ebook) |
 ISBN 9781503635357 (hardback) | ISBN 9781503635821 (paperback) |
 ISBN 9781503635838 (ebook)
Subjects: LCSH: Arts and society—History—19th century. | Arts and society—
 History—20th century. | Arts, Modern—19th century. | Arts, Modern—20th
 century.
Classification: LCC NX180.S6 G5325 2023 (print) | LCC NX180.S6 (ebook) | DDC
 700.1/03—dc23/eng/20220830
LC record available at https://lccn.loc.gov/2022041088
LC ebook record available at https://lccn.loc.gov/2022041089

Cover design: Jason Anscomb
Cover photograph: Auguste Bert, *Vaslav Nijinsky in Scheherazade*, 1913, halftone photogravure. Nijinsky, considered to have been the greatest male dancer of the early twentieth century, wore gold body paint and a brightly colored, bejeweled, and embroidered outfit in his role as the Favorite Slave. Bert was the official photographer of the presidency of the French Republic.
Typeset by Elliott Beard in Adobe Caslon 10/14.5

Contents

Acknowledgments

First and most important, I would like to thank Marcela Cristina Maxfield at Stanford University Press, who had faith in this project and whose support made its publication possible. In addition, the feedback I received from anonymous reviewers was insightful and invaluable. They have my deep gratitude.

Several students at Colorado College have given me great help with research. I would like to thank: Alicia Danielsen, Lauren Dinsmore, Clara Houghteling, Zora Jackson-Bartelmus, Anna Kay, Adison Petti, Mike Sorensen, and Kieran Woerner.

I am fortunate to be surrounded by a loving and supportive family: my sons, Aiden and Tris, the joys of my life; my brother, Joe, the most erudite person I know; my father, Paul, who gleefully introduced me to subversive art in the first place; and my husband, Jonathan, my partner in crime, to whom this book is dedicated.

OUTRAGE

ONE

Symbolic Warfare in the Field of Culture

In 1907, Pablo Picasso was a twenty-five-year-old impoverished painter living in squalid conditions in Paris and working obsessively on a large painting of five nude women, the proto-Cubist *Les Demoiselles d'Avignon*. After more than six months of intense labor, he was finally ready to unveil his groundbreaking masterwork to some of his closest friends and most important buyers.

It did not go well. Leo Stein, a collector whom Picasso was trying to woo, "brayed" (Richardson 2012, 45) with laughter at what he called "this horrible mess" (Richardson 2012, 6). The painter André Derain was even more horrified. "This can only end in suicide," he said. "One day Picasso will be found hanging behind the *Demoiselles*" (Richardson 2012, 76). In response, Picasso turned the painting to face the wall of his studio and did not publicly show it again until 1916.

But Derain was wrong. Picasso died in 1973, at age ninety-one, from heart failure. And *Les Demoiselles* became one of the most important paintings of the twentieth century.

OUTRAGE

In the history of the arts, misjudgments such as Derain's are common. Critics derided *The Great Gatsby*. *Moby Dick* was so unpopular that it effectively ended Herman Melville's flourishing writing career. Few people bought Henry David Thoreau's books in his lifetime, forcing him to take back the unsold copies from

1

the publisher in order to save them from being destroyed. "I have now a library of nearly nine hundred volumes," he quipped, "over seven hundred of which I wrote myself" (Thoreau 2009, 232). And on and on.

It is not difficult to see why this would be so. Cultural productions—books, paintings, movies, music, and so on—that we today see as works of genius are often revered because they are revolutionary; they changed the way that we see the world around us and the way that we think about ourselves and others. Precisely because they are revolutionary, these works take time to understand and to appreciate. They burst subversively into our consciousness without warning or preparation. No wonder they are initially misunderstood.

But with some works, there is more to our reactions than just misunderstanding or incomprehension. There is also outrage. It is one thing to be left unmoved or indifferent to a piece of art—to shrug it off as not to one's taste. It is another to be enraged by it—to feel a need to smash and destroy not only the work, but also the person who made it. In the history of culture, some works that we now consider to be classics were initially met not merely with uncomprehending indifference, but with everything from malicious gossip and character slurs to fisticuffs, book burnings, and pistols at dawn. That is, they were met with outrage.

The outrage did not arise because audiences and critics failed to understand these subversive works, but, instead, because they did. This book will look at some of the cultural productions—novels, paintings, poetry, music, and dance—now seen as classics but that caused outrage when they first appeared in the nineteenth and early twentieth centuries. These works spoke to deep divides in the time and place of particular societies and ignited battles over some of the most sensitive points of social change. In doing so, they helped create the modern world.

SYMBOLIC WARFARE

All societies have members who deviate from the prevailing norms. As Durkheim argued in 1893, every society has deviants because every society needs deviants and creates the deviants it needs (through formal laws or otherwise). Punishing deviants helps a society solidify and makes known the acceptable boundaries of behavior in that society. By punishing those who disrupt the functioning of the interdependent parts of our social machine, we keep that

machine running smoothly, mostly invisibly. Restitutive (civil) law, Durkheim argues, is meant to fix what breaks in the social system—to put right the malfunctioning pieces. But an older, more atavistic repressive law that predates restitutive law still survives. It is there to soothe the collective conscience that has been inflamed by deviant behavior, a collective conscience that is outraged over this attack on social solidarity, the foundation of social order. Without outrage at deviants, we don't know who we are as a society.

This does not mean that the deviants are imaginary: they are very real. And their attack on the social order can be intentional and ferocious, happening sometimes with direct physical violence (as in political revolutions) and sometimes through more subtle, but just as challenging, cultural warfare. Deviance may be disruptive, but it can also be an important source of positive social change. But rather than directly attack the social world through its unjust laws or economic systems, cultural deviance instead attacks the hegemonic ideas that underlie those systems.

Cultural warfare is about the disruption of hegemony at the level of the symbol. Think of a safety pin in the cheek of a London punk circa 1977, a 1920s flapper eschewing a corset, or a national flag being set on fire. These disruptions point out the ideologies that underlie the symbols—the usual (perhaps hegemonic) connection between the signifier and the signified. An important part of hegemonic control is that those being oppressed accept their own oppression, seeing it as right, normal, and natural. Hegemony is powerful because it is unquestioned, for the most part. Raymond Williams explains:

> Hegemony . . . is a whole body of practices and expectations, over the whole of our living: our senses and assignments of energy, our shaping perceptions of ourselves and our world. It is a lived system of meanings and values. . . . It thus constitutes a sense of reality for most people in the society, a sense of absolute because experienced reality beyond which it is very difficult for most members of the society to move, in most areas of their lives. It is, that is to say, in the strongest sense a "culture," but a culture which has also to be seen as the lived dominance and subordination of particular classes. (Williams 1977, 110)

But as Williams also points out, that unquestioning acceptance of "the way things are" is never total: it must be fought for and reproduced on a continuing basis, responding to anti-hegemonic challenges and neutralizing critiques:

A lived hegemony is always a process. . . . [I]t does not just passively exist as a form of dominance. It has continually to be renewed, recreated, defended, and modified. It is also continually resisted, limited, altered, challenged by pressures not at all its own. . . . In this active process the hegemonic has to be seen as more than the simple transmission of an (unchanging) dominance. On the contrary, any hegemonic process must be especially alert and responsive to the alternatives and opposition which question or threaten its dominance. (Williams 1977, 112)

The concept of power implies resistance, and hegemonic power is no different from other kinds of power. As John Clarke and coauthors note: "Hegemony, then, is not universal and 'given' to the continuing rule of a particular class. It has to be *won*, worked for, reproduced, sustained. Hegemony is, as Gramsci said, a 'moving equilibrium,' containing 'relations of forces favourable or unfavorable to this or that tendency.' . . . The idea of 'permanent class hegemony,' or of 'permanent incorporation' must be ditched" (Clarke et al. 1976, 40–41; italics in original).

In their analysis of post-war British youth subcultures, Stuart Hall and his colleagues focused on the myriad cultural forms that members of subordinated groups used to resist the normalizing of their oppression: "Negotiation, resistance, struggle: the relations between a subordinate and a dominant culture, wherever they fall within this spectrum, are always intensely active, always oppositional, in a structural sense (even when this opposition is latent, or experienced simply as the normal state of affairs—what Gouldner called 'normalised repression'). Their outcome is not given but *made*" (Clarke et al. 1976, 44; italics in original).

This struggle can occur in the field of culture at the level of signification, at the point of breaking the unquestioned connection between signifier and signified. Of the youth subcultures of post–World War II Britain, Dick Hebdige writes that

the challenge to hegemony which subcultures represent is not issued directly by them. Rather it is expressed obliquely, in style. The objections are lodged, the contradictions displayed . . . at the profoundly superficial level of appearances: that is, at the level of signs. . . . The struggle between different discourses, different definitions and meanings within ideology is therefore always, at the same time, a struggle within signifi-

cation: a struggle for possession of the sign which extends to even the most mundane areas of everyday life. (Hebdige 1979, 17)

Through style, subordinate groups can bring to light the hidden assumptions that form the basis of their oppression.

In other words, "symbolic warfare" uses symbols as weapons in a struggle over the foundational ideas, norms, values, and beliefs of a society. It is warfare fought in the arena of culture. These struggles are no less powerful for the fact that they appear to be over such trivial matters: the rhyme scheme of a poem, the finish of an oil painting, or a blue note. These are keys to a larger issue: the questioning of (and, therefore, bringing into consciousness of) the hegemonic ideas embedded in cultural forms. To question hegemonic ideas is in itself to weaken their power to oppress.

This has political implications. Murray Edelman argues that owing to its power to create new categories of thought and to highlight previously over-looked aspects of social life, art "can intrude upon passive acceptance of con-ventional ideas and banal responses to political clichés. For that reason art can help foster a reflective public that is less inclined to think and act in a herd spirit or according to cues and dictates provided be a privileged oligarchy" (1995, 143–144). The normalization that is so important for the functioning of hegemony is exposed as a fabrication. The disruption of the social order by subversive artists is an attack on society, and it is perceived as such. It causes outrage, Edelman argues:

> At any historical period the most widely promulgated and accepted perceptions reflect and reinforce the dominant social relationships. . . . Material conditions and striking events render people susceptible to new ways of building reality, but artists must provide the categories, the premises, the modes of seeing, and the cognitive pathways. . . . So art lays the basis for the developments we conventionally see as political: voting, lobbying, participating; supporting, obstructing, or ignoring political causes. (Edelman 1995, 63)

Despite this, not all acts of nonconformity provoke an intense response. Sometimes a purposely provocative cultural act invokes nothing more than a shrug or a blank stare. Culture is easy to dismiss as frivolous. In order to pro-voke a response of outrage, cultural acts must not only touch the sore point of

the society at the time when that point is most vulnerable; they must also do so in a way that speaks in a language that is understood by the wider audience (even when that audience claims the cultural acts are incomprehensible). Cultural acts have the ability to interject questioning into ideas that had heretofore maintained their power by being unquestioned. Cultural productions are poised to do this precisely because they are so multifaceted, metaphorical, and easily dismissed. Raymond Williams notes: "The finite but significant openness of many works of art, as signifying forms making possible but also requiring persistent and variable signifying responses, is then especially relevant" (1977, 114). That is, the openness to audience interpretation of works of art allows for a range of responses. Regarding novels, Wendy Griswold writes that "different literary meanings may be woven from the same literary symbols interacting with the concerns of distinct sets of readers insofar as these concerns highlight different aspects of a multivocal text" (1987, 1105). Unlike a manifesto, cultural productions can work at a level below conscious resistance. They slip in under the radar, masquerading as meaningless, defying easy interpretation, context dependent. However obliquely it is done, though, the disruption to the hegemonic chain between signifier and signified must be felt if it is to provoke outrage.

Analyzing the example of punk's use of symbols in the 1970s—bondage gear, ransom-note typefaces, desecrated Union Jacks—Hebdige argues that the symbolic assault on the hegemonic norms of the times caused outrage because it spoke so clearly and understandably (if metaphorically) about the chaos Britons were feeling and fearing:

> The punks appropriated the rhetoric of crisis which had filled the airwaves and the editorials throughout the period and translated it into tangible (and visible) terms. . . . The various stylistic ensembles adopted by the punks were undoubtedly expressive of genuine aggression, frustration and anxiety. But these statements, no matter how strangely constructed, were cast in a language which was generally available—a language which was current. . . . In order to communicate disorder, the appropriate language must first be selected, even if it is to be subverted. For punk to be dismissed as chaos, it had first to "make sense" as noise. (Hebdige 1979, 87–88)

Punk symbols made sense as "noise": the disruption of the hegemonic connection between signifier and signified. The symbols of chaos were understandable to everyone, provoking outrage in those observers most invested in maintaining

the hegemonic order. Does a "safety pin" signify "safety" or, instead, "danger" when it pierces a young punk's cheek?

> When people experience a cultural object, read a book, for example, a societal tenor—a set of presuppositions, concerns, problems and associations held by a particular group in a particular historical and institutional context—interacts with the cultural vehicle, the symbols and characteristics of the cultural object at hand. The presuppositions generated by the tenor select, highlight, and suppress characteristics of the vehicle; the manifest and latent meanings of the vehicle trigger, organize, evoke, reflect, and seem to comment on attributes of the tenor. The more powerful the cultural object constituting the vehicle, the more aspects of the societal tenor it will seem to address. (Griswold 1987, 112)

It is only by understanding the social context within which the outrage occurs that we can begin to answer the question "Why?" What nerve did the cultural producers of the modernizing West touch—sometimes unwittingly—that led to such vociferous reactions to their art?

There was a symbiotic relationship between the artists and the society. Each affected the other. Artists responded to and exposed the tensions in the world around them, and their art pushed those tensions further. When reviewers suggested that the Brontë sisters were fallen women (discussed in Chapter 2), for example, or when Berthe Morisot was denounced as a whore during an auction of Impressionist paintings (Chapter 3), those reactions were telling, indicating a profound social tension about women's role in the society and fears about the changes that role was undergoing. The particular incidents discussed in this book were battles in a larger war: a revolutionary war in which art was playing a role by not just reflecting society but also by changing society, by breaking down the unquestioned state of hegemonic ideas. These battles were so fiercely fought—more fiercely than they seem on the surface to merit— because they were important. They were important because they actively engaged the tensions, cleavages, and breaking points in the societies around them. To understand the battles and the ferocity with which they were fought, we have to understand the social context in which they occurred. And that context in which the cultural warfare occurred was one of profound uncertainty and change.

UNCERTAINTY

This was an age of revolutions—of coal mines, textile mills and Luddites, of empires and civil wars, of the *Communist Manifesto* and the *Origin of Species*, of the steam engine and the guillotine. In western Europe and North America from the end of the eighteenth century through the early part of the twentieth, society transformed not in gradual stages at the leisurely pace of the preceding millennia, but instead in an alarming torrent of continuous change punctuated by moments of cataclysm.

Perhaps the most obvious moments of upheaval were the political revolutions that overturned the old order of absolute monarchy. Especially important was the French Revolution of 1789. Fueled by the discontent of the rising bourgeoisie and of the starving peasants and *sans culottes* against the corrupt and oppressive *ancien régime*, the revolutionaries of 1789 set out to destroy the political system of aristocratic and ecclesiastical control that had organized French life for centuries. Feudalism still dominated French society, but passionate beliefs—in progress rather than tradition, in "enlightened" thinking rather than superstition, in individual talent and merit rather than social position based on birth—had been brewing for decades and finally broke out violently in 1789. Revolutionaries took to the streets in a bloody conflict that would last years.

Between 1795 and 1870, France boomeranged between directory, consulate, empire, restored Bourbon monarchy, constitutional monarchy, republic, and empire again. War was almost incessant. Wave after wave of revolution swept across Europe throughout the nineteenth century. National borders were in a state of constant flux. Meanwhile, the fledgling United States had ongoing wars and genocidal campaigns against the Indigenous inhabitants of the North American continent on top of major international wars in 1812 and 1846. The Civil War to end slavery in the United States between 1861 and 1865 was the bloodiest war ever in the country's history in terms of American deaths. The climax of this period would be the horrors of World War I, the Great Depression, and World War II.

Sources of legitimacy for governments were called into question. The divine right of kings was shattered, but the legitimacy of various voting schemes and even of democracy itself was and is still being debated. In 1848, as revolution rocked country after country in this part of the world, women met at Seneca Falls, New York, in the first women's rights convention. That same year, Marx

and Engels published *The Communist Manifesto*, a searing indictment of the interlocking political and economic systems.

But Marx and Engels were only two of the many reformers produced by the age of uncertainty: the era was awash in every type of proposal for reorganizing society. Having dispensed with the old ways of doing things, there seemed no obvious blueprint for how to go forward, either politically or economically. The search for a plan was cultural as well as purely political. Values, ideals, and norms affect political decisions and were debated in the arena of culture. The political uncertainty of the times lent a life-and-death immediacy to battles over culture and hegemony. And the political uncertainty was made even more disruptive by the vast changes in day-to-day life fueled by another type of revolution occurring simultaneously: the Industrial Revolution.

THE INDUSTRIAL REVOLUTION

Eric Hobsbawn writes of the bewildering and incessant changes of industrialization: "If the sudden, qualitative, and fundamental transformation, which happened in or about the 1780s, was not a revolution then the word has no common-sense meaning. The Industrial Revolution was not indeed an episode with a beginning and an end. To ask when it was 'complete' is senseless, for its essence was that henceforth revolutionary change became the norm" (Hobsbawn 1962, 46). Before this time, the overwhelming mass of people in western Europe and North America lived agrarian lives in sparsely populated rural areas. There was relatively little geographic mobility. But as industrialization took off, people were both pushed off the land (through means like the Enclosure Act) or pulled into cities by the lure of wages and the hope of steady work. Urban areas grew at astounding rates. The population of Paris was a little over half a million people in 1801, but it was 2.7 million in 1901. London's population increased from just over a million to 6.5 million in the same time period. New York City had a mere 79,000 inhabitants in 1800 but almost 3.5 million by 1901. In England, the urban population outnumbered the rural population for the first time in 1851 (Hobsbawm 1962, 26). Overall, the population boomed (Hobsbawn 1962, 204).

Moreover, the isolation of the preindustrial village was breaking down. Geographic mobility increased rapidly with the coming of the steam engine and the railway (Hobsbawm 1962, 204). Especially in Britain, but over all of western Europe and North America, the number of miles of track increased

dramatically. In 1838, there were 490 miles of railroad in England and Wales, but in 1850, a mere twelve years later, there were 6,621 miles, a more than twelve-fold increase (Thomson 1981, 156). In the United States, miles of railroad track skyrocketed from just 23 in 1830 to 3,000 in 1840 to 30,000 in 1860 (Folkerts and Teeter 1998, 134). The railway took formerly isolated rural dwellers into the new metropolises and brought the ideas and attitudes born in those metropolises back to the rural areas. Contact with differing ideas spread through changing technology as well; the telegraph allowed quick communication over large distances. In the United States, miles of telegraph lines grew from 16,735 in 1852 to 237,990 in 1902 (Folkerts and Teeter 1998, 134).

Urbanization meant a radical change in day-to-day life. Unlike a rural village, where a person could spend a lifetime surrounded by the same set of friends and kin, following the same traditions and norms as had countless past generations, the urban centers were crowded with strangers who had different ways, different languages, different religions, different traditions, different beliefs of every kind. Hobsbawm argues that "by uprooting men and women in unprecedented numbers and depriving them of the certainties of the ages, [the Industrial Revolution created] probably the unhappiest world" (1962, 350).

Life for the laboring poor in the industrializing centers of the nineteenth century was brutal and squalid: labor practices (including those for children) were vicious, housing was dilapidated and overcrowded, unsanitary conditions led to constant disease, crime was horrific, and life spans were short. The new breed of capitalists who exploited the urban poor had good reason to fear the specter of communist revolution that Marx and Engels predicted would inevitably rise from the urban slums.

At the same time, the urban centers provided other freedoms than merely the freedom to starve. The coffeehouses and cafés of London and Paris were gathering places where revolutionary ideas of all kinds were formulated and discussed. Schools opened in urban areas. A genuine middle class evolved. Working for wages could mean freedom and mobility for those (like women, perhaps especially) who would have been nothing other than chattel in a rural village. Emancipated from tradition, women began to find a political voice in the nineteenth century.

Scientific advances further unsettled traditional assumptions about the social order. Darwin published *On the Origin of Species* in 1859. The book, David Quammen argues, "provoked the most cataclysmic change in human thinking within the past four hundred years" (2006, 18). Although ideas about the

possibilities of the transmutation of species had been floating in the air of the scientific community for decades, publication of *Origin of Species* was nevertheless a seismic turning point. The idea that God had not created a fixed and unchanging set of creatures to populate the earth was disturbing enough. But the further idea that natural selection, rather than the guiding hand of divinity, was the mechanism of change was so shocking that Darwin himself had held off publishing his research for two decades.

READING AND WRITING

Challenges to tradition seemed to come from every direction of human endeavor. And the controversies they brought forward played out for the first time in an arena of public discussion made possible by two other changes occurring at this time: the growth of literacy and the explosion of the mass media.

In England, for example, literacy rates had been very slowly creeping upwards from about 1500, when almost no one in the general population could read. The nineteenth century, however, was a literacy watershed. An analysis of literacy rates in England shows that slightly more than 40 percent of women and 60 percent of men were literate in 1800; but by 1900 both men and women had literacy rates above 95 percent (Mitch 2004, 344).

These same trends were evident all over Europe and in North America. The growth in literacy went together with a massive increase in the availability of reading material during the nineteenth century—and with a change in the content of that material and the audience for it. The "penny press" arrived in the early 1800s. The low price coupled with expanding literacy meant that these papers had a much higher circulation than the newspapers that preceded them. For example, by the end of 1836 when the new *Philadelphia Public Ledger* had been in business for only eight months, its circulation of 10,000 readers was five times higher than the circulation of the city's previous largest newspaper (Folkerts and Teeter 1998, 120). By 1900, over a quarter of the U.S. population subscribed to a newspaper (Folkerts and Teeter 1998, 251).

Not only did the numbers of newspapers (as well as magazines and books) increase, but their content underwent a profound change. Whereas previously newspapers had been a luxury item aimed at an elite audience, the arrival of inexpensive periodicals meant that they could perform a wider role in urban society: "One might say that, for the first time, the newspaper reflected not just commerce or politics but social life. To be more precise, in the 1830s the news-

papers began to reflect, not the affairs of an elite in a small trading society, but the activities of an increasingly varied, urban, and middle-class society of trade, transportation, and manufacturing" (Schudson 1978, 22–23). The mass market periodicals of the nineteenth century directly engaged in the social, cultural, and political debates of the day. Newspapers embraced a wide variety of viewpoints, and their writers began to do much more than merely report information: they interpreted, analyzed, argued, and opined. As the economic foundation of the press changed from elite patronage to mass sales, owners and editors quickly discovered that sensation sells and that outrage is wonderful for the bottom line. The pages of the press became a gleeful ideological field of battle.

These public debates are crucial components in understanding outrage. In his analysis of the culture wars in the United States in the late 1980s and early 1990s, Steven Dubin (1992) argues that, along with an already socially fractured community and in the absence of external sociopolitical villains (such as the former USSR for the United States) to serve an internally unifying purpose, publicness is a key factor in igniting controversies over art works. Whether it is the use of public funding or the display in public places, art that is brought to the notice of the general public (rather than remaining confined among the relatively insular art world cognoscenti) is much more likely to spark culture wars. In the nineteenth and early twentieth centuries in the United States and western Europe, the popular mass media provided the arena for public outrage.

THE FIELD OF CULTURE

While the press provided a field for battle, it was only one player among many on a larger field: the field of culture. Pierre Bourdieu's insights about the workings of the cultural field allow us to make sense of the outrage. Bourdieu defines the field as

> a network, or configuration, of objective relations between positions. These positions are objectively defined, in their existence and in the determination they impose upon their occupants, agents or institutions, by their present and potential situation [*situs*] in the structure of the distribution of species of power (or capital) whose possession commands access to specific profits that are at stake in the field, as well as by their objective relation to other positions (domination, subordination, homology, etc.). (Bourdieu and Wacquant 1992, 97)

That is, a field is a social space within which social agents operate. Social agents occupy particular positions in the field that are determined by the "capital" an agent possesses and are in relation to other agents in that field. The field is hierarchically ordered; some positions in a field are more powerful than others.

Bourdieu theorizes that culture operates within a field. The cultural field is a social space filled with cultural agents: cultural producers, cultural consumers, cultural institutions, and the cultural objects themselves. These cultural agents have relations with one another, and these relations, Bourdieu argues, are hierarchical. The hierarchy in the cultural field is organized around two poles: two different and divergent principles regarding the production and consumption of culture. These are the "autonomous" (self-directed or self-governed) pole, which Bourdieu says is dominated by the principle of "art for art's sake," and the "heteronomous" (other-directed or governed-by-others) pole, which is dominated by what he calls "bourgeois art" (Bourdieu 1993, 40).

If we imagine the cultural field as a social space with the autonomous and heteronomous poles occupying points furthest from each other, agents in the field occupy positions of greater or lesser social proximity to either pole. An avant-garde experimental film shown in a not-for-profit venue to a small group of connoisseurs and film aficionados lies very close to the autonomous pole of art for art's sake. Conversely, a big-budget summer blockbuster screening in hundreds of movie theaters across the country and raking in millions during its opening weekend lies much closer to the heteronomous pole of large-scale production directed at the mainstream. Each of the agents in the field (the avant-garde film and the blockbuster movie) is operating on a different principle of success. And each of these agents is engaged in a struggle against the other to legitimate their own particular style of success as the dominant one in the field. They are in conflict over the very definition of success. Is a massive number of tickets sold the measure of success? Or is it critical acclaim, awards, or some other measure?

The conflict in the field of culture is a conflict over the right to legitimation—not only to be considered legitimate oneself as a cultural agent (a serious filmmaker, a groundbreaking painting, a high-powered agent) but, even more importantly, to be able to confer legitimacy on others in the field, to make the rules that others must follow—that is, to shape the functioning reality of the field itself. Since the very definition of success is itself a point of contention, an important priority for a cultural agent is to gain the power of consecration: the ability to define success and, therefore, the ability to define who does or does not count as legitimate.

> [T]he field of cultural production is the site of struggles in which what is at stake is the power to impose the dominant definition of the writer and therefore to delimit the population of those entitled to take part in the struggle to define the writer. . . . [T]he fundamental stake in literary struggles is the monopoly of literary legitimacy, i.e., *inter alia*, the monopoly of the power to say with authority who are authorized to call themselves writers; or, to put it another way, it is the monopoly of the power to consecrate producers or products. (Bourdieu 1993, 42)

The ultimate goal is to gain the power of consecration—to be able to make the rules of the cultural game, to impose them on other players, and to have them accepted as legitimate (as, in fact, unquestioned and seemingly obvious). That is, to move in what Bourdieu terms a "trajectory" towards the autonomous pole, displacing others along the way. Bourdieu calls this "symbolic violence," a term that highlights the way in which his conception of the field of culture is fundamentally about conflict.

For Bourdieu, the field is structured around hierarchy and around the struggle of agents to achieve dominance so that they have the power to set the rules and define the terms by which the art world operates. This means that the value of a work of art is socially produced, determined by systems of beliefs that are hierarchically structured by the struggles in the field:

> The work of art is an object which exists as such only by virtue of the (collective) belief which knows and acknowledges it as a work of art. Consequently . . . [we must] assert the possibility and necessity of understanding the work in its reality as a fetish; it has to take into account everything which helps to constitute the work as such, not least the discourses of direct or disguised celebration which are among the social conditions of production of the work of art *qua* object of belief. The production of discourse (critical, historical, etc.) about the work of art is one of the conditions of production of the work. (Bourdieu 1993, 35)

The discourses in the nineteenth and early twentieth centuries in this book frequently played out in the pages of the mass media. By tracking the discussions of and by cultural agents, we can watch those agents struggle for dominance in the field and watch the production of beliefs and ideologies in situations of great conflict and cultural shift. In doing so, we not only see the transformation of the cultural field, but we also gain insight into transforma-

tions in the larger society of which the cultural field is a part, and in the larger field of power in which the cultural field is embedded. Outrage over the finish of an oil painting could be so virulent because the issues at stake lay at the heart of the social order, in what we are as a society and who we want to be.

Figure 1 depicts the main concepts in my argument. Subversive art in the nineteenth and early twentieth centuries triggered a disruption of the heretofore unquestioned hegemonic processes that depend for their efficacy on seemingly self-evident acceptance as normal. This art also caused battles within the cultural field over occupancy of the autonomous pole and, therefore, over control of the power of legitimation. These battles themselves played a role in undermining pre-modern hegemonic ideas. And the art sparked important public discussions in the newly emerging popular mass media, where the very existence of debate also undermined hegemonic legitimacy. The cultural works

FIGURE 1: Concept map showing the connections between subversive art and the public disruption of hegemonic power, a process leading to outrage and facilitating the rise of modernity.

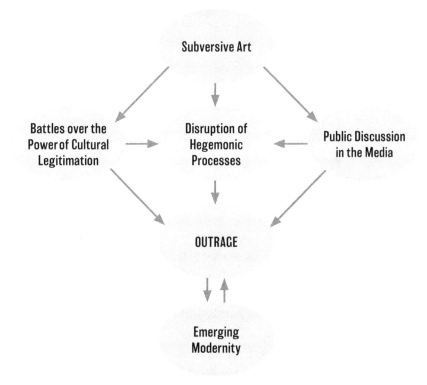

in question arrived at the right time and place to engage with critical points of social transition and to elicit a proportionate response. They created a reaction of outrage in some segments of their societies. The social disruptions of emerging modernity played a part in eliciting outrage and the outrage itself—by vivifying critical transition points and bringing about new mindsets, conceptions, and ways of thinking that further facilitated social change. Alongside political and economic change, this cultural change is a crucial part of what we now think of as modernity.

BATTLES IN A LARGER WAR

This book examines six specific battles in the larger culture war that played out in public in the pages of the media beginning in 1847 and going through 1937. These battles were over cultural productions that we now consider classics: the novels of the Brontë sisters, the paintings of the Impressionists, Emily Dickinson's poetry, the Ballets Russes production of *Le Sacre du printemps*, James Joyce's *Ulysses*, and Zora Neale Hurston's *Their Eyes Were Watching God*. Each of these was greeted with outrage, but they were not all greeted with the same type of outrage. Some were critically reviled while being popular with audiences; others experienced the reverse. Most reactions were more complicated than a simple audience versus critics split. In addition, there were legal battles and physical assaults. In some cases, the producers were shocked by the negative reactions; in others they were delighted.

What all of these works have in common, though, is that they spoke to the tensions and sore points of society in a language that their audiences understood. This is not about audiences not "getting it" or about obtuse critics or simpleminded consumers. Quite the contrary. In each case, the work reflected an emerging flash point in the society, and by bringing into the light the previously unspoken assumptions that undergird social tensions, each cultural producer played a part in undermining the hegemonic notions of their era. By examining the contemporaneous reviews of these works, situated within their particular social and historical context, we can see how the outrage directed at them is an indicator of or even a catalyst for the specific types of social changes that were occurring. The specifics of the battles tell us about the goals of the war.

To analyze these specifics, I examined the contemporaneous reviews for each of the six case studies presented. In addition to concentrating on the re-

views, I also read letters and diaries, remembrances and interviews with the principal participants or audience members, and court documents wherever any of these were available. The reviews came from a variety of sources. In some cases, there are collections of reviews gathered by previous researchers. There are also numerous direct quotes from reviews in texts such as biographies, scholarly studies, critical editions, and *catalogues raisonnés*. I also directly searched for reviews in databases of periodical literature, although that was less useful further back in time. It is difficult to know the precise number of reviews studied since many appear (in whole or part) in multiple sources, but altogether I examined approximately 3,000 primary source items. For the content analysis, I followed Griswold's method in her analysis of reviews of the work of George Lamming (Griswold 1987, 1096) in that I did not code reviews for a predetermined set of themes, but rather allowed patterns, commonalities, and themes to emerge from the material itself. Each case is put into historical context, and in the final chapter they are compared with one another in order to make sense of the role they played as battles in a cultural revolution that was taking place alongside the political and economic revolutions that have been more widely studied.

The battles in this revolution occurred in the context of the cultural field and were played out as strategies by active cultural agents. While some producers were deliberately provocative and others were genuinely astonished by the reactions to their work, all of them incited outrage from some part of the cultural world. All of them upended the prevailing hierarchy. And the outrage they provoked opened the public debate over critical issues and transformations that helped bring the modern world into being.

It is not surprising that culture producers—especially marginalized ones—should be at the forefront of social commentary or that they should pursue subversive strategies in the field. The view from the edge of society often allows for the perspective of the entire system at work. Certainly, the lived experience of marginalization frees many culture producers from the illusion that success will come to those who toe the establishment line. And cultural producers often exist in symbiotic relation with the larger society around them. For example:

> Few men saw the social earthquake caused by machine and factory earlier than William Blake in the 1790s, who had yet little except a few London steam-mills and brick-kilns to go by. With a few exceptions, our best treatments of the problem of urbanization come from

the imaginative writers whose often apparently quite unrealistic observations have been shown to be a reliable indicator of the actual urban evolution. (Hobsbawm 1962, 311)

And it is also no wonder that such serious battles were fought over such seemingly trivial objects. The power of symbols is that they are able to concisely represent our most important and cherished ideals, values, and identities. In *The Thief's Journal*, Jean Genet recounts how the discovery of a tube of Vaseline—a sign of his homosexuality—among his possessions when he was arrested led the police to mock and humiliate him. In doing so, they turned the Vaseline into the concrete marker of not only Genet's sexuality, but also of his very identity, his self. In the face of the brutish attack by his captors, Genet unequivocally embraces the object that symbolizes that self. He writes, "I would indeed rather have shed blood than repudiate that silly object" (1964, 22). Genet was willing to shed blood over a tube of Vaseline for the same reason that spectators in the audience for the first performance of *Le Sacre du printemps* were willing to fight a duel: because symbols matter enormously to us.

TWO

"A Morbid Love of the Coarse, Not to Say the Brutal"

The Novels of the Brontë Sisters

Charlotte Brontë knew that although she *could not be* a man, she *should not* be a woman. And so the Brontë sisters played with gender as capital throughout their careers in the literary field.

POEMS AND PEN NAMES

In the fall of 1845, Charlotte was twenty-nine years old, living with her two younger sisters Emily and Anne, her alcoholic brother Branwell, and her widowed father in the parsonage of Haworth village in the Yorkshire moors, where her father was the perpetual curate. Charlotte later told the story:

> One day, in the autumn of 1845, I accidentally lighted on a MS. [manuscript] volume of verse in my sister Emily's handwriting. . . . I looked it over, and something more than surprise seized me,—a deep conviction that these were not common effusions, not at all like the poetry women generally write. I thought them condensed and terse, vigorous and genuine. To my ear, they had also a peculiar music—wild, melancholy, and elevating. (Bell 1850a, 307–308)

Charlotte addressed the violation of gender norms in Emily's writing from the very beginning: "I know no woman that ever lived ever wrote such poetry

19

before. Condensed energy, clearness, finish—strange, strong pathos are their characteristics; utterly different from the weak diffusiveness, the laboured yet most feeble wordiness, which dilute the writings of even very popular poetesses" (Hanson and Hanson 1949, 193). When their sister Anne brought forth her own stash of poems, Charlotte, who had poems of her own to share, decided that the three sisters should together publish a book of their verse.

Charlotte recognized the subversive nature of Emily's poetry and knew that in order to be taken seriously as authors, the sisters would have to present themselves to the world as something other than women in the field of literature. Their gender would determine their position and trajectory through the field. To be successful, their gender would have to be kept hidden, as Charlotte explained:

> [W]e veiled our own names under those of Currer, Ellis, and Acton Bell; the ambiguous choice being dictated by a sort of conscientious scruple at assuming Christian names, positively masculine, while we did not like to declare ourselves women, because—without at that time suspecting that our mode of writing and thinking was not what is called "feminine"—we had a vague impression that authoresses are liable to be looked on with prejudice; we had noticed how critics sometimes use for their chastisement the weapon of personality, and for their reward, a flattery, which is not true praise. (Bell 1850a)

Poems by Currer, Ellis, and Acton Bell was officially published in late May 1846. Three reviews appeared, all quite favorable, singling out Emily's work in particular for praise. The anonymous reviewer for *The Critic* called their work "good, wholesome, refreshing, vigorous poetry—no sickly affectations, no namby-pamby, no tedious imitations of familiar strains, but original thoughts, expressed in the true language of poetry" (Barker 1994, 497). Already the work was being praised for its originality—that is, for staking out a position nearer the autonomous pole of the field.

Assuming that the authors were brothers, Sydney Dobell, writing in the *Athenaeum,* prophesied a bright future for Ellis Bell, saying that his poems rise "into an inspiration, which may yet find an audience in the outer world. A fine quaint spirit has the latter, which may have things to speak that men will be glad to hear, —and an evident power of wing that may reach heights not here attempted" (Barker 1997, 151). Under the assumption that the authors were

men, the poems were praised for their "vigorous" "power." These same quali-ties would be disparaged later when the secret of the authors' gender became known.

Despite the good notices, the book was a failure. At the end of a year, only two copies had been sold. This was more than just a blow to the sisters' literary hopes; it was also a blow to their precarious finances.

Their father Patrick Brontë's income was meager enough that it was diffi-cult to provide for his children, all of whom knew from an early age that they would need to somehow support themselves as adults. For the girls, options for the future were limited. They would need to either marry a suitable husband or find work in one of the few professions open to young ladies at the time: teacher, governess, or perhaps lady's paid companion. For women of their era, the Brontë sisters were quite well educated. They read widely and could read and write in French and German; they also studied history, geography, rheto-ric, art, music, and classics. All of the sisters worked at various times as teach-ers and governesses. Although they still lived in the parsonage house, it would only be theirs while their elderly, sickly father lived; upon his death it would revert to the church, and the family would be turned out to make room for the new incumbent. The sisters' hopes for their manuscript had been financial as well as artistic; they had expected to make money from their writing. Instead, after paying printing costs, they lost money.

"LITERATURE CANNOT BE THE BUSINESS OF A WOMAN'S LIFE"

The publication of *Poems* was not the first time Charlotte had made her poetry public. Ten years earlier, in late 1836, Charlotte had written an admiring letter to Robert Southey, then the poet laureate of England, sending him some of her poems and asking his opinion of them. He answered with what he called a "dose of cooling admonition to the poor girl" (Frank 1990, 111). He warned that Charlotte might be endangering her place in society as a woman by imag-ining a life as a writer: "But there is a danger of wh[ich] I w[oul]d with all kindness & all earnestness warn you. The daydreams in wh[ich] you habitually indulge are likely to induce a distempered state of mind, & in proportion as all the 'ordinary uses of the world' seem to you 'flat & unprofitable,' you will be unfitted for them, without becoming fitted for anything else" (Southey 1837, 47–48). Southey continued with a stern admonition: "Literature cannot be the

business of a woman's life: & it ought not to be. The more she is engaged in her proper duties, the less leisure will she have for it, even as an accomplishment & a recreation" (1837, 47–48).

As Katherine Frank points out, "Charlotte had sought some sort of sanction for her writing, but no less than the Poet Laureate of England had told her to extinguish all ambitions of becoming a writer" (1990, 111–112). Her gender, and her gender alone, made her ineligible to pursue her art. It is no wonder, then, that when she next appeared in public as an author, she was hidden behind the masculine-sounding pen name of Currer Bell. Gender presentation was important because gender can be symbolic capital.

SYMBOLIC CAPITAL

Cultural agents employ various types of capital as weapons in their struggles in the field. We tend to think of capital strictly in economic terms. But Pierre Bourdieu posited multiple types of capital, all of which can be used to enhance the position of an agent in the field. Certainly economic capital can be used in this way, but there are also other types of useful capital: social capital (the relations, connections, and/or networks that an agent has and that can be used to further advance that agent's position in the field); cultural capital (the knowledge, dispositions, and tastes that one can use); and symbolic capital. Of symbolic capital, Bourdieu says: "'Symbolic capital' is to be understood as economic or political capital that is disavowed, misrecognized and thereby recognized, hence legitimate, a 'credit' which, under certain conditions, and always in the long run, guarantees 'economic' profits. Producers and vendors of cultural goods who 'go commercial' condemn themselves . . . the only usable, effective capital is the (mis) recognized, legitimate capital called 'prestige' or 'authority'" (Bourdieu 1993, 75). That is, as Randal Johnson writes, "*Symbolic capital* refers to degree of accumulated prestige, celebrity, consecration or honour and is founded on a dialectic of knowledge (*connaissance*) and recognition (*reconnaissance*)" (1993, 7; italics in original).

An important point with regard to symbolic capital is that its value must always be situated within a cultural and social context and is always subject to contention and debate. What we see in the cultural field is a constant struggle by the actors to define themselves and their positions as higher in the hierarchy of power and prestige than their rivals. These are relational struggles, conflicts of cultural agents against one another.

There is often a generational aspect to these positional conflicts as newly

emerging cultural producers push down those who had previously dominated the field, relegating them to the category of passé or old hat:

> The aging of authors, works or schools is something quite different from the product of a mechanical slippage into the past. It is the continuous creation of the battle between those who have made their names [*fait date*] and are struggling to stay in view and those who cannot make their own names without relegating to the past the established figures, whose interest lies in freezing the movement of time, fixing the present state of the field for ever. (Bourdieu 1993,106)

Because the field is relational and hierarchical, a change in the position of one cultural agent means a relative repositioning of all other agents. A cultural agent who merely stays still can nevertheless be surpassed by other actively advancing agents and, in effect, move down in the hierarchy. As Bourdieu notes, "Each author, school or work which 'makes its mark' displaces the whole series of earlier authors, schools or works" (1993, 60). This means that the prestige of a cultural agent (whether an artist or a particular artwork or any other type of agent) is continuously being reassessed as the whole panoply of cultural agents struggles against one another to improve their own positions. Moreover, fields are nested so that the field of art, for example, is nested inside the field of power, which is itself inside the larger field of class relations (Bourdieu 1993, 38). This means that agents' positions in one field may be homologous with their positions in the larger fields within which that first field is nested, and agents' trajectories in one field may also be tied to movements in another field. Upward mobility, to take one simple example, with regard to economic class may possibly be accompanied by upward mobility in political power. These homologies raise the stakes for the competition for positions within any particular field. The Brontës, as women in the field of literature, were unwittingly beginning the process of repositioning the value of gender as capital in the cultural field—and perhaps also in the larger society within which the cultural field is situated. But they were doing so surreptitiously, at least initially.

FIRST NOVELS

With no market for their poetry, the Brontës tried their hands at prose. Again hoping to make money from their writing, the three Brontë sisters each sat down to write a novel. Charlotte produced a book based on her romantic feel-

ings for a former teacher of hers, *The Professor.* Anne wrote *Agnes Grey* based on her experiences as a governess. And Emily wrote her neo-Gothic masterpiece, *Wuthering Heights.* In the summer of 1847, Thomas Newby, a London publisher, agreed to take Anne's *Agnes Grey* and Emily's *Wuthering Heights,* but not Charlotte's *The Professor.*

Charlotte had already been hard at work on her next novel, *Jane Eyre,* and she sent the completed manuscript off to George Smith, the young head of Smith, Elder & Co. on 24 August 1847. The novel was quickly accepted for publication. It appeared on 16 October 1847, under the pseudonym of Currer Bell and caused an immediate sensation.

The initial reviews were glowing. Reviewers commented repeatedly on the "power" of the book. The reviewer in the *Era* wrote, "This is an extraordinary book . . . unlike all that we have read, with very few exceptions; and for power of thought and expression, we do not know its rival among modern productions" (*Era* 1847, 170). Likewise, the reviewer for the *Examiner* proclaimed, "There can be no question but that *Jane Eyre* is a very clever book. Indeed it is a book of decided power" (Barker 1994, 536). The ability to write with "power" was supposedly valid only for male authors.

Despite such praise, a hint of future criticism lurked in the reviews. Even with overwhelmingly positive reception, there were side comments that began to question the propriety of writing this type of book. This hints at the boundary-breaking nature of the novel. For example, the reviewer for the *Halifax Guardian*, assuming that Currer Bell was a man, wrote, "Without the conventionalities and cant of the novel-school, [*Jane Eyre*] wins upon the reader with scenes of pathos, which mark the true artist. . . . What could not such a writer do, were his talents devoted to some more useful and some better line of literature!" (*Halifax Guardian* 1847, 172). The reviewer from the *Spectator*, likewise, was dismayed by the "low tone of behavior (rather than of morality) in the book" (Barker 1994, 536).

This bit of spiciness, however, coupled with the puzzle of authorship, did nothing to hurt the popularity of *Jane Eyre.* As Lawrence and E. M. Hanson note, "*Jane Eyre* became the novel of the season; the sex and identity of the author was one of the questions of the hour among literary circles" (1949, 223). The first edition sold out in three months so that a second printing was required in January 1848 and a third in April 1848. Waiting lists at subscription libraries were long. *Jane Eyre* and Currer Bell were sensations.

While their sister was becoming a literary celebrity (albeit behind a pen name), Emily and Anne still waited for Thomas Newby to publish their books. Now the hubbub over *Jane Eyre* finally goaded Newby into action; *Agnes Grey* by Acton Bell and *Wuthering Heights* by Ellis Bell appeared in December 1847. In advertisements and other promotional materials, as part of his marketing strategy, Newby deliberately misled readers into thinking that the three Brontë novels were written by the same person. A general confusion as to authorship was soon common among the reading public, further adding to the controversy over the identity and gender of the authors (Frank 1990, 233–234).

LADY SCRIBBLERS AND BOOKS FOR WOMEN

The identity of the Bells mattered greatly to reviewers and public alike because the gender of the authors would have material weight in deciding how the books were to be received. The 1840s in England were a time of great ferment regarding the question of women's education. Queen's College for Women, the first institution in the world to award academic qualifications for women, began instruction in 1847 (the same year that the three Brontë novels were published), not without controversy. Partisans on both sides hotly debated the practicality, reasonableness, and morality of educating women. The question of what women should read and the question of what—and even whether—women should write were parts of that larger debate.

In 1807, Thomas Bowdler had published his first edition of the *Family Shakspeare* [sic] in which he edited twenty-four of the plays to make them more proper for women and children by replacing individual words and whole characters and plot lines that he felt were inappropriate. By 1850, there had been eleven editions. Queen Victoria herself as a child had been allowed to read no novels and no fiction other than "moral tales" (Ewbank 1966, 20). Women, like children, were considered too delicate for the possibly inflaming contents of literature and were also too susceptible to its pernicious influence. Even as novels became increasingly available through circulating libraries and as the number of readers rose exponentially, medical, social, and religious authorities all worried about the deleterious effects on the female body, mind, and soul.

Novel reading in particular was linked to impiety, a serious concern. In her 1839 advice book, *Hints on Reading: Addressed to a Young Lady*, Miss M. A. Stodart wrote: "a Christian novel-reader is a contradiction in terms; a thing,

which, like the gryphon, dragon, unicorn, etc., may be imagined, but which like them, has not, and never had any real existence." If reading was bad, writing was worse. With regard to women writing novels, Miss Stodart continued: "This is exceedingly to be regretted. If the evils to women from novel-reading are not small, those which arise from novel-writing, are alarming [*sic*] great" (Ewbank 1966, 29–30).

Miss Stodart asserted that women pursuing intellectual endeavors meant "aiming a presumptuous blow at that wisdom which assigned to man to rule, to woman to obey" (Ewbank 1966, 31). She continued her argument on theological grounds, drawing from the book of Genesis: "The same wisdom that taught the lion to prowl in the midnight forest, and the little birds to sing among the branches, that taught the fishes to glide in deep waters, and the mole to burrow underground, has assigned to woman her post, and richly, most richly endowed her for fulfilling its duties" (Ewbank 1966, 31). Those "duties" were, first and foremost, to be a good wife and mother. That a woman might combine those roles with any other activity seemed self-evidently absurd. Writing a review of Charlotte Brontë's second book in 1849, G. H. Lewes asked, "What should we do with a leader of opposition in the seventh month of her pregnancy? or a general in chief who at the opening of a campaign was 'doing as well as could be expected'? or a chief justice with twins?" (1850, 155).

In 1850, an article in Lewes's weekly *Leader*, "A Gentle Hint to Writing-Women," takes a light tone, but nevertheless makes the opinion of its author clear:

This is the "march of mind" but where, oh, where are the dumplings! Does it never strike these delightful creatures that their little fingers were made to be kissed not to be inked? . . . Woman's proper sphere of activity is elsewhere. Are there no husbands, lovers, brothers, friends to coddle and console? Are there no stockings to darn, no purses to make, no braces to embroider? *My* idea of a perfect woman is one who can write but won't. (Ewbank 1966, 9; italics in original)

One reason that the questions about female writers seemed to have so much urgency at this time was that the first half of the nineteenth century had seen an explosion in the number of women authors being published, profoundly affecting the shape of the literary field. Innovations such as circulating libraries and cheaper methods of bookbinding as well as increases in literacy rates led

to a surge in reading and the demand for books. For more than half a century, women writers had been supplying the material to help meet that growing demand. At the same time, the novel as a literary form had been rising in status in the cultural field (Ewbank 1966, 6–7). This elevated status helped to precipitate the backlash against women stepping out of their traditional places. High-status cultural forms (as the novel was starting to become) should be the preserve of homologously high-status producers, that is, educated white men.

One way that women mediated the tensions between writing and maintaining their gender-specific roles was to limit the books they produced to a lower-status type. The didactic "improving" novel of the nineteenth century was one type of writing that women could produce without too much fear of being censured (Ewbank 1966). Usually religious in tone, these edifying novels treated serious social issues with tedious, heavy-handed moralizing. Restricting women's writing to syrupy sermons of little literary merit took the authors of these books out of the competition for claims of literature and categorized them instead as mere second-class scribblers. By definition, writing by women was permanently placed at the heteronomous pole. An emphasis on the centrality of morality above all else in a work of fiction did not often lead to engaging writing, but it was an acceptable strategy for women in the cultural field—a strategy that left the men at the top of the hierarchy secure in their positions, unthreatened in their dominance.

The edifying novel aimed at women was wildly popular in the nineteenth century. As women's roles expanded and changed in a society undergoing industrialization and urbanization, the conservative tone of these books may have fed a comforting illusion that all was not changing, all was not lost; it was still possible to hold at bay the unknown and unsettling future.

But whether or not their work was explicitly didactic, one key feature of women's writing was the absolute necessity that it displayed "delicacy of mind." As opposed to the presumed "coarseness" of male minds, women minds were not supposed to be capable of even conceiving of anything not thoroughly moral, domestic, righteous, and tame. To be able to even imagine anything crude was supposed to be beyond the ability of well-bred ladies (Ewbank 1966, 39). The Brontës, writing novels that passionately and unapologetically exposed the inner lives of their protagonists, clearly violated every precept for femininity, upended every rule for proper female decorum, and usurped every privilege usually reserved for the male counterparts. The murmurs of impropriety that had started

with *Jane Eyre* would be unleashed with full force with the publication, at long last, in December 1847 of *Agnes Grey* and, especially, *Wuthering Heights*.

THE PROBLEM OF POWER IN WOMEN'S WRITING

Sensing money in scandal, the publisher of *Wuthering Heights* and *Agnes Grey* did as much as possible to connect the two books with *Jane Eyre* and to imply that all three were written by the same mysterious author. Given the uproar around *Jane Eyre*, it was not surprising that the newest Bell productions sold well. But the initial reviews were mixed. Despite the care that the sisters had taken to conceal their true identities, the general consensus had now emerged that the Bells were probably women and, moreover, that they must women of low and debauched character to have written such books.

Early reviewers of the two books tended to dismiss Anne's *Agnes Grey* and to concentrate on Emily's more sensational—and more transgressive—novel. One of the first reviews to appear, in the prestigious *Athenaeum*, worried that the power of the writing would bring readers under the sway of a story that "true taste rejects":

> In spite of much power and cleverness; in spite of its truth to life in the remote nooks and corners of England, "Wuthering Heights" is a disagreeable story. The Bells seem to affect painful and exceptional subjects: —the misdeeds and oppressions of tyranny—the eccentricities of "woman's fantasy." They do not turn away from dwelling upon those physical acts of cruelty which we know to have their warrant in the real annals of crime and suffering, —but the contemplation of which true taste rejects. (Chorley 1847, 281)

H. F. Chorley especially objected to Heathcliff and wished that his character was not so vivid and compelling:

> The brutal master of the lonely house on "Wuthering Heights"—a prison which might be pictured from life—has doubtless had his prototype in those uncongenial and remote districts where human beings, like the trees, grow gnarled and dwarfed and distorted by the inclement climate; but he might have been indicated with far fewer touches, in place of so entirely filling the canvas that there is hardly a scene untainted by his presence. (Chorley 1847, 281)

Chorley further exhorted both Ellis and Acton Bell to focus their future efforts on more light and pleasant subjects. A plea for more "sunshine" in all the Bells' work would recur in more than one review:

> [I]f the Bells, singly or collectively, are contemplating future or frequent utterances in Fiction, let us hope that they will spare us further interiors so gloomy as the one here elaborated with such dismal minuteness. . . . In both these tales there is so much feeling for character, and nice marking of scenery, that we cannot leave them without once again warning their authors against what is eccentric and unpleasant. Never was there a period in our history of Society when we English could so ill afford to dispense with sunshine. (Chorley 1847, 282)

E. P. Whipple, writing in the *North American Review*, and falling prey to the confusion over authorship that Newby had deliberately created, castigated the author of *Wuthering Heights*, whom he assumed to be a brother-sister pair, for the "coarseness" of the novel and the "morbid imagination" of the author, while simultaneously recognizing the "power" of the writing:

> The work bears the marks of more than one mind and one sex. . . . From the masculine tone of Jane Eyre, it might pass altogether as the composition of a man, were it not for some unconscious feminine peculiarities, which the strongest-minded woman that ever aspired after manhood cannot suppress. . . . There are also scenes of passion, so hot, emphatic, and condensed in expression, and so sternly masculine in feeling, that we are almost sure we observe the mind of the author of Wuthering Heights at work in the text. . . . The truth is, that the whole firm of Bell & Co. seem to have a sense of the depravity of human nature peculiarly their own. (Whipple 1848, 300)

Again, the reviewer was especially disturbed not only by the unpleasantness of Heathcliff's character, but even more so by the skill of the author in making him so vivid: "[Heathcliff] is a deformed monster. . . . This epitome of brutality, disavowed by man and devil, Mr. Acton Bell attempts in two whole volumes to delineate, and certainly he is to be congratulated on his success. . . . [T]he power evinced in Wuthering Heights is power thrown away" (Whipple 1848, 301).

A reviewer in the *Atlas*, after first wondering about the gender of the Bells, again acknowledged the power of the writing and condemned the author for

the "contemptible" nature of the characters: "There are evidences in every chapter of a sort of rugged power—an unconscious strength—which the possessor seems never to think of turning to the best advantage. The general effect is inexpressibly painful. We know nothing in the whole range of our fictitious literature which presents such shocking pictures of the worst forms of humanity" (*Atlas* 1848, 282–283). Again, the reviewer criticized the author for the lack of "sunshine" and cheerful characters. "The book wants relief. A few glimpses of sunshine would have increased the reality of the picture and given strength rather than weakness to the whole" (*Atlas* 1848, 283).

Decent women, including women authors, were not supposed to be able to even imagine such characters, much less delineate them with such precision, and reviewers were quick to castigate Ellis Bell for writing about such depraved and gloomy persons. Calling *Wuthering Heights* "one of the most repellent books we ever read," one reviewer wrote: "With all its talent—and it has much—we cannot imagine its being read through from any fascination in the tale itself. The powers it displays are not only premature, but are misdirected. The characters sketched are, for the most part, dark and loathsome, while a gloomy and sombre air rests on the whole scene, which renders it anything but pleasing" (*Eclectic Review* 1851, 353). The reviewer at *New Monthly Magazine* quipped, "It should have been called *Withering* Heights, for any thing from which the mind and body would more instinctively shrink, than the mansion and its tenants, cannot be easily imagined" (Frank 1990, 238).

Moreover, reviewers were disturbed over the lack of didacticism in *Wuthering Heights*. There was no obvious moral, and the author seemed unconcerned with turning the power of the writing "to the best advantage." The reviewer in the *Examiner*, for example, called the characters "coarse and loathsome" and fulminated, "nor can we perceive any very obvious moral in the story" (1848, 286). The authors were not following in the footsteps of successful female didactic authors and hoping eventually to emulate their predecessors' heteronomous positions in the field. Furthermore, the valuation of the symbolic capital of gender itself was also in the process of changing. The proper placement of "female" in an intersection of status hierarchies was a site of conflict. In that same year of 1848, the convention at Seneca Falls was only one highlight of the nascent feminist movement that was engaged directly in the conflict over the position of "femaleness" itself in fields of power.

The Brontës' transgression of the rules of nineteenth-century literature called forth several homilies on the true purpose of writing as well as assertions

that there must be some "defect" in these non-edifying works. For example, complaining that "The story rushes onwards with impetuous force, but it is the force of a dark and sullen torrent, flowing between high and rugged rocks," the reviewer in *Britannia* lectured about the purposes of writing:

> The aim of fiction is to afford some sensation of delight. We admit we cannot rejoice in the triumph of goodness—that triumph which consists in the superiority of spirit to body—without knowing its trials and sufferings. But the end of fictitious writings should always be kept in view; and that end is not merely mental excitement, for a very bad book may be very exciting. Generally we are satisfied there is some radical defect in those fictions which leave behind them an impression of pain and horror. (*Britannia* 1848, 289–290)

The review ended with a baffled acknowledgment once again of the power of the writing, but also with the hope that the author would evolve in a more "noble" direction:

> It is difficult to pronounce any decisive judgment on a work in which there is so much rude ability displayed, yet in which there is so much matter for blame. . . . With all its power and originality, it is so rude, so unfinished, and so careless, that we are perplexed to pronounce an opinion on it, or to hazard a conjecture on the future career of the author. As yet it belongs to the future to decide whether he will remain a rough hewer of marble or become a great and noble sculptor. (*Britannia* 1848, 291)

The reviewers were caught in a normative bind: how do we define the "good" in "good writing"? They were faced with a "powerful" book that was compellingly written but that was nevertheless not "good" (i.e., moral) in the conventional sense. It was, in fact, subversive and therefore called into question the very definition of good. How did the quality of the writing and the morality of the story intersect? And how much did the gender of the author affect the evaluation? The Brontës' novels hit a transition point in the history of English literature, a time when the purpose of writing was being redefined, especially as the novel as a literary form rose in status. Normative boundaries ruled that good writing by women was inevitably circumscribed by rigid morality, even at the cost of abandoning vivid storytelling. These boundaries were transgressed by the Brontës, whose powerful writing did not conform to gendered expec-

tations. Critics were left without workable evaluative schema. The rules of the game were being rewritten.

The *Britannia* reviewer was not the only one who struggled to evaluate *Wuthering Heights*, perplexed by a book so at odds with the prevailing norms of the world of Victorian fiction. Another reviewer wrote:

> *Wuthering Heights* is a strange sort of book—baffling all regular criticism; yet, it is impossible to begin and not finish it; and quite as impossible to lay it aside afterwards and say nothing about it. . . . What may be the moral which the author wishes the reader to deduce from his work, it is difficult to say; and we refrain from assigning any, because to speak honestly, we have discovered none but mere glimpses of hidden morals or secondary meanings. There seems to us great power in this book but a purposeless power, which we feel a great desire to see turned to better account. (*Douglas Jerrold's Weekly Newspaper* 1848, 284–285)

A question about the Bells' gender appeared in almost every review. The reviewer at the *Eclectic Review*, for example, speculated:

> Whether these works were the productions of a gentleman or a lady, and whether their authorship was single or threefold, have been mooted with considerable interest in some literary circles. . . . Though the internal evidence of the works is strongly favorable to the hypothesis of a female authorship, there is, nevertheless, a certain masculine air about their style, a repudiation of conventionalisms, and a bold, nervous, cast of thought and action, which suggests the presence of the other sex. (*Eclectic Review* 1851, 352)

The confusion over the identities of the Bells meant that the criticisms directed at Emily's work would soon start to spill over onto *Jane Eyre*, despite its initially positive reception. When Anne's second novel, *The Tenant of Wildfell Hall*, appeared in June 1848, it was the final blow to the Bells' reputation, despite its popularity with the reading public. The story of an abused wife who flees from her drunken husband and the realistic depiction of domestic violence brought to Anne all of the negative critical notice she had escaped with *Agnes Grey*.

GENDER TRANSGRESSION AND POLITICAL UNREST

Wuthering Heights violated the standards of mid-Victorian literature in important ways. The characters were coarse, the story lacked a moral, and it opened a window into the female heart with a passion that seemed obscene in its lack of delicacy. A consensus soon emerged that these breaches of decorum were the result of one inescapable assumption: the Bells were women, but women "unsexed," as coarse and loathsome as their own vile creations. That is, because they did not accept the conventional place of women in the field, they were defined as something other than true women.

Writing in the *North British Review*, James Lorimer explicitly contrasted *Jane Eyre* with conventionally didactic novels by women who wrote "as an English gentlewoman should write." Of *Jane Eyre*, however, he said: "[M]any of us can hardly repress the feeling, that the works of [the Brontës], however more striking in point of intellect have in them a something harsh, rough, unsatisfying, some say all but unwomanly, as compared with the full, and wholesome, and most womanly perfection of the other" (Lorimer 1849, 169). Lorimer is caught between acknowledging that *Jane Eyre* is a better book than the typically edifying novels of women and evaluating it nevertheless as a worse book precisely because it is not typical of women writers. Is overthrowing the expectations associated with female writing—when those expectations that the writing will be weak and feeble—positive or negative? It is a subversion of the hierarchy of the literary field. Overthrowing expectations of proper female behavior, Lorimer implied, is a transgression that even brilliant writing cannot excuse.

Elizabeth Rigby, writing in *The Quarterly Review*, was even more direct: "[I]f we ascribe the book to a woman at all, we have no alternative but to ascribe it to one who has, for some sufficient reason, long forfeited the society of her own sex" (1848, 453). In an age where sexual impropriety resulted in social shunning for women, Rigby was calling the author of *Jane Eyre* a sexually fallen woman who had, through her immoral actions, forfeited the company of respectable ladies. Her readers would have understood her meaning perfectly well. Currer Bell, she was implying, was a whore.

Sharpe's London Magazine reviewed *The Tenant of Wildfell Hall*, which it called "revolting," "coarse," "profane," and "disgusting," only "to warn our readers, and more especially our lady-readers, against being induced to peruse it"

(1848, 194). *The Spectator* accused Acton Bell of having "a morbid love of the coarse, not to say the brutal" (L. Miller 2001, 22). But it did not stop there. Now all of the Bells' works were found to be in violation of standards of taste and decency: "There is coarseness of tone throughout the writing of all of these Bells, that puts an offensive subject in its worst point of view" (L. Miller 2001, 22).

"Coarse" was gendered as a specifically male attribute at this time. By using it incessantly in their descriptions of the Bells' novels, reviewers were highlighting for their readers that the female Bells were transgressing gender boundaries, crossing the border out of the "feminine" sphere and usurping the privileges of men. Appalled by the Bells' violation of gender norms, one reviewer in 1848 wrote:

> [W]e cannot wonder that the hypothesis of a male author should have been started, or that ladies especially should still be rather determined to uphold it. For a book more unfeminine both in its excellences and defects, it would be hard to find in the annals of female authorship. Throughout there is masculine power, breadth and shrewdness, combined with masculine hardness, coarseness, and freedom of expression. (*The Christian Remembrancer* 1848, 192–193)

The Bells were condemned for writing with the "excellences" reserved for men as much as for the "coarseness" of them. As Charlotte had recognized from the first moment she read Emily's poetry three years before, this writing was not like the weak and feeble effusions typical of women writers of the day; Charlotte had seen that as a virtue of the writing. Now the sisters were being criticized on precisely the grounds that their work was not as feeble as it should have been. Critics were recognizing the subversive nature of the novels and were working hard to conserve the traditional hierarchies and traditional norms for the literary field—especially the gender norms that automatically relegated women authors to the secondary arena of didactic, morally edifying writing.

G. H. Lewes wrote, "A more masculine book, in the sense of vigour, was never written. Indeed that vigour often amounts to coarseness—and is certainly the very antipode to 'ladylike'" (1850, 158). But it was Elizabeth Rigby in *The Quarterly Review*, appearing in December 1848, who had some of the harshest criticism for the Bells—especially for *Jane Eyre*, which Rigby called "pre-eminently an anti-Christian composition":

Jane Eyre is throughout the personification of an unregenerate and un-disciplined spirit. . . . She has inherited in fullest measure the worst sin of our fallen nature—the sin of pride. Jane Eyre is proud, and therefore she is ungrateful too. It pleased God to make her an orphan, friendless, and penniless—yet she thanks nobody, and least of all Him. . . . There is throughout it a murmuring against the comforts of the rich and against the privations of the poor, which, as far as each individual is concerned, is a murmuring against God's appointment—there is a proud and per-petual assertion of the rights of man, for which we find no authority either in God's word or in God's providence—there is that pervading tone of ungodly discontent which is at once the most prominent and the most subtle evil which the law and the pulpit, which all civilized society in fact has at the present day to contend with. We do not hesitate to say that the tone of mind and thought which has overthrown authority and violated every code human and divine abroad, and fostered Chartism and rebellion at home, is the same which has also written *Jane Eyre*. (Rigby 1848, 451–453)

Writing in the volatile year of 1848, with her references to the "rights of man" and rebellion at home and abroad, Rigby tied her critique to the specter of political unrest. Masquerading as the tale of a poor and plain governess finding love, Rigby asserted that *Jane Eyre* in fact contributed to the spirit of the political and social turmoil that threatened to engulf both Britain and France. Resentment against the rich and dissatisfaction with the oppression of the poor had sparked waves of revolution throughout Europe for the past sixty years, and *Jane Eyre* had tapped into the vast discontent at the injustice of the class system.

At just this time, Karl Marx had visited Manchester (less than forty miles away from the Haworth parsonage), where he met with the leaders of the so-cialist Chartist movement. *The Communist Manifesto* was published in February 1848, two months after the publication of *Wuthering Heights* and *Agnes Grey* and two months before *The Tenant of Wildfell Hall*. Rigby, recognizing the spirit of rebellion in Jane, a passionate claim for equality in the face of a rigidly hierarchical class structure, feared that Currer Bell's novel would insinuate anti-hegemonic ideas of social or even political transgression into the unsus-pecting and impressionable minds of readers. Rigby saw the spirit of the book as undeniably dangerous—morally, socially, and politically.

And Rigby was not alone. The harsh review in *The Christian Remembrancer* also referenced revolutionary politics in its critique: "Every page burns with moral Jacobinism. 'Unjust, unjust,' is the burden of every reflection upon the things and powers that be" (1848, 193). The idea of a social hierarchy based on merit—on talents and virtues rather than on inherited position—was shockingly revolutionary for nineteenth-century England. Like the debate over whether or not women should read, the criticism now directed at *Jane Eyre* was about unsettling the "natural" social hierarchy. God intended men to rule and women to obey; likewise, the upper classes had been placed over the lower, and God intended everyone to stay put. Social stability, political quiescence, and Christian duty were intertwined. But these precepts were under attack. The February Revolution in France and the shift in tone from positive to negative in the reviews of *Jane Eyre* happened simultaneously.

Rigby couched her criticism of *Jane Eyre* in terms of the violation of Christian ethos. Jane's story is simultaneously one of undermining the social hierarchy and one of denying the will of God. This same sin of pride could be claimed against Charlotte and her sisters as well. To the daughters of a clergyman, such an accusation was serious, and the sisters took it seriously.

THE BELLS FIGHT BACK

In a letter to William Smith Williams, her editor at Smith, Elder & Co., Charlotte responded to the gendered cast of her reviewers' evaluations of her work. Regarding Lorimer's criticism in the *North British Review*, she answered:

> He says "if 'Jane Eyre' be the production of a woman—she must be a woman unsexed." . . . I am reminded of the "Economist." The literary critic of that paper praised the book if written by a man—and pronounced it "odious" if the work of a woman. To such critics I would say—"to you I am neither Man nor Woman—I come before you as an Author only—it is the sole standard by which you have a right to judge me—the sole ground on which I accept your judgment." (C. Brontë 2007, 140)

This was a revolutionary idea.

In a preface that she added to the second edition of *Jane Eyre*, Charlotte responded to the criticisms that her novel violated propriety by showing debased characters: "I would remind [critics] of certain simple truths. Conventionality

is not morality. Self-righteousness is not religion. To attack the first is not to assail the last. To pluck the mask from the face of the Pharisee, is not to lift an impious hand to the Crown of Thorns" (C. Brontë [1847] 2001, 1). In fact, Charlotte was attempting to cast her book as a successor to the didactic and moralizing novels that were acceptable to those, like critics, with the legitimacy to consecrate actors in the field.

Anne, in the preface to the second edition of *The Tenant of Wildfell Hall*, directly took on those critics who had chastised her for her gender. "I am satisfied," she said,

> that if a book is a good one, it is so whatever the sex of the author may be. All novels are or should be written for both men and women to read, and I am at a loss to conceive how a man should permit himself to write anything that would be really disgraceful to a woman, or why a woman should be censured for writing anything that would be proper and becoming for a man. (A. Brontë [1848] 2001, 5)

Anne also claimed a position of consecrated propriety in the field by laying out for her critics an argument for the morality of her book in precisely its depictions of the evils of "vice and vicious characters":

> [W]hen we have to do with vice and vicious characters, I maintain it is better to depict them as they really are than as they would wish to appear. To represent a bad thing in its least offensive light, is doubtless the most agreeable course for a writer of fiction to pursue; but is it the most honest, or the safest? Is it better to reveal the snares and pitfalls of life to the young and thoughtless traveler, or to cover them with branches and flowers? O Reader! if there were less of this delicate concealment of facts—this whispering "Peace, peace," when there is no peace, there would be less of sin and misery to the young of both sexes who are left to wring their bitter knowledge from experience. (A. Brontë [1848] 2001, 4)

Anne claimed, in the face of her critics, that *The Tenant of Wildfell Hall* was, in fact, a didactic novel, albeit not nearly so boring as others in the genre. The power of the writing had blinded her critics to the morality of her story. It seemed that despite their complaints on the subject, reviewers actually preferred that edifying novels for women be dull.

Although *Wuthering Heights* received as much moral outrage as either

Charlotte's or Anne's books, Emily remained silent in the face of her critics. It is doubtful that by this time Emily would have been capable of much of a response, even on the chance that she had wanted to produce one. Emily, like all the Brontës, had carried the tuberculosis bacterium for a long time. But in the cold, wet autumn of 1848, her fragile health allowed the disease to flourish. On 19 December 1848, almost exactly one year after the publication of *Wuthering Heights*, Emily Brontë died of tuberculosis. On 28 May 1849, Anne died from the same cause. Only Charlotte remained.

In her grief over her siblings' deaths, Charlotte turned to the solace of working on her next novel, *Shirley*. When the novel appeared in October 1849, G. H. Lewes used it as the moment to go on the attack against the Bells, focusing especially on the ways in which they violated gender norms.

In his review of *Shirley*, Lewes began with a long preamble on the question of the "mental equality of the sexes," noting that "the prevalent opinion certainly is that women are inferior in respect of intellect. This opinion may be correct. The question is a delicate one. . . . It is true, no doubt, that none of them have yet attained the highest eminence in the highest departments of intellect" (1850, 154). Lewes continued with an assertion of the unquestioned difference between the sexes as a way of leading into his main point about the role of women in society: "The grand function of woman, it must always be recollected, is, and ever must be *maternity*; and this we regard not only as her distinctive characteristic and most endearing charm, but as a high and holy office. . . . All women are intended by nature to be mothers" (Lewes 1850, 155; italics in original). It is on the basis of her deficiencies as a woman and as a mother that Lewes critiques Charlotte: "Currer Bell! if under your heart had ever stirred a child, if to your bosom a babe had ever been pressed . . . never could you have imagined such a falsehood [as a female character rejecting a child]!" (1850, 165). It was because Charlotte was not a wife and mother that she could not, in Lewes's view, write convincingly about her female characters. He ended his review with an "exhortation" to Currer Bell that she not in future "step out of her sex" (Lewes 1850, 173). Usurping male privilege by displaying intellect, energy, and power, while disdaining the role of wife and mother—that was Charlotte's true crime. She had upset the assumed status hierarchy of the sexes.

Charlotte was deeply wounded by the review and the attack on her womanhood. In a series of letters to Lewes, Charlotte laid out her case to be taken seriously as an author, without regard for her gender: "I wish you did not think

me a woman; I wish all reviewers believed 'Currer Bell' to be a man—they would be more just to him. You will—I know—keep measuring me by some standard of what you deem becoming to my sex—where I am not what you consider graceful—you will condemn me" (C. Brontë 1849, 248).

The secret of the Bells' identities was slowly becoming known. As Charlotte contemplated the shift in tone of the reviews of her and her sisters' work, she was aware of how the books of all three were now being read as autobiography. The "coarseness" of the characters in those books was now being attributed to the personalities and morals of the authors themselves. Charlotte decided that the time had come to go public with their true names and, more importantly, with their life stories, in order, she said, "to wipe the dust off their gravestones, and leave their dear names free from soil" (Bell 1850a, 312).

REFRAMING THE BRONTËS

At the time that Charlotte had first discovered Emily's manuscript poems in the fall of 1845, the sisters did not "suspect that our mode of writing and thinking was not what is called 'feminine,'" Charlotte wrote. Emily's poetry had seemed to Charlotte then to be strong and powerful, attributes that she thought were praiseworthy regardless of the gender of the author. In the years since, she had discovered her error. Despite the mask of their pseudonyms, the Brontës would be judged as women first and authors second. That being the case, Charlotte took up the fight with what weapons she had at hand: she would plead for her own and her sisters' reputations using the remoteness of their upbringing in Yorkshire to make a case for their innocence and lack of worldliness, feminine attributes that she could claim for them to mitigate their sins of bad taste and masculine vigor, trying to excuse the subversive power of their work.

In 1850, Smith, Elder & Co. issued a new edition of *Wuthering Heights* and *Agnes Grey*. Charlotte wrote an introductory Biographical Notice and an Editor's Preface that at last revealed the Brontës' true identities. In them, Charlotte began her campaign against the Brontës' critics by posing her sisters (and herself) as innocent and naïve authors who, because of the intellectual isolation of their upbringing, had no idea that their writing would offend. "Neither Emily nor Anne was learned," she untruthfully wrote; "they had no thought of filling their pitchers at the well-spring of other minds; they always wrote from the impulse of nature, the dictates of intuition, and from such stores of observation as their limited experience had enabled them to amass" (Bell 1850a, 312).

This was an appealingly Romantic notion of creativity, but it was also a false characterization of her sisters, given how educated and well-read they actually were. But instead of conscious artists purposefully constructing their novels, Charlotte posed her sisters as innocent maidens too far away from civilization to have understood what they were about:

> In externals, they were two unobtrusive women; a perfectly secluded life gave them retiring manners and habits. In Emily's nature the extremes of vigour and simplicity seemed to meet. Under an unsophisticated culture, inartificial tastes, and an unpretending outside, lay a secret power and fire that might have informed the brain and kindled the veins of a hero; but she had no worldly wisdom. . . .
>
> Anne's character was milder and more subdued; she wanted the power, the fire, the originality of her sister, but was well-endowed with quiet virtues of her own. Long-suffering, self-denying, reflective, and intelligent, a constitutional reserve and taciturnity placed and kept her in the shade, and covered her mind, and especially her feelings, with a sort of nun-like veil, which was rarely lifted. (Bell 1850a, 312)

This was an explicit strategy to use the symbolic capital of innocence to place the sisters in more socially acceptable positions.

In her Editor's Preface, Charlotte went even further in erasing all of Emily's education, experience, thoughtfulness, and conscious artistry. As she did with Anne, she compared Emily to a nun, indicating the virginity—both sexual and intellectual—that she thought would protect the sisters from criticisms of their vulgarity and sensuality, the assumptions raised of their sexual impropriety. But she also reduced Emily to a wild child, an untamed creature of the moors:

> With regard to the rusticity of "Wuthering Heights," I admit the charge, for I feel the quality. It is rustic all through. It is moorish, and wild, and knotty as a root of heath. Nor was it natural that it should be otherwise; the author being herself a native and nursling of the moors. . . . I am bound to avow that she had scarcely more practical knowledge of the peasantry amongst whom she lived, then a nun has of the country people who sometimes pass her convent gates. . . . except to go to church or take a walk on the hills, she rarely crossed the threshold of home. (Bell 1850b, 313–314)

Rather than the woman of formidable intellect, Emily, she contended, was merely a passive vessel, a nursling of the moors, through whom inspiration passed, without even her own knowledge:

> Having formed these beings [Heathcliff, Earnshaw, and Catherine], she did not know what she had done. . . . Whether it is right or advisable to create beings like Heathcliff, I do not know: I scarcely think it is. But this I know; the writer who possesses the creative gift owns something of which he is not always master—something that at times strangely wills and works for itself. (Bell 1850b, 314–316)

Emily could not be blamed for what she could not control. Charlotte offered excuses and apologies for her sisters' works, trying to assure readers and critics that any challenges to established hierarchies were unintentional and reframing her sisters—especially Emily—as that most unthreatening of social actors: a child.

Although some critics continued to rail against the coarseness of the sisters, others reacted to Charlotte's pleas in more positive ways. The reviewer, having read Charlotte's Biographical Notice, wrote:

> Curious enough it is to read *Wuthering Heights* and *The Tenant of Wildfell Hall*, and remember that the writers were two retiring, solitary, consumptive girls! Books, coarse even for men, coarse in language and coarse in conception, the coarseness apparently of violent and uncultivated men—turn out to be the productions of two girls living almost alone, filling their loneliness with quiet studies, and writing these books from a sense of duty, hating the pictures they drew, yet drawing them with austere conscientiousness! (*The Leader* 1850, 348–349)

By placing the novels into the framework of the didactic writing expected of women and by positioning twenty-nine-year-old Emily and twenty-eight-year-old Anne as mere "girls," Charlotte began her campaign of excuse and rehabilitation.

Charlotte's attempts to placate the Brontës' critics did not stop at apologizing over her sisters and presenting them to the public as demure maidens. In taking control of their works, she also re-edited their writing to make it more acceptable and suppressed what could not be changed. The new edition of *Wuthering Heights* also included a selection of Emily's poetry that Charlotte

edited and changed "with an astonishing lack of sensibility, making them at times almost a mockery of Emily's intentions" (Hanson and Hanson 1949, 305). Charlotte also altered *Wuthering Heights* itself, "softening the forthrightness of many passionate scenes" (Hanson and Hanson 1949, 305). There are even indications that she may have destroyed a second novel that Emily was working on (Barker 1994, 579).

Anne's second novel, *The Tenant of Wildfell Hall*, Charlotte suppressed altogether, refusing to allow it to be reprinted. To her editor she wrote: "'Wildfell Hall' it hardly appears to me desirable to preserve. The choice of subject in that work is a mistake—it was too little consonant with the character—tastes and ideas of the gentle, retiring, inexperienced writer" (C. Brontë 1850, 295). Even to her publishers, Charlotte persisted in putting forth the excuse that Anne was a naïf, despite the fact that Anne had worked for years as a governess, and she had closely observed her brother Branwell's protracted decline into brutal and violent addiction to drugs and alcohol, finally culminating in his death. Far from being "inexperienced," Anne had a wealth of examples to draw on in telling her story of abuse and domestic violence owing to alcoholism. But Charlotte presented her sisters as examples of unsullied womanhood working strictly within the didactic idiom. She wrote of Anne, "She hated her work, but would pursue it" (Bell 1850a, 311).

Charlotte's own efforts to reframe the Brontës ended with her death a few years later, on 31 March 1855. The campaign was then taken up by others. Following Charlotte's death, her father called in the author Elizabeth Gaskell to memorialize Charlotte by writing a biography, a step in consecrating his daughter's position in the cultural field.

The Life of Charlotte Brontë was published in 1857. In it, Gaskell took her cue from Charlotte's Biographical Notice—portraying the sisters as innocent, isolated, and ignorant. It was a book-length defense of, and excuse for, their writing. Gaskell relied heavily on gendered expectations and norms. If the critics had been shocked by the power and passion of the Bells, Gaskell explained their writing not as the result of lives of sexual impropriety, but instead as the result the sisters' rural Yorkshire upbringing among uneducated countryfolk and their pious determination to portray life as they saw it for the moral benefit of their readers. Gaskell loaded the Brontë sisters with acceptable feminine attributes: they were uneducated, she claimed, and completely innocent of literary fashions; they were dutiful and submissive daughters to a strange misanthropic father; they were pious maidens trying to write didactic novels; they

were so secluded that they had no idea they would give offense with their work; the shocking parts of their novels were direct copies of their lives in Yorkshire; they were powerless in the grip of a creative force they could not control. In sum, they didn't know what they were doing. Rather than conscious artists, Gaskell portrayed the sisters as naïve girls. And it worked.

The Christian Remembrancer, which had castigated Charlotte's writing while she was alive, now wrote, "Whatever extenuation can be found for want of refinement—for grosser outrages on propriety than this expression indicates—the home and the neighbourhood of Charlotte Brontë certainly furnish; she wrote in ignorance of offending public opinion" (Barker 1994, 796). The critic for the *North American Review* was similarly forgiving: "the knowledge that the authors painted life as it lay around them in their daily path is sufficient refutation of the charge, that they reveled in coarseness for coarseness' sake, and drew pictures of vice in accordance with their own inherent depravity" (Barker 1994, 796). The sisters were excused from responsibility for their own writing.

Although not the naïfs that Gaskell portrayed, the Brontë sisters were outsiders to the cultural field. They were well-read but initially knew almost nothing about the workings of the publishing world. Nor did they fully anticipate the degree to which the critics who reviewed their work were motivated by concerns to conserve the structure of the field. Left without the support of her deceased sisters, Charlotte pulled back from their subversion and tried to reframe the sisters as writers in the didactic tradition of female scribblers who had stumbled accidentally, and with only pure intentions, into offense. But the anti-hegemonic message of the Brontës' novels was already loose among the reading public, who had eagerly snapped up the work despite, or because of, the critics' outrage.

Not only the Brontës as female authors, but the symbolic capital of "female" itself was engaged in struggle in the field for movement to a different position vis-à-vis "male." While "female author" could be valuable in the heteronomous sector of didacticism in the field, the Brontës' novels were part of a subversive strategy to redefine the valuation of "female" itself, delegitimizing it as a marker of weakness and passivity—characteristics valued at the heteronomous but not at the autonomous pole of the field. Charlotte's argument that she wanted to be perceived as "an Author only," without regard for her gender, struck a blow against the very idea of gender hierarchies. She was uncoupling traditional feminine stereotypes from the possibilities for achieving new positions in the field where women had been by definition relegated to the

heteronomous sector. Moreover, she was doing this just at the time when the feminist movement itself—tied as it was to other types of political upheaval, such as abolition of slavery—was being born. The outrage over the Brontës' novels signaled the precarity of unquestioned hegemonic beliefs in women's innate inferiority.

In some ways, it is true that the Brontës had not originally intended to have such disturbing effects on the cultural field. After all, they had originally written the novels as a moneymaking venture. They recognized that their gender might be problematic, hence their pen names, but did not see the full scope of the challenge they were presenting and the critical outrage they would provoke. Although the novels themselves were seriously intentioned, the subversive strategy itself was accidental. The next chapter discusses a group of artists, the Impressionists, whose subversive strategy was more consciously chosen.

THREE

"The Summit of Vulgarity"

The Paintings of the Impressionists

In April 2011, the royal family of Qatar purchased Paul Cézanne's 1892 painting *Les Joueurs de cartes* for an estimated $250 million. It was the third highest price (as of this writing) ever paid for a painting, but it was merely the highest in a long list of astronomical amounts that buyers have paid for Impressionist works: $78 million in 1990 for Pierre-Auguste Renoir's *Bal du moulin de la galette*, $80.5 million in 2008 for Claude Monet's *Le Bassin aux nymphéas,* and $81.4 million for his *Meules.* The list goes on. It is hard, in light of such astonishing numbers, to remember that in their day, the Impressionists garnered mostly sneers, derisive laughter, and disgust from both critics and the general viewing public. For many years, the Impressionist painters were forced to sell their work at rock bottom prices. Often, they could not sell their paintings at all—or even give them away. A servant girl who won a painting by Camille Pissarro in a raffle held in 1876 to raise money for the impoverished artist willingly traded away her prize to the baker Eugène Murer in exchange for a large cream bun (Roe 2006, 175). This lack of commercial success in their own time only enhances their prestige in ours.

The Impressionists were a loose group of young artists who, in the second half of the nineteenth century, challenged the French art world with an unconventional style of painting and an unabashed embrace of the modern world. Between 1874 and 1886, they held eight exhibitions of their work in Paris, each

providing an occasion for battles between conservative critics and the subversive avant-garde. Over time, these exhibitions changed the way that art was sold, changed the audience for art, and changed the ways in which we see art and its place in the world. They would influence every major art movement of the twentieth century (Watson 1992, 80). At the beginnings of their careers, the Impressionists were almost universally failures; at the end, they were deeply admired and respected. They rewrote the rules of the cultural field. And unlike the Brontës, they had every intention of doing so.

It is fitting that there should have been dramatic changes in the status of the Impressionists. They emerged during—and in many ways were shaped by—equally dramatic changes in the social and economic status hierarchy of France in the mid-1800s.

RAPID CHANGE

The population of Paris exploded during the course of the nineteenth century, reaching 2.5 million by 1900, while the wealth and purchasing power of French citizens also snowballed (M. Miller 1981, 45). The middle decades of the nineteenth century were the take-off period for the French Industrial Revolution (M. Miller 1981, 32). The city of Paris itself was being radically restructured through "Haussmannization." Between 1853 and 1870, Baron Georges Haussmann, under direction from Emperor Napoléon III, engaged in a massive redevelopment of Paris, tearing down the old meandering streets and ramshackle buildings in order to create the grand boulevards cutting through the city. Larger apartments suitable for the rising middle class were constructed, and space for economic ventures, such as the new-concept department stores, opened up.

Changes in the physical structure of Paris mirrored changes in the structure of the society, causing rising anxiety in those who had prospered under the traditional regime of class stability and social stasis. As Sebastian Smee writes, "Not even fashion and dress brought clarity to the situation, since people could no longer be depended upon to dress in ways that reflected their social standing. Instead—and increasingly—people's clothes expressed their social *aspirations*" (2016, 138; italics in original).

The age of consumerism had begun, and the traditional status hierarchies expressed by cultural and symbolic capital were in flux. A rearrangement of social norms meant opportunity for new ways of thinking to emerge and find

an opening in French society. The young painters who would become the Impressionists fit in well with the new energy and excitement in Paris. They embraced the turmoil and the social upheaval. They began searching for new ways to visually represent in their art the evanescent tenor of modern life.

The Franco-Prussian War detonated like a bomb in the midst of all of this change. In July 1870, France declared war on Prussia over the issue of the succession to the Spanish throne. The war was short-lived. The defeat of the French armies at Sedan led to Napoléon's surrender on 2 September 1870 (six weeks into the war) and the proclamation of the Third Republic two days later. Prussian armies then marched on Paris and laid siege to the capital during the last cold months of 1870. The siege was a brutal and hungry time for Parisians, and they finally surrendered on 28 January 1871.

Defeated and humiliated, revolutionary Parisians turned on the new French government, ensconced at Versailles, blaming it for abandoning the city to the Prussians, and in March 1871 the Paris Commune, a new revolutionary government, was proclaimed in the city. Its suppression by the official French government was bloody. In one week in May 1871, as many as 20,000 Parisian Communards were killed by French troops (Tucker 1995, 47). By the end of that week, the Commune was broken. Between the war and the Commune, thousands were dead, including the young Impressionist painter Jean-Frédéric Bazille, and hundreds of buildings in the city had been razed to the ground.

With so much of the Old World destroyed and the old norms shattered, this became an era of the "self-made" person. Entrepreneurs started new businesses or expanded old ones. Provincials refused to stay in their place in the country but came instead to Paris to make new lives for themselves that were not tied to the traditions of their ancestors. Young women got jobs and supported themselves working in the offices and the new department stores in the capital, living on their own rather than as the property of first their fathers and then their husbands. A middle class of enterprising young people developed. Harrison and Cynthia White write that "the nineteenth century witnessed the rise of the bourgeoisie to material and cultural predominance within France" (1965, 77). And this new tide of cosmopolitan, free-spirited upstarts wanted things: fashionable clothes at affordable prices, holidays, evening and weekend entertainment, access to urban culture—and art. Fine art had formerly been the preserve of the very rich, the aristocracy, and the government. No more.

Many social commentators of the mid-1800s were aghast at the rapid changes they saw hurtling France into a new era. Part of the problem these

social critics saw was the social mobility that endangered the old status hierarchy. But more than that was the seeming *duplicity* involved in upward social movement. The newly made cosmopolitans crowding the cafés, the young single women in their cheap fashionable dresses, the *flâneurs* strolling the broad boulevards and stopping in at the art galleries, the parvenus—they were all perceived by the conservatives as ersatz sophisticates, as fakes hiding behind a shoddy veneer of polish. There was to some a disturbing, subversive breach of social boundaries. The newly fashionable people had been only recently members of the urban working class or the provincial peasantry (Seigel 1986, 93). Instead of solid respectability, critics feared that there was merely flimsy style with no real foundation underneath. They would accuse the Impressionist paintings of having those same faults.

CONSPICUOUS CONSUMPTION

It was becoming increasingly difficult, if not impossible, to place anyone in their proper social category, to know who anyone was (socially speaking). In a society where ancestral dignity, hooked to inherited wealth and position, had been all-important, a new class was emerging, wealthy with "new" money (M. Miller 1981, 35).

Bourgeois culture in France in the 1800s was divided between values of individual achievement and those of self-restraint (M. Miller 1981, 237). While one fraction of the middle class was staunchly traditional in its outlook, another fraction of the same class was eagerly embracing the view that clothes (and other consumer goods) make the person. Having figured out that the visible signs of status were important symbols of class distinction, the nouveaux riches realized that symbols could be purchased now on the open market (M. Miller 1981, 165). So while one segment of the middle class was eagerly purchasing the accoutrements of respectability, another was fighting a rearguard action to expose their status rivals as frauds and to shift status markers away from what could be bought (with economic capital) towards refinements that could only be learned and acquired over time (embodied cultural capital). It seemed possible that Bourdieu's "hidden economy of time" by which cultural capital could be acquired only over a long period of time—and, therefore, be used to mask the inherent inequality and rigidity of social hierarchies—was in danger of being bypassed in favor of simply purchasing the symbolic trappings of high culture.

But the attainment of social status is a competitive game. Simply consuming more and more is not enough to win points in the game of status. One must consume *correctly*, with a certain refinement that separates one from the parvenus, the frauds, and the fakes. In *The Theory of the Leisure Class*, Thorstein Veblen argued, "The knowledge and habit of good form come only by long-continued use. Refined tastes, manners, and habits of life are a useful evidence of gentility" (Veblen [1899] 1994, 31). Moreover, "The . . . gentleman of leisure . . . must also cultivate his tastes, for it now becomes incumbent on him to discriminate with some nicety between the noble and the ignoble in consumable goods. He becomes a connoisseur" (46–47). Through the correct display of one's possessions, an identity was claimed (54).

For purposes of claiming status, displayed objects—clothing, household goods, and art— were conspicuously costly and therefore "beautiful" and "refined." Objects show their costliness, and therefore their beauty, by the degree of "finish" they exhibit, as a mark of the amount of labor that went into their making. The obvious degree of work and craft that went into "finishing" the object was an important aspect, in Veblen's theory, of its beauty. Costliness had become so tightly associated with beauty, Veblen argued, that "we have finally reached such a degree of conviction as to the unworthiness of all inexpensive things, that we have no longer any misgivings in formulating the maxim, 'Cheap and nasty'" ([1899] 1994), 94).

THE DEMOCRATIZATION OF LUXURY

At the beginning of the nineteenth century, the idea of "shopping" as we know it now was nonexistent (M. Miller 1981, 24; Rosalind Williams 1982, 204). Customers entered a store only when they wanted to buy a specific item. There was no browsing among items on display. A shop assistant would bring out the requested item. Haggling would then begin: there were no marked prices. Once haggling began, or even once the customer entered the store, there was an assumed obligation to buy. There was no idea of exchanging or returning unsatisfactory items.

All of that changed when Aristide Boucicaut opened Le Bon Marché, the world's first department store, in Paris in 1852 (Masset 2010, 14; Rosalind Williams 1982, 204). Boucicaut's ideas revolutionized the practice of shopping, contributing to what was commonly called at the time "the democratization of luxury" (Rosalind Williams 1982, 224). His innovations included marked

and fixed prices on items, open entry to the store without obligation to buy, affordable prices, and a policy for returns or exchanges. The addition of public lavatories and restaurants in the stores meant that women now had a place outside the home where they could comfortably spend the day and meet friends. Soon these practices were widespread, not only in France, but also in England and the United States.

What Boucicaut and the flood of imitators was selling was not just household goods but identity and status—specifically middle-class identity for the status-insecure self-made Parisians arriving by the thousands in the French capital, looking for social mobility to mirror their geographic mobility. Department store displays demonstrating, for example, how to decorate a dining room or to dress for a night out at the theater became a guide for how the upwardly mobile could embody their aspirations (M. Miller 1981, 182–183). Michael Miller writes, "Consumption itself became a substitute for being bourgeois" (1981, 184). And the customers and the nouveau riche owners of the department stores, rather than the traditional aristocracy, were the first buyers of the Impressionists' work. Predictably, conservative social critics were alarmed.

One faction of the middle class disapproved of the newfangled, topsy-turvy social world and was solidly traditional. This faction had been made insecure in their status by the incursions of the parvenus into their ranks and asserted their refinements through connoisseurship and the display of "good taste." The other faction eagerly embraced the modern world, the excitement of urban life, the transitory pleasures of conspicuous consumption. They wanted all the luxuries associated with their new identities—including art. Traditionally, the place to find art was the annual Salon des Beaux-Arts, which would become the physical place where battles in the social space of the cultural field would occur.

REJECTING THE SALON

The nineteenth-century French art world was dominated by the Académie des Beaux-Arts and the annual juried exhibition it sponsored, the Salon de Paris, held every spring in the Palais de l'Industrie. The jury, especially during the Impressionist era, was dominated by classicists. Works based in traditional techniques, depicting elevated moral themes "and, wherever possible, the glory of the French state were highly favored. . . . Painting that directly reflected contemporary Parisian life was nowhere to be seen" (Smee 2016, 100). Enor-

mous history paintings were perceived as the pinnacle of excellence (White and White 1965, 33).

Until dealers and galleries emerged in the second half of the nineteenth century, the Salon was almost the only place outside of their own studios that painters could show their work. To survive as a painter meant getting government commissions or patronage from members of the elite. Awards from the Salon were a necessary prerequisite: there was simply no other way to bring oneself to the public's notice.

Thousands of spectators crowded the exhibition every year. Many of them were members of the bourgeoisie, and a trip to the Salon was part of their display of breeding and good taste. Sue Roe notes, "Anything out of the ordinary, in subject matter or execution, was viewed with suspicion" (2006, 9). This was precisely the "bourgeois art" that exemplified the heteronomous pole for Bourdieu.

The Impressionist movement in many ways began at the Salon of 1863. The jury that year was particularly harsh, rejecting over 3,000 of the 5,000 submitted works. The outcry among the rejected artists was so intense that Napoléon, having viewed the rejected works, created the Salon des Refusés. Opening in a nearby annex two weeks after the main Salon, this exhibition would show every rejected artwork, unless the artist chose to withdraw it. The public at large was to have a say in judging the merits of these works.

Over 70,000 visitors came to the first day of the Salon des Refusés. They came mostly to jeer. The center of attention was a painting hung in the farthest gallery, *Le Bain*, by Édouard Manet. Now known as *Le Déjeuner sur l'herbe*, it was the focus of shock and horror for many and of fervent admiration for a very few. It is a picture of a naked young woman seated between two young men fully dressed in modern clothing on a forested streambank amid the remains of a picnic lunch. Another young woman is washing herself in a stream in the background. The primary female figure is looking out directly at the viewer. Although based on an engraving by Raphael, the painting shocked the crowds with the modernity of the scene—and with the brazen young woman's regarding stare.

The shocking subject matter was matched by the shocking technique Manet had used, eschewing the muted palette of classical painting and the soft blending of edges. In *L'Artiste*, critic E. Chesneau complained that Manet's "lurid way of painting cuts into the eye like a steel saw; his figures are cut out as if by a punch, with a brutality which is not eased by any form of compro-

mise" (1863, 28). Pierre Assouline succinctly noted, "In the eyes of the Academy, Manet was the anti-Christ" (2004, 73). But for a small group of younger, unknown painters, Manet's uncompromising work was a beacon, lighting the path forward. As Renoir later said, "with Manet, it was a new era in painting" (Danchev 2012, 88).

It is interesting to see what critics were saying about Manet's work during the 1860s, long before the first show of the Impressionists in 1874. These early criticisms would be echoed again and again in discussion of the Impressionists. A chief complaint was that the subject matter was "vulgar"—that bugbear of the status-insecure bourgeoisie. Marius Chaumelin in *L'Art contemporain* wrote: "Manet must be taken to task, for although he possesses the true painter's temperament he has persisted in reproducing repulsively vulgar subjects, scenes devoid of interest. All his efforts should be directed toward expressing living nature in its most beautiful forms" (Chaumelin 1869, 131).

Many critics believed Manet must be ill, either physically or morally. Paul Mantz in the *Gazette des beaux-arts* wrote, "In short, this art may be strong and straightforward but it is not healthy" (1863, 40). Louis Leroy, who a decade later would become one of the most unrelenting of the Impressionists' detractors, wrote in *Le Charivari*: "Manet must suffer from an acute affliction of the retina. Nature couldn't appear this way without an aberration of the optic nerve" (Leroy 1864, 55).

Furthermore, the critics, accustomed to the high polish of classical academic painting, saw Manet's work as unfinished and unrefined, which, as Veblen's theory of beauty argued, was the definition of ugliness. Marc de Montifaud wrote in *L'Artiste*: "What he lacks is control, the precise tint in the intense coloring of which he dreams and which he only crudely portrays. His portrait of Émile Zola, less black than those of other years, was done with a few strokes rather than really painted" (de Montifaud 1868, 117). Albert Wolff, in *Le Figaro*, wrote dismissively, "Manet believes he is making paintings, but in reality he only brushes in sketches" (1869, 139).

With these attacks on Manet, the battle expanded. The traditionalists had their say about the unfinished, unhealthy, vulgar works they saw. Manet's defenders then took up the cause. The twenty-seven-year-old Émile Zola, working as a journalist for *L'Événement*, had only recently left his position in the PR department of the publisher Hachette and knew the value of publicity. Never one to shy away from a fight, he all but called Manet's critics shallow ignoramuses: "The public has not even tried to understand the work. It has stayed, so

to say, on the surface. What shocks and irritates it is not the essential structure of the work but the general and superficial aspects. If possible it would willingly accept the same subject presented in another manner. The worst horror is originality" (Zola 1867, 102).

A group of young artists began to gather at the Café Guerbois to discuss and argue about these new ideas emerging in the Parisian art world. They saw themselves as outside the herd, estranged from the accepted practices of the Académie art world, marginal to the field, but nonetheless ambitious to dominate it. What drew these artists together was a commitment to ideals that they were slowly formulating about capturing a new kind of beauty: modern, evanescent, nontraditional, and transgressive. They hashed out their theories in the freewheeling discussions, but they also figured them out through practice. They began to paint together, side by side in the open air, learning not to just talk about modernity, but also to capture it.

Routinely rejected by the Salon jury, on 27 December 1873, they launched the *Société anonyme coopérative des artistes, peintres, sculpteurs, et graveurs.* Admission was open to any practicing artist for sixty francs. In return, all society members were eligible to show and sell their works in the society's exhibitions, without interference from any jury. The society was radically egalitarian in pointed contrast to the Salon. The artists were rejecting the Salon and the old patronage system and throwing their lot in with the new world of the marketplace.

STRATEGIES IN THE FIELD

Again, Bourdieu's theories regarding the cultural field are relevant here. As actors in the field struggle for advantageous positions, they may employ different types of strategies: conservation, succession, or subversion. Strategies of "conservation" attempt to conserve the structural positions of the field in the current hierarchical order: an eminent critic, for example, derides the work of a newcomer because it does not follow the same standards and techniques of the work of the established order. Newcomers to the field, therefore, may choose to employ a strategy of "succession" in which their planned trajectory is to follow in the footsteps of previous cultural agents, bowing to the acknowledged legitimacy and consecration of those who have come before them.

But, the third type of strategy in the field, the strategy of "subversion," aims instead to completely reorganize the field, shifting the positions of the poles. Rather than hoping to head in a trajectory towards the traditional autonomous

pole, subversives attempt instead to bring that pole to where they themselves are already located. David Swartz wrote that "These strategies take the form of a more or less radical rupture with the dominant group by challenging its legitimacy to define the standards of the field" (1997, 125). Bourdieu argued: "When a new literary or artistic group makes its presence felt in the field of literary or artistic production, the whole problem is transformed, since its coming into being, i.e. into difference, modifies and displaces the universe of possible options; the previously dominant productions may, for example, be pushed into the status either of outmoded [déclassé] or of classic works" (Bourdieu 1993, 32).

The strategy of subversion is one of burning down the cultural hierarchy in order to build it up anew with new radical agents at the top of the heap. It is an attack on the established cultural order and is perceived as such by those in power. Those at the top of the cultural heap respond to these challenges from the upstarts; they have much to lose in terms of their power, prestige, and income. Symbolic capital only has worth so long as it is perceived as legitimate: therefore, the value of their personal store of capital is under siege. And as their personal capital goes, so too go the prevailing cultural norms of the larger society. This is precisely the strategy the Impressionists employed: consciously denying the right of legitimation to the Salon jurors and claiming it for themselves, their dealers and critics, and the public.

FROM PATRONAGE TO MARKET: THE DEALER-CRITIC SYSTEM

Until the early-1800s, artists in France had depended on patrons from the aristocracy or the government for their survival. The intention of the Impressionists, disheartened by the cool reception they received from the Salon where they had only minimal success, was to stage a large exhibition of their work without any support from either government or private patrons. This was a bold step, trusting in the public market, and in the public taste, to appreciate their innovative vision. In the status game the new bourgeoisie were playing, taste—especially demonstrating "good" taste—was a matter that struck at the heart of one's identity. For the status-insecure middle class, judgments about art were fraught with feelings of self-doubt and anxiety. Could the Impressionists really trust the members of the public to look at their paintings with a friendly eye? Taste was far too important an issue to be left to the whims of the urban crowd. A new system—the "dealer-critic system" (White and White 1965, 94–98)—was coming into play to help the new bourgeoisie figure out

what their artistic taste should be, as the department store displays had done for home furnishings and fashion.

Two changes helped put the dealer-critic system in place and set it up to replace the old Académie/Salon system. One was the increase in the number of newspapers and periodicals being published, and the other was the opening of art galleries among the other entrepreneurial businesses booming in Paris. Rather than rely on the Salon to make their names, artists now could have more steady access to the public—both the public's attention and its purse, overflowing with ready cash. And not incidentally, as Assouline noted about the enormous paintings produced for display at the Salon, "It is true to say that on one level history painting was unlikely to reach the salons of the bourgeoisie because it could not fit into them" (2004, 70). The rising middle class may have admired the enormous Salon masterpieces, but they could not hang them in their homes. Dealers stocked galleries with pictures the bourgeoisie could realistically own and display. These shops filled with paintings were like the department stores of art. Indeed, the Bon Marché itself installed an art gallery inside.

In this endeavor, dealers partnered with critics. Critics became educators of the public, helping to explain the avant-garde works to potential buyers:

> Although French critics had always considered it their role to instruct the public in matters of taste, such discussions had generally been in terms of subject matter, following the Academic emphasis. In articles on Impressionism a new type of instruction appeared. Style and painting method were analyzed. The better critic attempted to teach the public how to look at a painting, rather than how to interpret its subject. (White and White 1965, 119)

To achieve their aims, dealers turned to the techniques that had been so successful for other businesses, like the department stores. They waded into the modern world of publicity. Both dealers and artists were aware that the success in the art marketplace depended on notice from the new masses of middle-class consumers.

THE FIRST IMPRESSIONIST SHOW

The first group show opened on 15 April 1874 in gallery space on the Boulevard des Capucines rented from the photographer Nadar. Altogether, 3,500 visitors came during the course of the month-long exhibition. This was a respectable

number for such a novel affair but was, of course, nothing like the 400,000 visitors to the annual Salon, which was going on simultaneously.

Thirty painters took part, including Paul Cézanne, Edgar Degas, Berthe Morisot, Camille Pissarro, Pierre-Auguste Renoir, Alfred Sisley, and Claude Monet, who showed a painting of the Le Havre harbor whose title—*Impression, Sunrise*—would give critics a convenient term of abuse to hurl at the group. The group did not call itself "Impressionists" but "Independents" or "Intransigents."

Of the fifty paintings shown in this exhibition, very few were purchased. Degas and Morisot sold nothing, Pissarro made 130 francs, and Monet and Renoir each made less than 200 francs. Sisley did the best with total sales of 1,000 francs (Roe 2006, 131). They also sold 350 catalogues for another 175 francs. The 3,500 francs they collected in entrance fees was by far the most profitable part of the venture. Nevertheless, there would be seven more exhibitions (as well as a number of auctions and solo shows) of the artists whom Cézanne called "the painters who are on our side" (Assouline 2004, 142), ending with the eighth group show in 1886.

It was in the area of visibility and publicity that the group had most success. As true citizens of the modern era, the organizers of the exhibition were attuned to the importance of publicizing their efforts. "The organizers . . . spread news about the occasion by posters, word of mouth, and contacts in the press. Their efforts paid off. . . . There were at least fifty notices and reviews in the leading newspapers of the capital" (Tucker 1995, 77). Some of the notices, especially those in the smaller periodicals and those written by their friends, were favorable. The majority, however, were hostile and mocking, following the lines of criticism that had been laid down for Manet over a decade before, but adding new twists that highlighted the new fault lines showing up in French society.

One of the first pieces of criticism to appear is also one of the most notorious. Louis Leroy's scathing review of the first group show appeared on April 25, 1874, in *Le Charivari*. Written as a satirical dialogue between two viewers of the exhibition, Leroy repeatedly used the word "impression" to negatively characterize what he saw as the unfinished nature of the paintings. Here is the dialogue in front of a Pissarro landscape, *Ploughed Fields*:

> "Those furrows? That frost? But they are palette-scrapings placed uniformly on a dirty canvas. It has neither head nor tail, top nor bottom, front nor back."
>
> "Perhaps . . . but the impression is there." . . .

On to Monet's *Boulevard des Capucines*:

> "But those spots were obtained by the same method as that used to im-
> itate marble: a bit here, a bit there, slapdash, any old way. It's unheard
> of, appalling! I'll get a stroke from it, for sure."

And in front of Monet's image of the Le Havre harbor:

> "What does that canvas depict? Look at the catalogue."
> *"Impression, Sunrise."*
> *"Impression*—I was certain of it. . . . Wallpaper in its embryonic state
> is more finished than that seascape." (Leroy 1874, 319–320)

Leroy clearly meant "impression" as a derogatory label. (When the group of
painters adopted it themselves for their third show, it was in the spirit of defi-
ance.) Complaints about the unfinished nature of the work and its consequent
ugliness that began with the first group show reappeared continuously over the
course of subsequent shows.

Of the first show, Jules Claretie wrote: "M. Manet is among those who main-
tain that in painting one can and ought to be satisfied with the *impression*. We
have seen an exhibition by these *impressionists* on the boulevard des Capucines, at
Nadar's. M. Monet—a more uncompromising Manet—Pissarro, Mlle Morisot,
etc, appear to have declared war on beauty" (Claretie 1876, 326; italics in original).
Emile Cardon, in the conservative daily *La Presse*, was even more forthright: "the
debaucheries of this school are nauseating and revolting" (1874, 77).

The response from critics highlights an important point about the relational
nature of the cultural field. Lawrence Levine described the sacralization of
certain genres of music:

> The urge to deprecate popular music genres was an important element
> in the process of sacralization. If symphonic music was . . . divine, then
> it follows that other genres must occupy a lesser region. . . . Sacraliza-
> tion increased the distance between amateur and professional. . . . More
> and more it was asserted that it was only the highly trained professional
> who had the knowledge, the skill, and the will to understand and carry
> out the intentions of the creators of the divine art. (Levine 1988, 136–139)

The process of sacralization of "high" art, such as the art admitted to the Salon,
carried with it the concomitant need to belittle the work of the Impressionists—
and the buyers of that work.

"WHO CAN THE PEOPLE BE WHO HANG SUCH THINGS UP IN THEIR ROOMS?"

For the second show, in 1876, Alfred Wolff, the influential art critic for *Le Figaro*, wrote with a visceral disgust of Renoir's *Nude in the Sunlight*: "These self-styled artists call themselves Intransigents, Impressionists; they take some canvases, paint, and brushes, throw a few colors on at random, and sign the whole thing. . . . Try to explain to M. Renoir that a woman's torso is not a mess of decomposing flesh with green and purple spots that indicate that state of total putrefaction in a corpse!" (Wolff 1876, 58). In response to an auction of Impressionist works that the artists arranged in 1875, the same critic wrote: "The impression produced by the Impressionists is that of a cat walking on the keys of a piano, or a monkey that has got hold of a box of paints" (Wolff 1876, 55–56). For the third group show in 1877, Roger Ballu, the Inspector of Fine Arts, wrote in the *Chronique des Arts*: "Children entertaining themselves with paper and paint do better" (1877, 160). Those who were not disgusted were nonetheless unimpressed. An 1882 reviewer wrote: "Some of the landscapes are fair, but why make such a fuss about things that every artist produces, but does not see fit to frame and exhibit? What the multitude modestly calls a sketch, is dignified by this brotherhood of nine into a picture" (*Artist* 1882, 44).

In response to these criticisms, the painters held steadfast to their ideals. "Not since Diderot invented criticism has any critic ever got it right," Renoir shrugged. "They panned Delacroix, Corot, and Goya. If they smothered us with praise I would be seriously worried" (Assouline 2004, 133). Of an unfavorable review, Manet said merely, "Clearly one of us is mistaken" (Assouline 2004, 173).

Younger, more progressive critics, however, expressed more positive views. Their defense of the works' beauty may seem obvious today, but these were decidedly minority views at the time. As early as 1873, Armand Silvestre exclaimed:

> In looking at their painting, what strikes you first of all is the immediate caress which the eye receives from it—it is above all harmonious. One discovers soon, in fact, that its whole secret is a very delicate and very exact observation of relationships of tone. . . . What apparently should hasten the success of these newcomers is that their pictures are painted according to a singularly cheerful scale. A "blond" light floods

them and everything in them is gaiety, clarity, spring festivals, golden evenings, or apple trees in blossom. (Rewald 1961, 302)

There was also an undeniable class-based bias in the criticisms. The painters were excoriated not only for their technique, but also because the purchasers of their works were part of the new middle class. The people who bought them and the prices they paid exemplified Veblen's arguments about the dictum "cheap and nasty." Certainly, Impressionist paintings could be had at very low cost.

Vollard, recalled that Tanguy, the paint dealer, had taken paintings by Cézanne as payment for materials and that one could "choose from the pile of paintings, those which one wanted for the set price of forty francs for the small ones and one hundred for the large ones. There were also pictures on which Cézanne had drawn sketches of various subjects. He left it up to Tanguy to cut them up. They were intended for those admirers who could not even afford to pay forty or one hundred francs. One could see Tanguy with his scissors selling small 'motifs' when a patron handed him a louis coin and went away with 'three apples by Cézanne.'" (Engelmann 2007, 108)

When the Impressionists failed to sell many pictures at their group shows, they turned to the auction house at the Hôtel Drouot to sell their work. The first group auction was held in March 1875. It was a fiasco:

[E]very time an assistant carried one of the pictures up the aisle to show it to the bidders, he was greeted with catcalls, whistles, and insults. The roughest treatment was reserved for Monet and Renoir. The official appraiser, Durand-Ruel, who was also their dealer, was loudly announced as a lunatic who deserved to be locked up in the asylum at Charenton. . . . But in general there was less muttering than shouting, and Maître Pillet eventually had to summon the police to prevent a brawl. (Assouline 2004, 141)

Berthe Morisot, one of the female painters whose work was for sale, was subjected to the same sexual criticism as the Brontë sisters had been thirty years earlier. "As her first painting was raised, a cry of 'Whore!' went up. Pissarro went across and punched the man in the face" (Roe 2006, 141).

Those paintings that did manage to sell went for very low prices. Ten works

by Renoir sold for between 50 and 90 francs each (B. White 1988, 54). The highest price paid, 480 francs, went to a painting by Morisot, purchased by Ernest Hoschedé, a wealthy department store owner (Wildenstein 2015, 146).

It had initially been Renoir's idea to sell their paintings at auction at the Hôtel Drouot:

> He was aware that when serious collectors wanted to revitalize their collections, they held auctions at the Hôtel Drouot, and that the sales were well attended by the new class of acquisitive consumers, who seemed to be buying as if there was no tomorrow: furniture, ornaments, jewelry, clothes, and all the other accoutrements of the rising middle class. They also wanted paintings for the walls of their new apartments. (Roe 2006, 139–140)

Although the auctions themselves were financial flops, Renoir was correct in looking to the new middle class to buy their paintings. Aside from Hoschedé, the department store owner, some of the earliest to acquire Impressionist paintings included publisher Georges Charpentier, customs official Victor Chocquet, bankers Henri Hecht and Charles Ephrussi, industrialist Henri Rouart, textile manufacturer Jean Dollfus, and restauranteur Eugène Murer. It was Murer, at a raffle organized for the benefit of Pissarro in 1876, who traded a pastry to the winner, "a little servant girl, [who] was disappointed in her prize. 'If it's all the same to you,' she said, 'I'd rather have a *pâtisserie*'" (Roe 2006, 167). Murer happily acquired the Pissarro for his growing collection.

It is perhaps not surprising that the new rich should begin to develop a preference for the work of the Impressionists. Ines Janet Engelmann wrote that they "had attained their wealth through trade and industry and were open to new ideas, less influenced than the nobility by the classical notion of beauty preferred by the Salon. The simple, everyday motifs of the Impressionists appealed to them more than pompous depictions of glorious battles and mythological or biblical stories" (Engelmann 2007, 19–20). It is also not surprising that the status-insecure faction of the middle class that was threatened by the rising, self-made bourgeoisie should go on the attack. In discussing the first purchasers of Impressionist work, Anne Distel wrote, "The rest of the Parisian art world poked fun at those 'few worthy men, well equipped with colonial goods made of calico and flannel,' . . . who bought badly painted pictures" (1990, 54). The fact that customs officials and textile manufacturers embraced the Impressionists only strengthened the idea in the public's mind that the

Impressionist paintings were vulgar—made for vulgar people, depicting vulgar subjects.

The connection between the unrefined subject matter and the uncouth buyers of this art was explicit. In an 1882 piece in *Artist*, one critic wrote: "M. Mauet [*sic*] had reached the summit of vulgarity in his "Bar aux Folies-Bergères"; a girl in a blue gown covered with common white lace, and dyed yellow hair, serving bocks of beer. Who can the people be who hang such things up in their rooms? It might perhaps make a signboard to the lowest class of wine shop" (Penguin 1882, 246). The same sort of reaction to the members of the new middle class appeared in other countries of the industrializing West:

> On a bright March morning in 1865, [lawyer and diarist George Templeton] Strong stood on Fifth Avenue and Forty-ninth Street watching a throng of fancy carriages make their way to Central Park. This "vehicular gentility," Strong noted caustically, had been enriched during the Civil War by "profits of shoddy and petroleum . . . not a few of the ladies who were driving in the most sumptuous turn-outs, with liveried servants, looked as if they might have been cooks or chambermaids a very few years ago. (Levine 1988, 175)

That such people claimed an upwardly mobile status seemed both boorish and disrespectful to traditionalists.

The subject matter of the Impressionists—scenes of everyday contemporary life—also seemed ill-mannered to high culture and to those who controlled it (B. White 1988, 33). Henry Houssaye in the *Revue des deux mondes* deplored "the intrusion of banal and vulgar scenes of contemporary life into the field of serious painting" (1882, 253). Philippe de Chennevières in the *Gazette des beaux-arts* derided "the disgusting commonplaceness of their subjects" (1880, 235). Charles Furse, writing in the *Albemarle Review*, also decried Degas for "choosing as his subjects the every-day vulgarities that surround him, provided they are sufficiently repulsive and ugly—ballet dancers, for instance, with their dreadfully short skirts and dubious morals" (1892, 108).

Degas's "repulsive and ugly" ballet dancers seemed to call forth particularly incandescent indignation. His statue, *Petite Danseuse de quatorze ans*, was first shown in the sixth group exhibition in 1881. Modeled in wax and dressed in real clothes with a wig of real hair, it depicted Marie van Goethem, a fourteen-year-old student at the Paris Opera Ballet School, her hands clasped behind her and her feet in the fourth position. The realism of the piece disturbed many

viewers. In the *Gazette des beaux-arts*, Mantz took direct aim at the model herself, calling her the "flower of precocious depravity" and saying that her faced was "marked by the hateful promise of every vice . . . bearing the signs of a profoundly heinous character" (1881). A reviewer in *Artist* wrote:

> Even the Italian sculptors with their "Dirty Boy," and "Children Under an Umbrella," have not descended so low as M. Degas. But these people teach us many things; and having demonstrated that the province of art is to perpetuate the vile rather than the beautiful, to paint "declassés" in mind and body, we may soon expect to see a gallery of monstrosities on canvas equal to the collections at the Jardin des Plantes. (Our Lady Correspondent 1881, 43)

It was the temerity to realistically depict the "'declassés' in mind and body" that was the issue. The ballet students, called *petites rats*, mostly came from the lower classes. Kept hungry and vulnerable, they were sexually preyed upon by older gentlemen of leisure who were free to roam the hallways of the Ballet School, picking up girls to become their mistresses. Given the mores of the time, it was the defenseless girls, not the wealthy older men, who were considered depraved and immoral. As Mantz wrote, "the bourgeois audience 'stand stupefied for a moment, and you can almost hear fathers shouting, 'Heaven forbid that my daughter should ever become a dancer'" (Roe 2006, 228). Degas was exposing an uncomfortable truth about the modern world.

"FIVE OR SIX LUNATICS . . . GRIPPED BY CRAZY AMBITION"

What could cause artists to create such distressing work? The critics put forth theories that once again echoed their claims about Manet from the 1860s: the Impressionists were sick—not only physically, but mentally and morally as well. Charges that the Impressionists must be colorblind or have other eye diseases were a regular feature of the reviews. A new thrust, however, was that many critics now also claimed that seeing Impressionist work would cause illness in the viewer. For example, in his 1877 review of the third Impressionist exhibition, Leroy wrote in *Le Charivari*: "If you visit the exhibition with a woman in an interesting condition [i.e., pregnant], pass quickly by the portrait of a man by Mr. Cézanne. . . . That head the color of boot tops is such a strange sight that it might make too sharp an impression on her and give the fruit [her child] yellow fever before it comes into the world" (Leroy 1877, 137).

More than physical illness, however, critics charged the artists with mental illness. This began with the very first group show and continued for decades. Of the first group show in 1874, *La Patrie*'s critic wrote (making full use of capital letters): "There is an exhibition of the INTRANSIGENTS in the Boulevard des Capucines, or rather, you might say, of the LUNATICS" (Roe 2006, 127–128). Thirteen years later, after the final group show, the critic for *Athenaeum* was still using the same word: "Almost all the pictures might have been done by the same lunatic" (Armitage 1887, 82).

Regarding the second group exhibition, Wolff in *Le Figaro* expanded on the theme of insanity, calling the artists "a mutual admiration society of their shared psychosis":

> Five or six lunatics, one of whom is a woman—a group of miserable individuals gripped by crazy ambition—have combined here to exhibit their work. . . . What they do resembles what the distraught inmates of La Ville-Evrard [lunatic asylum] do, when they gather pebbles on the roadside and fondly imagine they are diamonds. It is shocking to witness human vanity pushed to such extremes of craziness. Try to make M. Pissarro understand that trees are not violet in color, that the sky is not the hue of fresh butter, that the things he paints are nowhere to be seen in any country, and that no rational intelligence can tolerate such waywardness. It would be as great a waste of time as attempting to reason one of Dr. Blanche's patients out of his conviction that he is not the pope, and that he lives in the Batignolles, not the Vatican. (Assouline 2004, 144–145)

An anonymous reviewer in *Artist* in 1880 wrote of their work:

> It is a pure, or impure negation. To begin with, it is a negation of common sense. In the next place, it is a negation of all that was ever taught by Raffaele, Titian, Lorraine, Ingres, and Delacroix. If the Parisian Independents are right, clearly everyone else is wrong. That in itself does not necessarily prove them to be madmen; but it assuredly is a sufficient reason for our hesitating to admit their sanity. (*Artist* 1880, 39)

This, of course, is precisely the fear that engenders so much strife in the field: if a new group of artists are legitimated as "right," by the relational nature of position-taking in the field, other artists can, therefore, be relegated to being "wrong." At the very first exhibition, Marc de Montifaud in *L'Artiste*, had writ-

ten: "M. Cézanne only gives the impression of a kind of madman who paints in delirium tremens" (Wechsler 1975, 25). Accusations of drunkenness would recur regularly. The artists were insane because they failed to follow the path of proper reason.

LAUGHTER AND DELEGITIMATION

Michel Foucault wrote that by the end of the eighteenth century, "Madness became pure spectacle" (Foucault 1965, 69). Certainly, crowds flocked to the Impressionist exhibitions for the spectacle and for the chance to jeer and laugh. Over and over again, reports emphasized how the crowds laughed uproariously at the paintings they saw hanging on the gallery walls. The Impressionist paintings were seen as jokes. In her study of jokes, Mary Douglas argued:

> Social requirements may judge a joke to be in bad taste, risky, too near the bone, improper, or irrelevant. Such controls are exerted either on behalf of hierarchy as such, or on behalf of values which are judged too precious and too precarious to be exposed to challenge. Whatever the joke, however remote its subject, the telling of it is potentially subversive. Since its form consists of a victorious tilting of uncontrol against control, it is an image of the leveling of hierarchy, the triumph of intimacy over formality, of unofficial values over official ones. (Douglas 1975, 297)

The Impressionist works were treated as jokes, thereby recognizing their subversive nature. Thus, the attacks against them.

The Impressionists began by challenging the official values of the Salon, but in the turmoil of nineteenth century France, their art also played a part in challenging the social hierarchy at large, a social order that was decidedly precarious. Critics and viewers alike responded with laughter—an attempt to dismiss and demean the message in the paintings. This was no innocent amusement. George Moore reported at the eighth group exhibition, the audience reacted with "boisterous laughter, exaggerated in the hope of giving as much pain as possible" (Rewald 1961, 526).

The Impressionists had become a spectacle. When Paul Durand-Ruel first showed the Impressionist work in his London gallery: "The *Morning Post* considered the exhibition meritorious for 'having provided the London season with a new sensation, which, besides its novelty, has the pleasant recommen-

dation of being also mirth-provoking. . . . [I]t is something for Londoners to have in their midst a source of comic entertainment, which Parisians heartily enjoy'" (Rewald 1961, 482–484). The laughter was often forced, concealing the underlying complex emotions. Oliver Merson in *Monde illustré* wrote:

> Good heavens, the best thing to do is to laugh it off. One could be angry. Certainly the circumstances invite such a reaction, for the public, which is not so stupid as is thought, look on in wide-eyed surprise, asking if it is being made fun of, while the connoisseurs shrug their shoulders in pity! Nonetheless, it is best to look at the matter from the comic and amusing side. (Hamilton 1969, 242)

The public laughed at the Impressionists to diminish a more serious and dangerous message that they perceived in the Impressionist work.

CONNECTION TO REVOLUTIONARY POLITICS

The first Impressionist show opened only three years after the bloody end of the Franco-Prussian War, the siege of Paris, and the Commune. Memories of destruction and death were still vivid. Critics and the general public alike saw a connection between the transgressive art of the Impressionists and the political revolutionaries who still congregated in Paris. In 1876, an anonymous writer for the *Moniteur Universel* wrote, "The intransigents in art holding hands with the intransigents in politics, nothing could be more natural" (B. White 1988, 58). An unsigned review in the London *Times* at the time of the very first group show had claimed, "One seems to see in such work evidence of as wild a spirit of anarchy at work in French painting as in French politics" (*The Times* 1874, 35). The field of art was clearly perceived as being nested inside the field of power and the field of class relations. The positions of actors in each were homologous.

The Impressionists were certainly set on upsetting the established order in the art world, and many of them saw themselves as revolutionaries. "Pissarro himself believed firmly that his art was an expression of his political philosophy. 'Our modern philosophy is absolutely social, anti-authoritarian, anti-mystical,' he wrote . . . 'All art is anarchist when it is beautiful and good!'" (Danchev 2012, 140). As Kate Flint explained: "'The Times' [in 1876] described the Impressionists as 'ostentatiously defiant both of rule and culture.' The use of the word 'rule' is ambiguous, indicating both an avoidance of traditional

artistic principles and a potential subversive rejection of a proper subordination within a power structure" (Flint 1984, 14). Many critics were quick to connect the Impressionists to the Communards, even though, in point of fact, their personal politics spanned the spectrum. As early as 1873, "Ernest Chesneau—with no evidence whatsoever—associated Renoir with the Commune of 1871: Renoir 'has been revoltingly wicked' and 'justifies all the rebels'" (B. White 1988, 45).

In 1896, Gabriel Mourey, an art critic for *Le Figaro*, wrote a piece for *Art Journal* that still sounded the alarm about the Impressionists, warning that they would engage in violence, if only (perhaps) of the symbolic sort:

> Yes, I repeat it, a spirit of anarchy prevails in the movement of Art in France, an impulse to destroy, a particular kind of madness which wishes to abolish everything. Nothing of the past must be allowed to exist. . . . Revolutions, alas! are not to be averted—and sure enough the next one will burn the cathedrals, the museums, the libraries, and all that represents the past and mystery. (Mourey 1896, 136)

Wake Cook, writing in *Vanity Fair*, went all the way back to the French Revolution of 1789 for the imagery to match his fears that the Impressionists would lead to an art world "overturned by a French Revolution which shall begin by guillotining Academicians and other guardians of law and orderly development" (Flint 1984, 15).

Far from being the perpetrators of violence, however, the Impressionists—or rather, their paintings—were much more likely to be the victims of it. At the first group exhibition, one of the visitors who admired the work wrote to a friend about the painting he had loaned for the show: "Today, Sunday, I am on duty at our exhibition. I am guarding your Cézanne [*A Modern Olympia*]. I cannot guarantee its state; I'm really afraid it will return to you punctured" (Distel 1990, 234). A painting by Monet "had once been punctured by the umbrella of a scandalized lady" (Assouline 2004, 234). When a show of Monet's work was held in London, "'A place showing filth like that should have its windows smashed!' jeered a couple of men driving by in a *fiacre*, in a tone of visceral hatred that [another dealer] never forgot" (Assouline 2004, 15–16).

SUCCESS IN AMERICA

In 1885, just as the painters were beginning to prepare for the eighth (and final) group show of their work, American dealer James Sutton arrived in France to see for himself the work that had created such an uproar in the press. He offered the Impressionists' dealer Durand-Ruel an invitation to show the Impressionists at his gallery, the American Art Association (AAA) in New York City. Durand-Ruel jumped at the chance.

The show opened on 10 April 1886. Many of the critics were hostile, but the general public was not. Instead of jeers and boisterous laughter, the American viewers greeted the paintings with respect and genuine attempts to understand. An anonymous reviewer in *The Critic* wrote: "It is distinctly felt that the painters have worked with decided intention, that if they have neglected established rules it is because they have outgrown them, and that if they have ignored lesser truths, it has been in order to dwell more strongly on larger" (Rewald 1961, 531).

In terms of sales, the show was not a smashing success—only fifteen pictures sold, for a total of $17,150—but Durand-Ruel sensed that the American buyers were more open to the work. Like his clients in France, the Americans were new money, building their art collections rather than inheriting them. They, like the Impressionists, were in favor of subverting the old status hierarchies. They too perceived the homologies between the fields of art and power, they too were social revolutionaries. And there were a lot more of them in America than in France. Durand-Ruel immediately began planning a second exhibition in America for the next year and opened his own gallery at 297 Fifth Avenue in 1888. American sales took off.

There had always been a small number of avant-garde critics and adventurous buyers in France who appreciated the Impressionists. But towards the end of the century, more French collectors and critics had begun to come around, especially as they found themselves in competition with the Americans. By the early 1890s, the Impressionists were beginning to have critical and financial success with their shows in Paris.

Official recognition, however, still lagged:

Indeed, when [Gustave] Caillebotte died in 1893, leaving his collection of sixty-five paintings to the Nation, the Government received his gift

with greatest embarrassment. The prospect of seeing Impressionist pictures in a museum aroused an uproar of protest from politicians, academicians, and critics, equaling and surpassing even the insults heaped upon the painters at the occasion of their first group exhibitions. Several official artists threatened to resign from *Ecole des Beaux-Arts*. (Rewald 1961, 570)

Further, Barbara White wrote:

> The following month, [conservative artist Jean-Léon] Gérôme stated in the *Journal des Artistes*: "For the State to have accepted such excrement, there must be very great moral blight. . . . There is anarchy everywhere and nothing is done to repress it. . . . There is no adequate expression to condemn such madness. . . . These people paint like mental patients of Dr. Blanche. . . . They are unable to control their own bowels." The review *L'Artiste* circulated a questionnaire to its readers and found that the Caillebotte bequest was considered "a pile of excrement whose exhibition in a national museum publicly dishonors French art." (White 1988, 200)

Despite strong conservative opposition, a deal was eventually struck for the government to accept a portion of the gift. The Americans, however, continued to buy Impressionist work. The industrialists, robber barons, and nouveaux riches in the United States collected avidly. Prices started to skyrocket. With regard to Renoir's *La Loge, Distel wrote:* "This painting sold for 220 francs [less than the average monthly salary for a professor] in 1875, for 31,200 francs in 1912, and for 12,100,000 dollars at auction at Christie's in New York on May 10, 1989. Those three figures sum up Impressionism's spectacular financial history" (1990, 155).

As prices went up, so did estimates of the works' beauty, as Veblen would have predicted. Camille Mauclair wrote of Monet's work in 1903:

> It is a dazzling display of luminous atoms, a kind of pantheistic evocation. Light is certainly the essential personage who devours the outlines of the objects, and is thrown like a translucent veil between our eyes and matter. One can see the vibrations of the wave of the solar spectrum, drawn by the arabesque of the spots of the seven prismatic hues juxtaposed with infinite subtlety; and this vibration is that of heat, of atmospheric vitality. (Mauclair 1903, 323)

John Elderfield and coauthors wrote: "Leo Stein succinctly summed up the artist's life and work when he said: 'Hitherto Cézanne had been important only to a few. . . . At the Autumn Salon of 1905 people laughed themselves into hysterics before his pictures, in 1906 they were respectful, and in 1907 they were reverent'" (2017, 244).

The outrage over the Impressionists occurred in a context of social upheaval with regard not only to status hierarchies, but with regard to the legitimate bases upon which those hierarchies should be constructed. The fear of the fake—of being duped into accepting the ersatz as genuine—pervaded the Parisian social world unmoored from the security of tradition. Moreover, there was suspicion that these fakes had an even more sinister motive of somehow resurrecting the radical politics of the Commune and its associated suffering. The fields of art, power, and class were nested and homologous. The entry of the Americans as agents into the field completely overturned prevailing hierarchies of power; the field had become more transatlantic.

The Impressionists shunned the judgments of the Salon, refusing to grant legitimacy to tradition and turning instead to the open market. What Bourdieu termed "the hidden economy of time" involved long-term accruing of cultural capital—including taste in art—and kept the social hierarchy in order while hiding the reproduction of social classes. If the Impressionists succeeded in capturing a position at the autonomous pole of the field of art, their buyers would have come a long way towards breaking through the cultural glass ceiling that kept these newly made entrepreneurs and industrialists forever out of the top ranks of French society. To delegitimate the artists, using laughter or claims of mental illness, was to delegitimate their buyers.

But the relations in the field were shifting. Precisely the earlier lack of recognition by the French public enhanced the status of the work of the Impressionists. In the economic world reversed, their work was now a refined taste appreciated only by the cognoscenti. The appearance in this cultural battle of the American buyers who simply ignored the upturned noses of the French traditionalists provoked an angry reaction. But the anger was impotent: fashion had changed. When French aristocrats at last hastily tried to claim the Impressionists as their own—discovering the beauty of the work once it had become very expensive—they were too late. Work that they could have once had for the price of a *pâtisserie* had left France to reside in the hands of upstart Americans.

"An Eccentric, Dreamy, Half-Educated Recluse"

The Poetry of Emily Dickinson

Sitting in her upstairs bedroom in the family home that she shared with her sister and parents, Emily Dickinson wrote almost 2,000 poems, carefully preserving them in handmade books and publishing fewer than a dozen—all anonymously—in her lifetime. The posthumous publication of this body of work made Dickinson a literary star after her death and transformed the course of poetry in the Western world, fracturing the rules for acceptable writing. But the myth of her hermetic existence shaped public perceptions of her work for decades, sometimes overshadowing the brilliance of her poetry. The myth was carefully crafted in an attempt to keep critics at bay, to shape the symbolic capital of a cultural producer (and her exploiters) for maximum success in the field. It failed.

SUSAN

Emily Dickinson was born in 1830 in Amherst, Massachusetts, into one of the leading families in town. In 1832, the Gilbert family moved to Amherst from Deerfield, Massachusetts. Their youngest daughter, Susan Huntington Gilbert, had been born nine days after Emily. No one is quite sure when Sue and Emily met, but it is likely that they were friends by the time they were

teenagers (Hart and Smith 1998, 3). Surviving early letters from Emily to Sue show a very warm friendship.

In a letter* to Sue from 1852 (Dickinson 1958, 176), when they were twenty-one years old, Emily writes:

Oh my darling one, how long you wander from me, how weary I grow of waiting and looking, and calling for you; sometimes I shut my eyes, and shut my heart towards you, and try hard to forget you because you grieve me so, but you'll never go away, Oh you never will — say, Susie, promise me again, and I will faintly smile — and take up my little cross again of sad — sad separation.

In a response to a letter from Sue written at about the same time (Dickinson 1958, 177), while Sue was away in Maryland, Emily's prose veers into passionate longing:

Oh Susie, I would nestle close to your warm heart, and never hear the wind blow, or the storm beat, again. Is there any room there for me, or shall I wander away all homeless and alone? Thank you for loving me, darling, and <u>will</u> you "love me more if ever you come home"! it is enough, dear Susie, I know I shall be satisfied . . . Never mind the letter, Susie; you have so much to do; just write me every week <u>one line</u>, and let it be, "Emily, I love you," and I will be satisfied! Your own Emily

Sue's letters to Emily were almost all burned after Emily's death, so we do not know how she responded to such effusions, only that she saved Emily's letters for her whole life.

Susan captivated not only Emily, but also her brother Austin, who developed a strong romantic attachment to Sue. Sue and Austin got engaged on 23 March 1853 and were married three years later on 1 July 1856, following several postponements by Sue. They built a house immediately next door to the house where Emily lived with her sister Vinnie and their parents, and soon a path was worn through the grass between the two houses. Sue and Emily not only visited each other almost daily, they also exchanged frequent notes and letters.

Emily wrote thousands of letters during her lifetime, but she wrote more letters to Sue than to anyone (M. N. Smith 1992, 28). One of Emily's very last

*All letters are presented as in the originals.

bits of writing was a brief note to Susan that said only, "Thank you, dear Sue—for every solace" (Dickinson 1958, 895). It was Sue who tended to Emily during her final illness, dressed Emily's body for burial when she died at age fifty-five in 1886, and wrote her obituary.

Sue had been the first to recognize how special Emily's poetry was. She had been Emily's sounding board and literary confidant all along. Sue and Emily frequently met in person and discussed Emily's poetry, which was not a secret from the family or even from the family friends and other more distant friends with whom Emily shared her work in letters. Betsy Erkkila notes that "Sue served over many years as the primary audience for Dickinson's work. She was the subject of several poems and the inspiration for many more, perhaps even some of the marriage and Master poems that appear to be addressed to men" (1996, 174). This was on top of their frequent face-to-face meetings, which Emily often mentions in her surviving notes. As well as being a close friend, a close neighbor, and a sister-in-law, Sue was clearly an important support for Emily's literary production. Was she more?

WOMEN'S EXPRESSIONS OF LOVE IN THE NINETEENTH CENTURY

Sue and Austin did not have a happy marriage. While Austin was quite passionate in his courtship letters to Sue, he also acknowledged her ambivalence towards sex. During their long engagement, Sue had written to Austin that the idea of the "mere relation of wife" left her with "gloomy thoughts," and Austin had responded with an offer of a sexless marriage (Habegger 2001, 335). Over the years, Austin emotionally withdrew from his marriage to Sue, eventually engaging in a very flagrant public affair with the young wife of an Amherst College faculty member, although he and Sue continued to share a house. Thoughts of men turned Sue to "stone," Emily said (Gordon 2010, 300). Instead, it is the letters and poems that Susan exchanged with Emily that traced passion for a lifetime. For example, a surviving note Emily wrote to Sue reads simply: "Remember, Dear, an unfaltering Yes is my only reply to your utmost question — With constancy — Emily — " (Dickinson 1958, 828).

The notes, poems, and letters show a devotion of affection lasting over a lifetime, yet there are many questions and debates about the exact nature of the relationship between Emily and Sue. Were they lovers? Was Emily in love but rebuffed by Sue? Were Emily's passionate words only poetic hyperbole? It is impossible to reconstruct the intimacies of their relationship.

Women's expressions of love in nineteenth-century America are difficult to decode from our twenty-first-century vantage point. Only in the last two decades of the nineteenth century did sexologists in Europe and America begin to develop and problematize terms like "lesbian" (Diggs 1995, 317). Women who eschewed heterosexual marriage, despite the intensity of their affective relationships with other women, were almost always seen, not as "mannish" or "lesbian," but instead as sexless, just as Emily would be portrayed after her death (Vicinus 2004). Until the end of the nineteenth century, the general public and the medical establishment in the United States assumed that women were naturally "pure" and had no sexual feelings. This characterization was at odds with some of Dickinson's poems, such as "Wild Nights" (Dickinson 1951, 114):

> Wild Nights — Wild Nights!
> Were I with thee
> Wild Nights should be
> Our luxury!
>
> Futile — the Winds —
> To a Heart in port —
> Done with the Compass —
> Done with the Chart!
>
> Rowing in Eden —
> Ah, the Sea!
> Might I but moor — Tonight —
> In Thee!

The types of romantic effusions with which Emily showered Sue were common among platonic female friends in the nineteenth century. Women constrained to the domestic sphere looked to their female friends for attention and affection. Safely enmeshed in the private worlds of home and family, women openly declared their love for each other, exchanged romantic quotes and poems, and displayed physical intimacy. It was socially acceptable, even encouraged, for women to shower their female friends with both verbal and physical endearments. Kissing and caressing between friends were considered highly feminine.

Without doubt, Emily and Sue shared their most intimate lives for four decades. Moreover, Martha Nell Smith notes that

> Dickinson seems well aware that her feelings for Sue are unacceptable. She urges her beloved to ignore her loving speeches and take up tales of holy virginity: "Susie, forgive me, forget all what I say, get some sweet scholar to read a gentle hymn, about Bethleem and Mary, and you will sleep on sweetly and have as peaceful dreams, as if I had never written you all those *ugly things.*" (M. N. Smith 1992, 24)

Emily wrote to Sue in mid-June 1878: "Susan knows she is a Siren — and that at a word from her, Emily would forfeit Righteousness — " (Dickinson 1958, 554). The cover for these types of private transgressions often involved a public demonstration of virginity or sexlessness. Martha Vicinus, writing about Victorian lesbian couples, notes that "Their acceptance depended upon a carefully constructed asexuality" (2004, 31).

Martha Nell Smith (1992) and others argue that the two women were lovers, and it is easy to see why. But it is impossible to know for sure, especially given what Vicinus calls "the definitional uncertainty at the core of lesbian studies" (2004, 62). But one thing is certain: Emily had a deep love for Sue that lasted a lifetime, and Sue played a primary role in Emily's life as a poet.

"MISTAKEN WOMEN-POETS, WHO ARE SO NUMEROUS LATELY"

After Sue finally married Austin and settled into the house next door to Emily, Emily's poetry took a decidedly new turn. For the next decade, Emily pioneered a striking form of mystical and elusive insights wrapped in the "slant rhymes" that broke all of the poetic conventions of the time. Rather than the easy rhymes and trite subject matter expected of women poets, Emily's writing pursued bold and difficult visions. Her output during these years was prodigious.

At first, Emily's work was for private consumption—circulated within the small circle of close friends and family. But with Sue's support, during these years, Emily did begin to reach out to the wider literary world, exchanging letters, poems, and visits with people like Samuel Bowles, a close friend of Sue's and the editor of the *Springfield Daily Republican*, where at least five of Emily's poems would be anonymously published. One of the most important connections that Emily made during these years was to Thomas Wentworth

Higginson, who would edit the first volume of her poetry after her death.

In a "Letter to a Young Contributor" in the April 1862 *Atlantic Monthly*, Higginson had offered advice for beginning writers. Emily had responded on 15 April 1862 by sending him some of her poems along with a letter asking for his feedback (Dickinson 1958, 403):

> *Mr Higginson,*
> *Are you too deeply occupied, to say if my Verse is alive?*
> *The Mind is so near itself — it cannot see, distinctly — and I have none to ask —*
> *Should you think it breathed — and had you the leisure to tell me, I should feel quick gratitude —*

Higginson's letter in reply has not survived, but some of its contents can be discerned in Emily's return letter on April 25 where she writes, "Thank you for the surgery — it was not so painful as I supposed. I bring you others — as you ask — though they might not differ — " (Dickinson 1958, 404).

It is clear from this letter that Higginson had given Emily suggestions for edits to the poems that she had sent. Although she thanked him for the "surgery" to her work, she also informs him that the next batch of poems that she is sending "might not differ." For the next twenty years, although she kept up her correspondence with him and even received visits from him at home, Emily would continue to ignore Higginson's editorial advice. It was Sue, not Higginson, whose advice influenced Emily's writing (M. N. Smith 1992, 4). Surviving letters show Emily rewriting poems in response to Sue's suggestions. Only after Emily's death would Higginson be able to edit her poems as he wished.

Emily was adopting a pose deliberately constructed for Higginson: the meek and timid poetess seeking his approval but abjuring the limelight of recognition as a serious writer. The publishing world in New England was not different for women from the publishing world in England that had savaged the Brontës. Among Emily's Dickinson's close friends was Josiah Holland, who founded and edited *Scribner's Monthly*, one of the leading literary periodicals of the day. Emily shared her poems with Holland, but he deemed them "unsuitable" for publication (Gordon 2010, 149). According to Lyndall Gordon, Holland "was fixed in the common view that 'the genuine classics of every language [are] the work of men and not of women' . . . for women could not create 'the permanent treasures of literature'" (2010, 149–150).

Closer to home, Martha Nell Smith found:

In 1865, the *Republican*, a staple in both Dickinson houses, featured an article entitled "Employment for Women," which advised "young women of the present day": "What you need is to be set to work at some useful occupation, the homelier the better, till such foolish notions as you now indulge are driven out of you. . . . You feel hurt if you are asked to mend a coat or wash the dishes, do it poorly and sulkily, and then go and write some stuff you call poetry, about your 'Unanswered Longings,' or 'Beautiful Visions,' or what not!" Two years later the same paper ran "Women as Artists," which emphatically editorialized, ". . . it will be no more terrible to have the country flooded with mistaken women-artists, so called, than with mistaken women-poets, who are so numerous lately." (M. N. Smith 1992, 136)

It is no wonder that Emily mostly eschewed attempts at publication and, when she did publish, kept her work anonymous.

Instead, Emily adopted what we would call today self-publication. Nineteenth-century norms were such that letters, especially those from distant relatives, carried an expectation that they would be shared with others who might be interested in their content. This was akin to the social media of today. Over a thousand letters that Emily wrote survive, and scores of them contain poems that she wished to share with her audience. Her main correspondent was Sue, but she also kept up a frequent correspondence with many of her relatives and friends and was, moreover, in contact with luminaries such as the sculptor Daniel Chester French and poet Helen Hunt Jackson—as well, of course, as Higginson and Holland. In addition, Sue held frequent gatherings at her house where Emily allowed her poetry to be read aloud to guests such as Ralph Waldo Emerson. And Emily also made handbound chapbooks of her poems, carefully selected and arranged. It is not certain with whom, if anyone, she intended to or did share these. Nevertheless, she made them. Today they would be called zines. So, although after her exchanges with Higginson and Holland she seemed to have no further interest in the traditional forms of publication, Emily was deeply engaged in a type of proto-social-media-based self-publication that is not so terrifically different (technology aside) from the forms used by many present-day culture producers.

"THE SOUL SELECTS HER OWN SOCIETY"

This reticence to publish traditionally mirrored Emily Dickinson's private life. Although her sister Vinnie said that Emily was "always watching for the rewarding person to come" (Gordon 2010, 14), the poet also took great care to avoid the tedium of socializing that would have eaten away at so many of her working hours. The rounds of "paying calls" and "visiting" that occupied much of the lives of upper-class women of the time were anathema to Emily. In a poem from about 1862, she wrote, "The Soul selects her own Society — / Then — shuts the Door — " (Dickinson 1951, 143).

Unmoved by social niceties, Emily was selective as to whom she chose to give her attention. As she got older, she consented to visits from fewer and fewer people, seeing only close friends and family. Even so, it could still be difficult to carve out the time she wanted. In 1850, Emily wrote caustically about the demands of housekeeping: "so *many* wants — and me so *very* handy — and my time of so *little* account — and my writing so *very* needless" (Dickinson 1958, 82).

Ellen Louise Hart and Martha Nell Smith point out the ways in which gender comes into play in our assessment of Emily's need for solitude: "Like many artists, she needed a great deal of time alone for reading, contemplation, and writing— a requirement that has rarely been questioned when enjoyed by male writers. However, in the case of Dickinson, the need for solitude and contemplation has been interpreted as a pathological reclusiveness and an indication of intense vulnerability and wounding, not a consciously chosen way of life" (Hart and Smith 1998, xvii). Further evidence that Emily's need for solitude was not the same as a timid shrinking from contact with the outside world lies in her actions. Although she consented to see relatively few outsiders face-to-face, Emily exchanged frequent letters with a wide range of correspondents, often enclosing poems. At the height of her poetic productivity, she was sending out poems to the world at the rate of almost one per day. And it is important to remember also that her friendship with Thomas Wentworth Higginson began when she responded to his call to new contributors by sending him six poems and asking for his feedback. She may have adopted the persona of the timid poetess, but the fact remains that she took the initiative to send her work to this famous editor.

In 1883, when Emily was fifty-three years old, her brother Austin (Sue's husband) began an affair with the wife of an Amherst College astronomy professor. Mabel Loomis Todd, born the year that Austin and Sue married, would never meet Emily Dickinson face-to-face, but she would take posthumous possession of Emily's work and meticulously craft the Dickinson legend.

Impressed by the Dickinson family wealth and status, at first Mabel fell into Sue Dickinson's orbit and began to attend the evening dinners and receptions that Sue often held at her house. Sue was in the habit of reading selections of Emily's poetry aloud to her guests, and in February 1882, Mabel first heard Sue read Emily's poetry and recognized its uniqueness. She was equally intrigued by the mysterious poet living next door.

Mabel and Austin were not very discreet, and soon all of Amherst society knew about the affair. Emily declined Austin's invitations to meet Mabel (which was not easy given that Austin used the house where Emily and Vinnie lived, which he owned, for his assignations with his mistress), and Sue began to snub Mabel socially. In return Mabel called Sue her "most bitter enemy" (M. N. Smith 1992, 158). As the affair went on, Mabel's feelings of hostility towards her lover's wife increased dramatically. She threatened Austin with suicide if he did not leave Sue, prayed for Sue's death, demanded that Austin emotionally abuse Sue enough to cause her to "wither" and die, cajoled Austin to leave his family and go west with her, to have a baby with her, and to change his will in her favor (Gordon 2010). But Austin did not leave Amherst, father Mabel's child, or change his will. Emily refused to see Mabel, and Sue refused to fulfil Mabel's wishes by dying.

Instead, in 1886, Emily, whose health had been declining, became increasingly sick, probably from a kidney ailment called Bright's disease. On 15 May 1886, she died at age fifty-five.

THE POEMS

Emily's poetry was no secret to friends and family. Nevertheless, her sister Vinnie was surprised when cleaning out Emily's room to find almost 2,000 poems in Emily's cherrywood chest, many of them preserved in the handwritten, hand-bound books that Emily had made.

Emily had left strict instructions for Vinnie to burn this trove along with all of the letters she had saved over the course of her life. Vinnie duly burned the correspondence, but when it came to the poems, she found that she could

not destroy her sister's work. Instead, she conceived a plan to have Emily's poems published as a book. She turned to Sue to help her in this venture. Sue had her own store of poems and letters from Emily—hundreds of them. Vinnie brought Sue the poems from Emily's chest, and Sue set to work sorting through the mass of material.

Seven months after Emily died, Sue submitted one of Emily's poems to the editor of *The Century* (M. N. Smith 1992, 214). Sue sent a scattering of other poems to various periodicals over the next few years. But her ultimate intention was to put together a collection of Emily's work "rather more full, and varied" than the typical volume of poetry (Hart and Smith 1998, xvi). It would include selections of Emily's letters, drawings, humorous notes, and other pieces of prose along with the poems themselves. She discussed her vision with Thomas Wentworth Higginson, but he told her the book she had in mind was "unpresentable" (Gordon 2010, 251). That is, the work was far too subversive to even enter the field.

Still grieving over her loss of Emily, Sue worked slowly. Vinnie grew impatient with the pace of Sue's progress. Meanwhile, Mabel Loomis Todd had turned her attentions to Vinnie. Lonely without her sister, Vinnie responded to Mabel's friendship and to her offer to show Vinnie some of Emily's poems in "print" by typing them on the new invention—a typewriter— that Mabel had recently acquired. In February 1887, Mabel began to type up Emily's poems.

Her attempts to get pregnant with Austin's child had been unsuccessful, but now Mabel saw a way to tie herself forever to the Dickinson family. Mabel, who had never met Emily, wanted to claim the poet as her own. She, not her "most bitter enemy" Sue, would edit a volume of Emily's poetry and bring it out into the world. Without telling Sue these plans, Vinnie demanded that Sue return all of the poems that Vinnie had given her. Sue complied.

Mabel recruited Higginson to coedit the poems with her, and the two of them began to work on a volume for publication. The first order of business was to do to Emily's poetry in death what she had refused to allow Higginson to do to them in life.

EDITING DICKINSON'S POEMS AND BIOGRAPHY

When Mabel Todd and Higginson took over the editing of the poems, they had between them several goals. One was to conventionalize the poems to fit in with Higginson's ideas of polished work while not sacrificing all of their orig-

inality. Another goal was to package the poems—and Emily herself—to sell. This meant creating the legend of the spinster recluse that was nonthreatening while still being appealingly odd. Creating an image of asexuality—or at least of thwarted, unrequited heterosexual love—was a crucial component of this plan. Todd and Higginson constructed a strategy of succession, rather than subversion, as an entry into the field for Dickinson.

By the end of the nineteenth century, psychologists and sexologists had at last begun to recognize the existence of lesbianism and to openly discuss female sexuality. The eroticism of Dickinson's writing that might have seemed conventional and even mundane when she wrote it in mid-century would be read with very different eyes by the 1890s. As Wendy Griswold argues, "Cultural meaning depends on an . . . interaction . . . between the cultural work, text, or symbol, and the human beings who experience it at the time of either its creation or its reception" (1987, 1080). The readers of Dickinson's work existed in a very different context from the one in which they were created. Martha Nell Smith writes that "by the end of the nineteenth century men were no longer 'convinced of their own representations of (their) women's basic purity and asexuality'" (1992, 23). As Vicinus notes, lesbians could exist peacefully within their communities as long as they pretended to be asexual, merely platonic friends (2004). The same process went into constructing Dickinson's image. This meant that the letters and poems directed to Sue had to be recast and attention directed away from Emily's relationship with Sue towards someone else: a mystery man who had broken Emily's heart, despite Vinnie's repeated denials that any such man existed.

In fact, for Todd, if not for Higginson, one last goal was to delete Sue all together: to make her disappear from Emily's life and, if possible, substitute Todd as Emily's intimate friend and the ultimate expert on her life and work. When editing a volume of Dickinson's selected letters later in the decade, Todd deleted from the record not only all of the letters that Emily had written to Sue, but also references to Sue in letters that Emily had written to others, effectively erasing Emily's chief correspondent from her correspondence (M. N. Smith 1992).

To achieve the first of these goals—conventionalizing the poems—Higginson and Todd simply rewrote many of them. They changed punctuation, wording, rhyme schemes, and lineation; added trite and misleading titles ("With a Flower" and "Playmates"); altered meanings; deleted sections of poems; and much else "in an effort to gain public acceptance for the poems"

(Franklin 1967, xv). The editing, Todd said, was done to make the poems "smoother" (Gordon 2010, 260). As Erkkila noted, "[Emily's] fracture of meter and rhyme, grammar and syntax, [was] carefully corrected and regularized" (1996, 173).

Martha Nell Smith documents other changes that Higginson and Todd made in order to change meanings of poems (1992, 30–32). Many of the changes were meant to remove Dickinson's subversive mocking of traditional gender roles, such as her "sneering" at the idea that the institution of marriage would bring women happiness and fulfillment in the poem "A solemn thing — it was — I said," or any hints of gender bending or androgyny.

Along with changes to the poems themselves, Todd and Higginson were also careful to group the poems into the conventional categories of "Life," "Love," "Nature," and "Time and Eternity" and to package the book in a "dainty" white leather binding with a flower painting by Todd on the cover. They also included a preface by Higginson that preemptively apologized for anything unorthodox or unconventional in the poems by painting Dickinson as a naïf—a child who did not understand what she was doing—whose work was flawed by a lack of discipline but worthwhile despite its shortcomings. Higginson began his three-paragraph preface by writing:

> The verses of Emily Dickinson belong emphatically to what Emerson long since called "the Poetry of the Portfolio," —something produced absolutely without the thought of publication, and solely by way of expression of the writer's own mind. Such verse must inevitably forfeit whatever advantage lies in the discipline of public criticism and the enforced conformity to accepted ways. On the other hand, it may often gain something through the habit of freedom and the unconventional utterance of daring thoughts. In the case of the present author, there was absolutely no choice in the matter; she must write thus, or not at all. (Higginson 1890b, 13)

After dismissing any idea of Emily Dickinson as a conscious author whose work was deliberately crafted (clearly shown by the multiple drafts of poems she preserved and worked over for long periods of time), Higginson went on to paint her as a recluse. She was, he said, "as invisible to the world as if she had dwelt in a nunnery" (1890b, 15). The symbolic capital of virginity would enhance the prestige of a female poet (in opposition to the way in which the symbolic capital of "rake" enhanced the prestige of, for example, Lord Byron).

Having thus set up the image of Dickinson as a nun-like recluse (who did not intend to write such exasperating poems but who couldn't help it) and having recast the poems themselves to fit in more easily with the conventional ideas of ladylike writing, Higginson and Todd felt that the book was ready for publication in November 1890. To prepare the reading public, including the critics, for the poems, Todd and Higginson embarked on a campaign to apologize for and dismiss what they saw as the "defects" in Dickinson's work. They aimed to divert attention away from the boldness of the writing and instead showcase the romantic image of the author as a timid and virginal recluse, uneducated in literature, writing from pure instinct as a way to alleviate the broken heart she had suffered from some mysterious unrequited love. Martha Nell Smith notes, "In 1890, audiences were prepared to receive a reclusive figure who robed herself in white and harbored some 'secret sorrow' quietly as she wrote poems at home, and publishers knew that a solitary literary figure was marketable" (2002, 55).

A few weeks earlier, in September 1890, Higginson had written a piece about the poems in *The Christian Union*, asking readers for indulgence about the form of the poems by positioning Emily as having been too disconnected from the world to understand what she was doing:

> [A] sheaf of unpublished verse lies before me, the life-work of a woman so secluded that she lived literally indoors by choice for many years, and within the limits of her father's estate for many more — who shrank even from the tranquil society of a New England college town, and yet loved her few friends with profound devotedness, and divided her life between them and her flowers. (Higginson 1890a, 4)

Higginson ignored the possibility that the "tranquil society" of a small town, with its social demands on women's lives, might have seemed insufferable to an artist such as Emily Dickinson. Higginson also ignored what was obvious from the many drafts and alternatives of poems that Dickinson left—that is, she worked and reworked her poems assiduously. The truth was not that Dickinson did not ever edit her writing; it was that she did not ever take Higginson's misguided advice about how to do so.

Dickinson was in fact extremely well-read and quite well educated for a woman of her time and was in contact with some of the leading literary figures of the day, many of whom had been houseguests of Sue's. The poems themselves, filled as they are with references not only to other literature (especially

the Bible and Shakespeare) but also to the scientific theories and information that Dickinson had absorbed during her education, especially during her time at the Hadley Female Seminary (now Mount Holyoke College), undermine the picture of the poet as purely instinctual naïf. But the image of an ethereal and childlike "woman in white" was calculated to appeal to a nineteenth-century audience. Like "the small, ladylike, white leather gilt-edged" volume of her work (M. N. Smith 1992, 45), Dickinson herself was now a commodity packaged to sell, positioned nearer the heteronomous than the autonomous pole in the literary field.

CONSTRUCTING AN IMAGE TO SELL

Todd also took to print to excuse and dismiss Dickinson's radical poetic innovations. In a piece called "Bright Bits from Bright Books" for *Home Magazine* published in November 1890, she wrote:

> The life of their author was intensely picturesque, and at the same time perfectly simple. She merely lived out her own ideas — a thing for which most of us have not the courage. For more than fifty years, her home was in Amherst, Massachusetts, yet few of the present residents in the beautiful little town have seen or spoken with her. Only those whose memories go back to her youth can tell of ordinary personal relations with her. (Todd 1890, 11)

In her promotional writings and, more importantly, her promotional speaking, Todd "sets in motion many of the fallacies that have since become Dickinson legend" (Hart and Smith 1998, 204). The title page of the volume announced it had been edited by the author's "friends," Todd and Higginson, and Todd threw herself into a series of speaking engagements designed to portray Dickinson in an appealingly strange light, luring readers with the legend of the recluse. This also allowed Todd to cement her position as Emily's intimate and the foremost authority on her life and work. Sue, of course, was erased from the picture of Emily's life.

Todd's public talks on Dickinson were enormously successful. Seduced by the romantic image of the "woman in white," audiences eagerly took up the poet. When the first volume of poetry was released just in time for Christmas sales, it was an immediate hit with the buying public.

"THE VERY ANARCHY OF THE MUSES"

Five hundred copies of *Poems by Emily Dickinson* were sold on the first day (Gordon 2010, 260). The publishers were obliged to reprint it six times in the first six months (Erkkila 2002, 14). The first edition would eventually sell almost 9,000 copies (Buckingham 1989, 558). This was, David Reynolds notes, "a remarkable sale for a poetry volume, then or now" (2002, 167). Gordon notes, "Public interest was fanned by Higginson's modest account of his correspondence and contact with a naïvely gifted recluse who had a 'quaint and nun-like look'" (2010, 260). Indeed, it was Higginson and Todd's bizarre picture of Dickinson's life on which many critics first focused, coming to the poetry only secondarily, as Todd did in the frequent public talks she gave about Emily Dickinson's life and work.

One of the first reviews to appear—on 16 November 1890, in the *Springfield Republican*, where Dickinson's verse had been anonymously published while she was alive—began by highlighting Dickinson's reclusiveness: "She possessed a sensibility so delicate, so immediately and painfully affected by the rudenesses of life, that she shrank more and more from contact with the world, and presently withdrew herself in the way her friend has described" (C. Whiting 1890, 15). The next month, the *Hartford Courant*, in a positive review, characterized Dickinson as the "child of a well-known Amherst family, and so much of an invalid that she rarely left the limits of her father's house, practically out of the world before death actually removed her from it" (*Hartford Courant* 1890, 64).

As the characterizations continued, they became increasingly lurid. A review from January 1891 stated:

> Emily Dickinson, who has recently died, and whose verses have just been published, was one of the oddest children of literature who has lived since Thoreau. She lived in an interior Massachusetts town. She was a perpetual invalid, and a woman of abnormally retiring disposition. She was far more shy than Hawthorne. She very seldom went beyond her garden fence; never visited her neighbors, and if her friends came to see her she would sit with her back to them and talk. (*Yankee Blade* 1891, 99)

The reviewer went on to backhandedly praise her work: "Her poetry, in spite of its great defects, is full of thought that sticks to the memory. Her rhymes were

as faulty as those of Emerson, but her thoughts were almost as profound. She might have done much more if she had been in touch with the world about her" (*Yankee Blade* 1891, 99).

Some reviewers explicitly brought in her nonconformity to gender norms as part of their characterization. *Book News* called Emily Dickinson "an eccentric old maid" (1891, 119), and the reviewer for *Rushlight* wrote, "Tradition tells us that there was a disappointment in love, her father opposing her marriage with the man she loved. Her work gains interest from this fact" (Blake 1891, 110). The reviewer was partly correct: it appears that her work did gain romantic interest from this "tradition," but there is no evidence that it was a fact.

Dickinson's life was used to explain what reviewers found most disturbing about her work: it was "unregulated," a dangerous and even frightening characteristic. The objection to her lack of regulation showed up in critiques of the poetry's "formlessness."

The overwhelming criticism of Dickinson's work was her blatant breaking of the rules. Over and over again, we hear from the critics that "her modeling is almost fatally defective" (R. M. Smith 1996, 118). The critic for *Book Buyer* wrote that her poems "bear witness to the erraticism of their author. These verses are largely fragmentary: they bespeak an unregulated fancy" (Brooks 1890, 44). A piece in *Scribner's Magazine* was a sustained attack on breaking with the "ordinary restrictions of form." The magazine's reviewer took issue with Higginson's apology in the preface to the volume that the ideas in the poems take one's breath away despite their "rugged" form. Readers must, the reviewer argued,

> lament the loss involved in a disregard of the advantages of form. . . . Formlessness is the antithesis of art, and so far as poetry is formless it loses that immensely attractive interest which is purely aesthetic. It not merely offends by perversely ignoring the conventionally established through rationally evolved and soundly based rules of the game it purports to play, but in announcing thus, boldly, its independence of any aesthetic, any sensuous, interest, it puts a severe strain on the quality of its own substance—handicaps it in most dangerous fashion instead of giving it that aid and furtherance which the best substance is sure to need. (*Scribner's Magazine* 1891, 120)

The reviewer from another publication agreed:

There is such a thing as poetic thought, doubtless; but when the poetic thinker is incapable of clothing the bones of his thoughts with the beauty of poetic form he should not consider himself a poet. . . . The reader . . . asks at least that the breath-taking thoughts shall not be disfigured by rags of grammar, tatters of rhyme and hobbling measures. (*New York Tribune* 1891a, 124)

A reviewer in a California newspaper wrote: "The poems are all short and most of them are not above ten or fifteen lines long. They read like the first random notes of a poem rather than of the poem itself, and appear to be fleeting ideas jotted down in a hurry with the intention of elaborating them later on" (*San Jose Mercury* 1891, 130). As with the Impressionists, many reviewers saw the poems as unfinished. A reviewer in *The Christian Intelligencer* wrote:

What shall one say of rhyming "tell" with "still," "arm" with "exclaim," "own" with "young," "pearl" with "alcohol"? all which are fair examples of many instances. There is a frequent scorn of traditional rhyme; an *abandonment* of expression, with a delightful *abandon* of thought and feeling. And yet you enjoy them all the more for it. You recognize them as mere studies; you exclaim, "Such sketches—then what pictures when finished!" (Wortman 1891, 147)

Picking up on this line of thought, Todd herself the next year would write of the poems in the introduction to the second volume: "They should be regarded in many cases as merely the first strong and suggestive sketches of an artist, intended to be embodied at some time in the finished picture" (Todd 1891, 236–237). This was clearly false.

When the book reached England in the summer of 1891, the critic for the *St. James's Gazette* wrote, "Possibly if Miss Dickinson had learned grammar and had known anything of the laws of metre, and had had any thoughts to express or any faculty of expressing them, she might have become quite a decent fifth-rate versifier" (1891, 160). Dickinson's chief critic in England was Andrew Lang who wrote a series of reviews of her work, bristling with indignation at her unconventionality. Writing in *The Speaker* in January 1891, Lang asked: "Is it poetry at all? For poetry, too, has its laws, and if they are absolutely neglected, poetry will die. This may be of no great moment, as there is plenty of old poetry in stock, but still one must urge that lawless poetry is skimble-skamble stuff, with no right to exist" (Lang 1891b, 108). A few months later, Lang took up the

matter again in a review entitled "An American Sappho." After saying Dickinson wrote "like a born idiot," he continued in his critique of her disregard for poetic laws: "[I]t is really next to impossible to see the merit of poetry like Miss Dickinson's. . . . Poetry is a thing of many laws—felt and understood, and sanctioned by the whole experience of humanity, rather than written. Miss Dickinson in her poetry broke every one of the natural and salutary laws of verse. Hers is the very anarchy of the Muses" (Lang 1891c, 203–204).

For Lang, one of the chief markers of Dickinson's lawlessness was her use of slant rhymes instead of the conventional chiming rhymes of the day. His reviews contained numerous examples of her transgressive rhyme schemes. In the first piece that he wrote about her, barely a month after the initial publication, Lang called Dickinson's work a "farrago of illiterate nonsense" and fulminated against the poem "I taste a liquor never brewed":

> "Alcohol" does not rhyme to pearl, but Miss Dickinson is not to be regarded as responsible for mere rhymes. Nor for grammar! It is literally impossible to understand whether she means that she tastes a liquor never brewed at all, or a liquor never brewed "from" tankards scooped in pearl. By "from" she may mean "in." Let us give her the benefit of the doubt, and she still writes utter nonsense. It is clearly impossible to scoop a tankard from pearl. The material is inadequate. . . . There are no words that can say how bad poetry may be when it is divorced from meaning, from music, from grammar, from rhyme; in brief, from articulate and intelligible speech. (Lang 1891a, 81–82)

Lang was not the only critic who expressed dismay at Dickinson's use of slant rhymes. Some critics made long lists of the slant rhymes so that readers could see for themselves the absurdities. As the critic for *Rushlight* commented, "That this woman should have chosen to write in rhyme is very strange. We would suppose that if she had written enough to fill a volume she would somewhere have had a *rhyme*, but seldom does she make one, and then only by accident" (Blake 1891, 110–111). Critics were angered by Dickinson's disregard of rules and norms—especially in this moment of cultural transition at the end of the nineteenth century when traditional social rules were falling by the wayside.

And yet many critics, still unhappy with the ways in which Dickinson defied conventional form, nevertheless found diamonds among the debris. In their reviews, they groped to explain how they could be so moved by work that was so technically "flawed" and "formless":

[A]fter a few pages form is forgotten, except when some monstrous rhyme arouses the reader from the spell of the poet. There is a peculiarly penetrating quality about these scraps of verse, something which imprints them upon the memory as firmly as those haunting scraps of doggerel chanted by the street boy, but these tranquilize instead of irritating, and fill one with the delight of a new possession. (*Boston Herald* 1890, 67)

The critic for the *Boston Beacon* concurred that if the reader could manage to forget the rules of poetry, Dickinson's work was a diamond in the rough: "Even those which at first glance seem to be most crude and rough, having the saving grace of originality, grow upon the fancy, and one soon forgets the roughness of the form in contemplating the beautiful idea enshrined like a diamond in its shattered matrix of discolored quartz" (L. Whiting 1890, 55). The critic for the *New York Tribune* lamented that she had been "uncurbed" by the rules of art:

Interesting as it is and marked by real genius, it is little less than exasperating to a reader who possesses the least feeling for the art of authorship. Phrases and characterizations so felicitous that they shine in splendor are followed by lines so crude and dull and commonplace that they could only be worthy of a schoolgirl. This woman certainly had genius; —but it was an uncurbed vine, whose roots sometimes touched sunless and unprofitable regions of thought and study. (*New York Tribune* 1891b, 84–85)

Other critics, though, began to recognize how breaking the conventional rules of form might have something to do with the power of the poems. The critic for a Chicago newspaper wrote: "What can be said about them? They are beyond the pale of criticism by reason of the proud indifference to opinion and the utter disregard of established rules for poetic composition, which the author shows in every line. But the spirit is there untrammeled by conventionality; daring, probing, showing things forth with a marvelous word power" (*Chicago Tribune* 1891, 116). In one of Dickinson's earliest reviews, Alexander Young wrote in *The Critic* that "the rough diamonds in the collection have a value beyond that of many polished gems of poetry" (1890, 9). A smaller group of critics fully made the connection between Dickinson's unconventionality and the meaning and power of the poems. The most influential of this group of

critics was William Dean Howells, writing in *Harper's New Monthly Magazine* in January 1891:

> Occasionally, the outside of the poem, so to speak, is left so rough, so rude, that the art seems to have faltered. But there is apparent to reflection the fact that the artist meant just this harsh exterior to remain, and that no grace of smoothness could have imparted her intention as it does. It is the soul of an abrupt, exalted New England woman that speaks in such brokenness. (Howells 1891, 77)

One way that critics grappled with their perplexity over the contradictions between their expectations for good art and the undeniable power of the poems was to classify them as outside the boundaries of the normal: as insane. Critics repeatedly use words like "queer," "weird," and "strange" to describe the poems. The implication that the author of these poems could herself not have been sane lurks just beneath the surface of many of the reviews. And as early as January 1891, *The Christian Advocate* was tying the story of her strange life to questions about her sanity: "In reading her poems we cannot resist the impression that there is something unhealthy in a life of isolation. Perpetual introspection is the mother of melancholy, and melancholy is the half-sister of madness" (1891, 107). The critic for *The Scotsman* was more direct: "there is the suggestion of a morbid mental condition or of a latent mental disease" (1891, 161). The *Springfield Sunday Republican* said, "No doubt that the recluse woman was scarcely in her right mind, if we accept the standard of ordinary life" (1891, 179). The critic for *Rushlight* simply said, "Here is poetry run mad" (Blake 1891, 111). But for whatever reason—from morbid curiosity to a genuine appreciation for Dickinson's artistry—despite the reservations and cavils of the critics, the book was a hit with the public.

Sue, who had had been kept in the dark about the plans for publication ever since she returned Vinnie's copies of the poems years before, was taken completely by surprise. She graciously thanked Higginson for having brought Emily's work into the public, but she could not conceal her hurt at what she saw as his and Vinnie's betrayal. Mabel, on the other hand, was exultant and planned a series of ten more volumes. She set to work immediately on *Poems by Emily Dickinson, Second Series*.

"GENIUS IS NEAR AKIN TO MADNESS"

Fired by her success with the first volume, Mabel Loomis Todd had the second volume of poetry ready for Christmas sales in 1891. She and Higginson again edited the poems to make them more conventional, but Todd took a more commanding role in the publication and promotion of this book, writing the preface to it herself. In it, she continued to present herself as an intimate of Dickinson's (despite never having met the poet), continued to focus on her romanticized and eccentric portrayal of Dickinson's life, and continued to preemptively apologize for the poems, explicitly comparing them to "impressionist pictures" and characterizing them as "merely sketches" that were waiting to be turned into a "finished picture" at some time in the future (Todd 1891, 237). Higginson, too, in a pre-publication article in *The Nation*, wrote that "they are, in short, to be viewed as sketches, not works of conscious completeness" (1891, 213). Higginson had seen the numerous copies and revisions of her poems that Dickinson had left behind, but he chose to ignore her obvious attention to craft.

The critics picked up on the theme of incompleteness. Even in generally positive reviews, critics excused what they saw as imperfections in craft with an assumed hastiness on Dickinson's part. The critic for *Amherst Literary Monthly* wrote, "A striking thought would come to her mind; instantly it was jotted down, there being but a moment's interruption in the task of the hour" (Schauffler 1891, 225). The critic for *Sylvia's Home Journal* similarly complained: "The fact is that Miss Dickinson had a very daring and original imagination, a very pretty fancy, and a great deal of poetic power, but was utterly ignorant of poetic art. She dashed down her thoughts, red hot, and just as they came into her mind, and sometimes she expressed herself with rare happiness and sometimes with equal clumsiness" (Wegg 1891, 229). Inevitably, given that Todd and Higginson had used the symbolic capital of innocence to position the poet in the field, Dickinson herself was treated dismissively. For example, E. J. Edwards, characterizing her as delicate and timid, wrote that the author "in many things seemed a mere child" (1892, 290).

While the public discussion of the first volume teetered from approval, to condemnation, to bafflement, the critical view of the second volume cohered more around negative assessments. A common opinion was that one volume of Dickinson's writing was enough: the trove of work had been fully mined for whatever of value it had held, and the second volume was not up to the quality

of the first. The critic for the *Hartford Courant*, while praising the first volume, nevertheless concluded about the second series:

> We have no hesitation in saying that it would have been a kindness to the gifted Amherst lady to exclude fully one half the poems herein included. Some of them are worse than sketchy, are incoherent, inchoate, non-parsable and occult to a degree, which leaves the reader in a state, not of poetic stimulation, but of intellectual irritation. A wrong has been done to Miss Dickinson in publishing them. (*Hartford Courant* 1891b, 248)

The critiques of this series echoed and amplified those of the first series: the poems were lawless; the poet was insane. In the *Atlantic Monthly*, Thomas Bailey Aldrich, after having rewritten Dickinson's "I taste a liquor never brewed" to show his readers how easily it might have been for Dickinson to write in a more conventional manner, concluded that there is "certainly established a precedent for independence; but an eccentric, dreamy, half-educated recluse in an out-of-the-way New England village (or anywhere else) cannot with impunity set at defiance the laws of gravitation and grammar" (1892, 283–284). As the nineteenth century turned into the twentieth, the critics' anger at Dickinson and their admonitions to retain conventions seem directed as much as the changing social world as at Dickinson herself, long deceased and beyond mending her ways.

The Hartford Courant said the poems "cast doubts on the writer's sanity" (1891a, 201). The *Boston Saturday Evening Gazette* noted that "we cannot help thinking that genius is near akin to madness" (1891, 249). The *Bookman* in London wrote that the poems are "not uninteresting in view of the theory of mental derangement which has been put forward concerning her" (1892, 305).

The critiques were beginning to catch up with the sales figures. The second series sold only about half as many copies as the first, despite the sensationalized stories of the poet's life that Todd continued to peddle in her public talks. She put out a volume of Dickinson's letters, carefully excising Sue from the record, and a third volume of poems, but each sold less than half the number even of the second series of poems. By the end of the decade, the Dickinson fad was over. Her work would re-emerge only when she was rediscovered by the modernists of the mid-1920s.

SELF-DEFEATING STRATEGIES

During her lifetime, as with the gendered customs that would have kept her busy visiting neighbors and drinking tea, Dickinson had for the most part rejected conventional publishing. Instead, she privately circulated her work among a surprisingly large circle of family and friends, including some of the key literary figures of the day. But her most important audience was always her sister-in-law Sue. It is impossible to know for sure whether or not the two women were lovers. But by the 1890s, when Dickinson's work—including her correspondence—was first published, it would have seemed so to the audience.

Because of the relational nature of positions in fields, as her editors, Higginson and Todd had positioned themselves to best promote their own status in the literary field by the position they could capture for the deceased poet, now no longer able to speak for herself. Todd framed herself in her talks about Dickinson as a dear friend who could speak in her stead. Todd and Higginson carefully constructed an image of Dickinson that was acceptable—virginal, reclusive, innocent, but just strange enough to be piquantly salable. Dickinson's relationship with Sue would have been shocking, so Sue was erased. Todd and Higginson also worked hard to downplay and erase the subversive nature of the poems themselves. Their strategy was to use symbolic capital not only to sell books, but to raise their own status (especially Todd's) by association as her discoverers.

At first, the strategy worked—at least with the buying public. Packaged as dainty, shy, and asexual, Dickinson was an immediate sensation. But reviewers, many of whom saw it as their obligation to preserve the ordered hierarchies of the literary field and determine what was legitimately high quality, attacked the poems' subversion of traditional norms. Their outrage at Dickinson's innovations was only heightened by the temerity of a writer of such insignificant status (for that was what the symbolic capital Higginson and Todd had created depended on) daring to claim serious consideration in the field. The symbolic capital that her editors had put forward to excuse Dickinson's innovations had, ironically, delegitimated her as an artist with stature enough to dare innovating in the first place. The myth, meant to sell the work, ended up undermining it.

The critical discussion of Dickinson's work in the 1890s generated two strains of thought. One privileged tradition, convention, and history in an either-or game that pitted Dickinson against the literary heritage of the West.

Aldrich had written in January 1892, "If Miss Dickinson's *disjecta membra* are poems, then Shakespeare's prolonged imposition should be exposed without further loss of time, and Lord Tennyson ought to be advised of the error of his ways before it is too late" (1892, 284). But the other side of the argument brought forward a critique of just this conventional thinking. The critic for the *Springfield Homestead*, explicitly responding to the critic from the *St. James's Gazette*, wrote: "An English critic told us upon their appearance that Emily Dickinson might have become a fifth-rate poet if she had only mastered the rudiments of grammar and gone into metrical training for about 15 years. If she had undergone this austere curriculum, one of the rarest poets in the century would have been lost to us" (G. 1894, 333).

Dickinson was eventually championed by modernists like Archibald MacLeish, who wrote, "*most of us* are half in love with this dead girl" (R. M. Smith 1996, 116; italics in original). Enthralled by Dickinson's unconventionality, this new generation of American poets in the 1920s nevertheless still saw her as a reclusive "girl," despite having been fifty-five years old when she died. Not until three decades later, when Thomas H. Johnson published the *Complete Poems* in 1955, were Dickinson's poems finally seen without the heavy hand of editorial interference. But Dickinson herself still has not escaped from the mythical symbols meant to sell her.

Dickinson provoked outrage among the critics because the subversiveness of her poetic innovations was at odds with the symbolic capital of "virgin recluse": a diminished and nonthreatening persona that was created by Todd and Higginson to deflect attention from the poet's equally subversive life, in which she eschewed the gender roles that would have eaten up her time in social visiting (or even marriage and motherhood) at the expense of her work. Todd and Higginson presented the poems as unfinished, rather than as the assiduously worked pieces that they were, in an attempt to find excuses for their transgressions. But this only inflamed critics who found the temerity of publishing the poems in such a state insufficiently respectful of the conventions that powerful actors in the field wished to conserve. Lowering Dickinson's status to that of a naïf or a child—as a strategy to placate these dominant actors—only begged the question of how such a nonentity dared to push herself forward so brazenly in the first place. That this personage should also be caught in the act of breaking so many "laws" of poetry was outrageous. She would not be allowed to do so with impunity.

As the nineteenth century turned into the twentieth, those most concerned with upholding tradition grew increasingly desperate to quash upstarts like Dickinson. And while the lurid myth that Todd and Higginson had concocted to intrigue the masses made Dickinson a fad for a few years, ultimately the novelty wore off and her popular appeal faded. And Emily's relationship with Sue, whatever its true character had been during her lifetime, was so dangerous to the social order that it had to be erased entirely. The next chapter discusses cultural producers who did not bother to hide their sexuality, but instead made it a centerpiece of their art.

"Delirious Cocksuckers"

Le Sacre du printemps *and the Ballets Russes*

On the night of 29 May 1913, Sergei Diaghilev's Ballets Russes premiered *Le Sacre du printemps (The Rite of Spring)* at the Théâtre des Champs-Elysées in Paris. The audience response was extraordinary. Artist Valentine Gross was there:

> The theatre seemed to be shaken by an earthquake. . . . It seemed to shudder. People shouted insults, howled and whistled, drowning the music. There was slapping and even punching. The dancers could not hear the music. Diaghilev thundered orders from his box. There was something wonderful about the titanic struggle which must have been going on in order to keep these inaudible musicians and these deafened dancers together, obedience to the laws of their invisible choreographer. The ballet was astoundingly beautiful. (Karthas 2015, 63–64)

The opening night of *Le Sacre du printemps* is not the only incident in which art has inspired violence, but it is one of the most famous.

"ASTOUND ME!"

Even as a young man in St. Petersburg in the 1890s, Sergei Diaghilev had a vision of creating art as a revolutionary act (Eksteins 1983, 236). When the Campanile of the Basilica of San Marco in Venice collapsed and was destroyed

in July 1902 while Diaghilev was in Venice visiting, he wrote: "The culture of twenty centuries, pressing down on our shoulders, prevents us from creating, and if along with S. Marco's Campanile the whole of our beloved Venice tumbled down, we would go mad with grief, but . . . for men of the future there would be one serious obstacle less" (Scheijen 2013, 34).

Diaghilev saw himself as a natural revolutionary and leader of the avantgarde. Part of the reason for this was his homosexuality, which at least by the turn of the century he was no longer hiding. Instead, he surrounded himself with a group of gay men, all engaged in one way or another with the arts. In the words of his future collaborator Igor Stravinsky, they were "a kind of homosexual Swiss Guard" (Eksteins 1989, 34). This was politically and socially subversive, even dangerous. Diaghilev was openly gay at the time when Oscar Wilde was imprisoned and doing hard labor for sodomy. Because of this, the traditionalists of the Russian aristocracy would never quite accept him as one of the inner circle. Diaghilev's rejection by the powerful upper echelon of the imperial arts bureaucracy impelled him to head in a bold new direction, following a more expansive vision: using art to make a realm of fantastic beauty that was outside the narrow St. Petersburg limits. He was not an artist himself, but rather an impresario; he was the one who would bring together all of the ingredients necessary to present an artistic vision to the world. Rejected by the imperial arts bureaucracy, Diaghilev relocated to Paris and unveiled a new artistic venture—a ballet company, the Ballets Russes—that officially debuted in March 1909.

Paris was the cultural center of Europe during the Belle Époque: "In this period, Paris, known as the 'City of Light,' drew in a variety of entertainments, witnessed innovations in theatre, and hosted a number of grand exhibitions. It would become the world capital of fashion, art, literature, and entertainment. Thus the capital emanated a new cultural and intellectual energy. If one was a writer or artist, Paris was the place to be" (Karthas 2015, 14). And, not incidentally, between 1792 and 1942 homosexuality was not illegal in France (Burt 1995, 77). There was less homophobia in France than there would have been in other countries. Moreover, because of the relatively lax censorship laws in France, art that would have been suppressed or banned elsewhere in Europe could appear in Paris (Eksteins 1989, 44).

Diaghilev's hopes for his ballet were to bring together dancers, choreographers, composers, and artists to create a world that would wrap the viewer

entirely in his vision. That was a radical departure for a ballet in the Belle Époque.

At the time, ballet as an art form was in a period of decline (Pritchard 2013b, 49–50). The major choreographers of the nineteenth century had retired or died, and different forms of entertainment (such as the variety theaters) and audiences for arts consumption (the urban bourgeoisie) were on the ascent. It was an opening that Diaghilev seized. His ballets were shorter, more in tune with modernity, and much more spectacular than traditional forms, using brightly painted sets that were works of art in themselves, music from avant-garde composers, colorful costumes covered in jewels, and groundbreaking choreography. He worked with young and innovative designers, composers, and choreographers. His charge to his artistic collaborators was "Astound me!" (Garafola 1989, 98).

The first performance of the Ballets Russes, on 19 May 1909, astounded all of Paris:

All contemporary sources speak of a shocking, entirely novel, even life-changing experience. "Invasion," "explosion," "outburst"—no hyperbole was left unused. The poet Anna de Noailles, who attended the first performance, described it as follows: "It was as if Creation, having stopped on the seventh day, now all of a sudden resumed. . . . Something completely new in the world of the arts . . . a sudden glory: the phenomenon of the Ballets Russes." (Scheijen 2009, 193)

The shock came from all parts of the production; the Ballets Russes had changed everything about ballet. The sets and costumes were stunningly colorful, the music and choreography were strikingly modern, and the dancers were energetic and powerful (Eksteins 1989, 25). The effect of the Ballets Russes reverberated far beyond merely the world of dance to touch the rest of the art world—not only music and design, but also fashion, painting, and even poetry. Auguste Rodin, André Gide, and Jean Cocteau were all devotees and drew inspiration from the Ballets Russes (Karthas 2015, 161–162). "When Bonnard, one of France's most prominent painters, was asked whether the Russians influenced his work, he answered, 'But they influence everyone!'" (Scheijen 2009, 206).

The Ballets Russes became the standard-bearers of the avant-garde. "In an interview with the *New York Times* in 1916, Diaghilev proclaimed: 'We were

all revolutionists . . . we were fighting for the cause of Russian art, and . . . it was only by a small chance that I escaped becoming a revolutionist with other things than color or music'" (Eksteins 1989, 42). If cultural producers like Dickinson and the Brontës tried to keep their subversiveness hidden, Diaghilev shouted his to the world.

A key part of Diaghilev's artistic revolution concerned gender roles. At the center of the Ballets Russes productions was the male star, a new phenomenon. There were female ballerinas in the company, and some of them attained star status, but the brightest star of all was a male dancer, Vaslav Nijinsky (Karthas 2015, 233). Nijinsky had turned twenty only a few weeks before the premiere, but he was already hailed as a miracle of dance. He was celebrated for his seemingly impossible jumps during which he would hang suspended in the air, appearing to defy gravity. He was the centerpiece of the Ballets Russes productions, itself an astonishing development in the world of ballet where male dancers had been rare and were only used as props to show off the female ballerinas. He was also Diaghilev's lover, a relationship that neither bothered to hide. Paris was perhaps less sexually repressive than the rest of Europe, but the Ballets Russes quickly became a byword for decadence, a reputation that lasted for years. From the very beginning, the Ballets Russes was transgressive with regard to more than just dance.

"VERY ROTTEN, VERY BALLETS RUSSES"

By the end of the nineteenth century, ballet had become a largely female world. Dancers were almost always women, and male roles were regularly danced by women dressed as men, *en travesti*. Male dancers were regarded as an abomination (Karthas 2015, 229–230). The female-centric nature of late nineteenth-century French ballet was closely tied to the sexualization and exploitation of the female dancers, who were often preyed upon by wealthy men who frequented the ballets looking for mistresses. "One critic described the female dancer in the late 1890s: 'As soon as she [a dancer] enters the Opéra her destiny as a whore is sealed; there she will be a high class whore'" (Karthas 2015, 272). As with Degas's *Petite Danseuse de quatorze ans* (*Little Dancer Aged Fourteen Years*), it was the women and girls who were seen as immoral and debased rather than the men who exploited their poverty and desperation. For the men, having a dancer as a mistress was a mark of high status (Karthas 2015, 269).

The Ballets Russes changed that. Instead of featuring female dancers, the

men, especially Nijinsky, were highlighted. Whole groups of male dancers also performed as a part of the supporting corps on stage in ways that had formerly been seen only with women, highlighting their athleticism but also their grace and physical beauty.

Although critics praised the male dancers' agility, strength, virtuosity, vigor, and technique, they, like the female dancers who came before them, were also presented as sexualized spectacles. Lynn Garafola writes, "Diaghilev's heroes traced a spectrum of male roles that transcended conventions of gender while presenting the male body in a way that was frankly erotic. Ballet after ballet celebrated its physique, dramatized its athletic prowess, and paraded its sexual availability" (1999, 246).

An important ingredient of the sexualization of the male dancers was the way in which they embraced androgyny. Expressions of gender were unmistakably queer, in the twenty-first-century sense. Nijinsky's roles combined both the kind of sensitivity usually thought of as female and the strength and athleticism usually thought of as male (Burt 1995, 84). "The Ballets Russes' androgynous imagery differed in that its bodies did not aim to entirely erase masculinity or femininity, but rather to present a modern vision of its fluidity" (Karthas 2015, 112).

Nijinsky was presented in ballet after ballet in gender-bending ways. Some were subtly coded to appeal only to those in the know; others were less so. In *Le Spectre de la rose*, for example, Nijinsky played the title role dressed in a pink body stocking decorated with rose petals, flouting conventional heterosexual norms: "Masculine in the power of his leaps, feminine in the curving delicacy of his arms, he emitted a perfume of sexual strangeness; he seemed a living incarnation of the third sex, a Uranian reveling in the liberation of his true self" (Garafola 1989, 33). As a result, the audience for ballet shifted and became more inclusive of gay men. Not only did it feature gay men in important roles both on stage and behind the scenes, but the performances themselves provided opportunities for gay men (and many others who lived outside the social norms) to come together for socializing openly and without fear (Garafola 1998, 65).

This added to the aura of decadence. While Paris may have been less repressive than other places in Europe, it was certainly not altogether free from homophobic biases. As the Ballets Russes dominated the Paris social season and as Nijinsky's sexually fluid persona captured the limelight, there were those who pushed back, tapping into negative stereotypes. "Robert de Flers and Gaston de Cavaillet had a character in their play, *Le Bois sacré*, say, 'We're

starting to become very elegant gents, to make very chic acquaintances, very rotten, very Ballets russes'" (Eksteins 1989, 36).

Although all the Ballets Russes company were wrapped up in the aura, it was Vaslav Nijinsky especially who became the focus of the erotic spectacle. He was photographed and drawn in frankly erotic ways. The images were then gathered in portfolios that were circulated privately to wealthy male patrons (Garafola 1998, 64). The roles Nijinsky danced helped with this: he often portrayed exotic and fetishized creatures, such as willing sexual slaves in *Cleopatra* and *Scheherazade* (Järvinen 2009, 202). At the same time, the power and control of his dancing defied categorization. Nijinsky was neither stereotypically male nor female, but both—or neither. One did not need to limit oneself to a single gender or to the gender binary. There were no limits, no boundaries, no walls—just as Diaghilev had celebrated when the walls of San Marco's Campanile collapsed. Such gender fluidity elicited a homophobic backlash. In 1911, in London, Nijinsky's dancing provoked an indignant letter to *The Times*, which concluded:

> Against Nijinsky personally, of course, nothing can be said. He is a conscientious artiste devoted to his work. But is not the influence of his dance a degenerate one? It is luscious and enervating. The type of young man who likes it and the type it will breed is precisely that which loves the languor of a rose-lit apartment with the curtains drawn all day, with the smoke of opium curling, and the heavy breath of strange perfumes in the air. And that means rottenness! (Moore 2013, 87)

"THE BARBARIANS OF ART ARE AMONGST US"

The gender bending of the Ballets Russes touched a nerve in France. The defeat in the Franco-Prussian War of 1870 had left in its wake concerns about French masculinity and manliness (Karthas 2015, 223): "Over the course of the nineteenth century, ideal masculinity lost its heroic classical associations of the previous century. Masculinity became linked with intellect (the mind) rather than physical prowess (the body)" (Karthas 2015, 242). Now, at the fin de siècle, the pendulum had defensively swung the other way. The ideal man was muscular and strong—athletic rather than intellectual (Karthas 2015, 244–245).

But resolving how to be the ideal man was not so simple. The emergence of feminism, changes in labor practices with industrialization, urbanization, the

rise of the middle class, and a new culture of leisure all complicated feelings about masculinity. The decades of the Ballets Russes were decades of conflict about how to appropriately perform gender. Part of the reason that homosexuality was tolerated in France was because it had not been obvious; it was unpunished because it was unrecognized. But that was starting to change. The trials of Oscar Wilde in the 1890s brought a tidal wave of attention. As Ramsay Burt noted, "The period 1890–1920 was one in which extensive legislative and medical attempts were made to define and control homosexuality" (1995, 78). France was beginning to move towards eventually criminalizing homosexuality.

Nijinsky himself became a site of conflict. A superb athlete with obvious strength and muscular control, he was nevertheless an openly queer artist. His foreignness compounded the problem by worrying the French that other nations were producing men who were bolder and more vigorous. Critic Pierre Lalo wrote in *Le Temps* in 1909: "More than us, the Russians make use of bold and violent colours, vigorously opposing and contrasting each other. . . . We [the French] employ only nuances as delicate as possible, degraded and melted with refinement" (Karthas 2015, 92). The fear of "degradation" may have been said about art, but it was meant to also be about the nation. That this queer foreigner could nevertheless perform more manly feats of strength and agility than any native-born Frenchman was tied to ideas of a "natural" and "primitive" masculinity that had been stripped from the more "civilized" Frenchmen (Burt 1995, 82).

France's defeat in the Franco-Prussian War followed by the bloody violence of the Commune was the beginning of a period of soul searching about the meaning and cultural identity of the French nation (Karthas 2015, 19). Moreover, as Europe lurched closer and closer to what would be World War I, nationalism was on the rise along with anxiety about foreign invasion—and about infection of French culture with foreign ideas, a cultural fifth column. The field of art was nested inside the larger field of power; there were fears in France that the entire edifice of world power was shifting and that France would find itself at the heteronomous pole.

A critic for *Le Monde illustré*, for example, wrote with regard to the 1912 Salon d'Automne:

> This ceaseless invasion of a growing number of metics [i.e., despicable foreigners], most without talent, who come, not as in the past to study the clear genius of our race but to subject us to the vapours or extrava-

gances of their own, is a real national peril. . . . Our artists imitate them and bad taste enters in their wake! . . . Italian Futurists or Hungarian and Slavic "delirious cocksuckers" contaminate our French youth; they are the cause of these ridiculous lunacies. (Järvinen 2013, 6)

Speaking for many, critic Louis Laloy wrote: 'The invasion of the barbarians is always to be feared. . . . The barbarians of art are amongst us" (Karthas 2015, 94).

The fear of foreigners was also tied to anti-Semitism. The Dreyfus affair brought out into the open the anti-Semitism that had been hidden just beneath the surface of French society. A Jewish artillery officer, Alfred Dreyfus, was accused of spying for Germany and passing on French military secrets. Despite a lack of evidence against him—and a wealth of evidence against a non-Jewish officer, Major Ferdinand Walsin-Esterhazy—Dreyfus was convicted in November 1894 and sentenced to prison on the notorious Devil's Island in French Guyana. Given the lack of credible evidence against him, many saw this as an act of pure anti-Semitism. The public uproar was such that Esterhazy, the real spy, was finally tried, but he was acquitted in 1898. These trials kept the affair at the forefront of the public consciousness and bitterly divided France along pro- and anti-Dreyfusard lines. Dreyfus was retried in 1899 and again convicted. The political divisiveness and discussions of the affair refused to fade away, however, and Dreyfus was eventually fully exonerated and decorated with the Legion of Honor in 1906, twelve years after his initial conviction.

Division among different factions worked its way into all areas of French life, including the arts: "The pro-Dreyfusards consisted largely of pro-republicans who included writers, artists, and intellectuals, and the anti-Dreyfusards comprised many anti-Semites, loyal supporters of the French Army, and embittered monarchists still reluctant to accept the Third Republic. Two conceptions of France emerged, creating debates, once again, over the authority of the army, Church, and nation" (Karthas 2015, 42). The field of art was nested in the field of power so that authority in one was homologous with authority in the other. The foreignness of the Ballets Russes had made them suspect already. That some of the leading lights of the company were Jewish pushed the anti-Semites over the edge:

At a time of increasing anti-Semitism, Jews were also targeted as "exotic," "barbaric," and "invasive." Thus when critics were not attributing "Russianness" to the orientalist flavour of the Ballets Russes,

they were often referring to the "Jewishness" of Leon Bakst's décor. Referring to the sets of Bakst, painter and critic Maurice Denis once noted in his diary, "Saison Russes: les ballets juifs" [Russian Season: the Jewish Ballets]. . . . Gabriel Astruc, the founder and manager of the Théâtre des Champs-Élysées where the Ballets Russes often performed, was often targeted for being a Jew. . . . In a headline article for *L'Action Francaise*, Léon Daudet viciously attacked Astruc's influence on Parisian culture, writing: "The Jew behind the Great Saison de Paris is demolishing the Parisian season, as his species demolishes the French forest, completely. . . . This is the behavior of the Jewish bank applied to the theatre." (Karthas 2015, 85–86)

The Ballets Russes came to represent the nexus of several streams of cultural and political anxiety and division within French culture: anti-Semitism, nationalism, the meaning of masculinity, and fears of invasion. Not only their detractors, but also their supporters saw them as invading barbarians. Marcel Proust wrote of them: "This charming invasion, against whose seductions only the most vulgar critics protested, brought on Paris, as we know, a fever of curiosity less acute, more purely aesthetic, but perhaps just as intense as that aroused by the Dreyfus case" (Kelly 2000, 265). Their supposed lack of civilization was part of their appeal. "Adolphe Boschot spoke for many: 'So we have to admire the Ballets Russes. In fact, for several years we acclaimed their *splendide barbarie*'" (Kelly 2000, 265).

The company's origins in Russia allowed critics and audience alike to see them through the lens of Orientalism. Russia was an exotic land—untamed, instinctual, and sexually enticing. Theater critic Alfred Kerr wrote of the Ballets Russes in a poem entitled "The Russian Ballet" (Kolb 2009, 156):

> Aiming, squinting, eyeing, lurking,
> Coiling, ducking in herds,
> Are they animals? Are they peasants?
> Are they Russians? Are they Tartars?
> How they snarl, strut, flirt,
> Fur-coated in long boots

In a 1912 article for *Le Temps*, Pierre Lalo characterized the Ballets Russes as "real barbarism, under the false appearance of a delicate art. That's what the

Russian shows are despite their research and refinement: the mark of the Barbarian is one of them" (Karthas 2015, 189).

The persistent Othering of the Ballets Russes associated them with a demeaning depiction of the supposedly barbarian Orient. But one person's "barbarian" is another person's "revolutionary." Diaghilev did indeed intend to destroy the old, straitlaced traditions. In this project, he was joined by a coterie of others who were increasingly gaining economic, cultural, and political power.

PATRONS

By the end of the nineteenth century, ballet audiences were almost entirely male, made up of wealthy men who came to ogle the dancers, choose mistresses from among the corps, and enjoy the sight of their lovers on stage. Artistry was much less important to them than skimpy costumes. Diaghilev changed that audience to include more women as well as avant-garde artists and writers and a broad array from other constituencies (Kolb 2009, 152). Garafola's research into the "booking forms" shows the heterogenous nature of the audiences for Diaghilev's productions: "an amalgam of financiers, bankers, and diplomats, members of the city's foreign and Franco-Jewish communities, and personalities from the worlds of fashion, music, entertainment, and the press" (1989, 279).

This heterogeneous audience had within it the seeds of conflict. Ilyana Karthas notes that the regular audience Diaghilev had assembled consisted of "not only the aristocracy, but also the 'haute bourgeoisie' and demimonde. The financial backers of the Ballets Russes (a significant portion from the aristocracy) came from the 'liberal' Right: philosophically and economically liberal but, unlike those of the Left, conservative on basic social conceptions" (Karthas 2015, 15). The various groups had distinct points of disagreement—the avant-garde artists who wished to push the boundaries of the socially acceptable and the liberal bourgeoisie who had only recently learned to love the Impressionists—and they were on a collision course.

This was exacerbated by the audience's including both old and new money—the aristocracy and the industrial tycoons—each of whom had a stake in laying claim to an exclusive place at the top of the social hierarchy. They may have come from the same class economically speaking, but in terms of cultural and social capital, they were worlds apart. Diaghilev, with a business

to run, catered to both factions of the upper class. Scholars have noted the ads in the programs that indicated the target audience for the Ballets Russes. There were full-page ads for expensive items like perfume, high fashion, travel, Veuve Clicquot champagne, and other luxury goods (Hart 2013, 124). But the very fact that there were advertisements in the programs at all indicates that this was a new approach to high culture. There were also ads for the Parisian department stores.

Diaghilev wooed patrons by hosting lavish parties and opulent receptions to which the wealthy were invited and at which they could conspicuously display both their cultural and their economic capital (Haill 2013, 182). Diaghilev also became a fixture at the salons of the Belle Époque where he could engage with the intellectual and artistic elite of the city.

The salons had become an important part of the city's culture. The most famous of these salons is probably Gertrude Stein's, frequented by the likes of Picasso, Matisse, and (eventually) Hemingway. Garafola quotes Raymond Rudorff: "They . . . helped to create a new society of talents in which the painter, the scientist, the philosopher, the politician, the novelist and the musician could meet on equal terms in a sympathetic atmosphere into which newcomers might make their way" (1989, 281). The hostesses of these salons were often women, many of them (like Stein) foreign and Jewish.

Like his audiences, Diaghilev's patrons were a more inclusive and heterogeneous group than the old guard. Among them, for example, was Winnaretta Singer, the Princesse de Polignac, an American-born heir to the Singer sewing machine fortune, openly lesbian (despite two marriages), and the patron of, among others, Debussy, Ravel, Stravinsky, Satie, and Weill. But in addition to Singer, Ballets Russes patrons included other upper-class names like the Rothschilds, Lady Ripon, and the Comtesse Greffulhe, all of whom were heavily involved in the arts (Sonner 2013, 95). In addition, Diaghilev was closely allied with artists like Rodin, Cocteau, high-society photographers Baron Adolphe de Meyer and Jacques-Émile Blanche, the "smartest artist of his day" (Garafola 1989, 289). There were also important government officials including "ambassadors, cabinet ministers, political hostesses, entire Russian legations, and even French President Clément-Armand Fallières" (Garafola 1989, 274).

Among these luminaries were a sizable number of Jewish industrialists, financiers, intellectuals, and artists. From the time Diaghilev first arrived in Paris from St. Petersburg, Gabriel Astruc, the owner of the Théâtre des Champs-Élysées, connected him to the wealthiest and most cultured Jewish

families in the haute monde (Garafola 1989, 277). French by birth and nationality, this group was key to Diaghilev's success, both financial and otherwise. Fabulously wealthy, these families had been marrying into the impoverished French aristocracy for decades. "From the 1880s onward this group played a key role in French cultural life as patrons, collectors, *salonnières*, artistic dilettantes, and supporters of innovative trends. Here, in a nutshell was *le tout Paris* mined by Astruc for Diaghilev's audience" (Garafola 1989, 281). Given the fears of foreign invasion and cultural "contamination," as well as the wounds left from the Dreyfus affair, the Ballets Russes's connection to the Jewish community opened the floodgates of anti-Semitism.

"A FLEETING VISION": A YOUNG GIRL DANCING HERSELF TO DEATH

Both composer Igor Stravinsky and artist Nicholas Roerich claimed to have come up with the idea for *Le Sacre*, a ballet featuring the rituals to welcome the coming of spring in prehistoric Russia. In Stravinsky's version:

> One day, when I was finishing the last pages of *L'Oiseau de feu* in St. Petersburg, I had a fleeting vision which came to me as a complete surprise, my mind at the moment being full of other things. I saw in my imagination a solemn pagan rite: sage elders, seated in a circle, watched a young girl dance herself to death. They were sacrificing her to propitiate the god of spring. (Scheijen 2009, 212)

According to Roerich, he had the idea first, and certainly his background and expertise in prehistoric Russian art and religion would have been appropriate to such a thought. But whatever the truth of the matter, by 1910, both men were working on a project they initially called "The Great Sacrifice," drawing on the prehistoric Russian ethnography that fascinated them both.

The ballet has two parts. The first, happening during the day, shows a community in "pagan Russia" going about the preparation for the sacrifice, a ritual to welcome the coming spring. The second part is the sacrifice itself, happening that night, during which a sacrificial maiden dances herself to death surrounded by other maidens and the community elders. This is not the spring of sweetness and romance, but a surge of life, violent in its procreative power, sweeping away the old in the cataclysm that brings about the new. Darwin's ideas of natural selection—pitiless and without sentimentality—dominate the conception. Reminiscent of Diaghilev's comments a decade before with regard

to the destruction of San Marco, only death and destruction can make possible new birth.

As the ballet began to take shape around Stravinsky's music and Roerich's scene and costume designs, Diaghilev assigned the choreography to Nijinsky, who had only recently begun his career as a choreographer. His first piece was *L'Après-midi d'un faune,* which was presented in May 1912 when Nijinsky was barely twenty-three years old.

Based on music by Claude Debussy, *Faune* was a short ballet—only eight minutes long—that featured Nijinsky dancing as the title character among a bevy of nymphs in a forest glade. Nijinsky's choreographic conception was to use the dancers' bodies to mimic the flat, angular images on ancient Greek pottery he had seen in the British Museum. In this, he broke the rules of ballet and played an important role in creating modern dance (Ostwald 1991, 59).

But while the choreographic form was innovative, it was the final gesture of the faun that caused Parisian audiences to reel. The faun, in a spirit of youthful sexual awakening, pursues the nymphs but is unable to catch them. At the end, he has only managed to capture a scarf left behind by one of the fleeing nymphs. He lies face down on the scarf and brings himself to orgasm. At this final unambiguous gesture, the audience was, to say the least, astounded—as Diaghilev had hoped. The audience was so shocked, in fact, that the final gesture of orgasm had to be considerably toned down in subsequent performances. The scandal was such that it even reached across the ocean to the United States. The *Pittsburgh Gazette's* all-caps headline of 5 June 1912 was "WICKED PARIS SHOCKED AT LAST" (Moore 2013, 111).

Diaghilev relished the controversy and the publicity that it brought to the Ballets Russes. He also recognized Nijinsky's innovative genius and felt justified in the faith he had placed in his young lover's abilities. In his choreography for *Le Sacre*, Nijinsky would continue to innovate. In the rehearsals, the dancers were perplexed and displeased. Rather than employing classical ballet turnout, pointe work, and grace, Nijinsky's choreography relied on flat-footed, turned in, straight-legged jumps. Rather than displaying elevation ("ballon"), the dancers were often hunched over and oriented towards the ground. "There was not a single jeté, pirouette, or arabesque" (Eksteins 1989, 51). The movements were different from everything they had been trained to do and were often physically painful for them to perform (Moore 2013, 133). The dancers occasionally rebelled against Nijinsky in rehearsals.

Stravinsky's score was equally radical, changing meter frequently and asking

instruments to play at the very limits of their ranges. Dissonance abounded. In rehearsal, the musicians under conductor Pierre Monteux were perplexed and angered by the score. Monteux himself said of it: "I detested it." But, Diaghilev was delighted. Hearing about the troubled rehearsals, Diaghilev merely remarked "that it was an excellent sign. It proved the composition to be strikingly original" (Moore 2013, 134).

"RADICAL STRAVINSKYITES IN SOFT CAPS"

Diaghilev had long recognized the value of pre-performance publicity in creating excitement around his company. In addition to courting the press and hosting lavish receptions, Diaghilev also opened rehearsals to tastemakers and trendsetters, including "actors, painters, musicians, writers, and the most cultured representatives of society" (Garafola 1989, 292).

The audience on the night of 29 May 1913 when *Le Sacre* premiered at the Théâtre des Champs-Elysées, therefore, was filled with the *beau monde*. Diaghilev had spent years wooing the cultured and cosmopolitan to his enterprises, and now they showed up in force. But the crowd was much more eclectic than merely the beautiful people. And, importantly, even before the performance began, the audience was divided into factions:

> Many were bejeweled ladies from the highest ranks of society, accompanied by men in white tie, the grand music-lovers who had been Diaghilev's earliest supporters in Paris. Others were younger, intellectual and rebellious—refusing to wear stiff collars and tail-coats (which anyway they could not afford) as a mark of their rejection of the traditional and outdated. Although the seats had all been sold, at double the normal price, Diaghilev, seeking support for his radical programme, had given these artists, critics and poets free standing passes, so that inside the theatre they were mingling on foot amidst the boxes occupied by the *gratin*. (Moore 2013, 140)

The different audience factions pursued social dominance in different ways: some espoused strategies of conservation, some strategies of succession, and some strategies of subversion. In this battle in the field of art, some came armed with economic capital, others with cultural capital, but all vying for power of legitimation.

This is remarkably similar to the United States in the nineteenth century

where violence, even riots, attended some cultural events. About the riot at the Astor Place Opera House, Lawrence Levine writes, "The full extent of class feeling and divisions existing in egalitarian America was revealed on a bloody Thursday in May 1894" (1988, 63). Further, Levine argues, "The Astor Place Riot, which in essence was a struggle for power and cultural authority within theatrical space, was simultaneously an indication of and a catalyst for the cultural changes that came to characterize the United States at the end of the century" (1988, 68). The future of culture in the United States would be one of "bifurcation," segregation along class lines.

But the important point is not just that there were *different* factions in the audience the night of the premiere of *Le Sacre*; it is that there were *competing* factions. They were competing over the status of having the position at the top of the French cultural hierarchy. And they were doing so in a climate of status insecurity about French global cultural dominance. Just as there were doubts about French masculinity after the Franco-Prussian War and fears of foreign invasion in the lead-up to World War I, there were also doubts and fears about French cultural superiority. The upstart Americans, after all, had beaten the French in recognizing the genius of the Impressionists, and many of the greatest Impressionist works were now in American hands. And the cultural highlight of Paris had been (for several years running) a troop of Russian foreigners who had taken over a specific artistic form—ballet—that the French considered themselves to have invented and given to the world.

In this situation of feeling an outside attack, there were multiple ways of responding. One was to assert traditional conceptions of good taste; another was to embrace the modern world. People representing both positions were in the audience that night. Each saw the members of the other camp as philistines or barbarians.

One group sneered at the socialites and aristocrats who had started coming to the Ballets Russes performances only once it had become "the thing to do":

Reviewing the 1912 season, critic Louis Laloy described these newcomers to Diaghilev's audience: "Finally, four consecutive seasons of ballets have brought out the noisy mob of the fashionable public who arrive late, whose chatter serves to drown out the orchestra the moment the curtain had fallen, who know neither the titles of the works nor the names of their creators, but who glory in stuffing with their diamonds and pearls the hall of the Châtelet which becomes even more sparkling

than the Opéra for a few evenings, in spite of its ineffaceable dust and its moldy smell of the stable." (Garafola 1989, 292)

In the eyes of the avant-garde, these audience members had high economic capital but little valuable cultural capital. The conflict was between those who saw economic superiority going hand in hand with cultural superiority and those who saw the economic elites as boors with no real cultural understanding. The valuation of whose capital granted elite status—of the right of legitimation—was at stake.

What Astruc called "some radical Stravinskyites in soft caps" (Eksteins 1983, 234) were ready to assert their cultural superiority over the *grand bourgeoisie*. "Many of them were friends and acquaintances, here to defend their bold new work. The grandees, [Diaghilev] knew, were here to be shocked by it" (Moore 2013, 2). Moreover, in the midst of all these status games and status insecurities, anti-foreign sentiment was running high. "A good half of the so-called Parisian audience," wrote Léon Vallas in *Revue française de musique*, "is made up of people who are as foreign to France as they are to art" (Garafola 1989, 297).

The events that were to erupt that night were not just a conflict over a ballet. They were a conflict over the shape of the social hierarchy and a conflict over who would be at the top of the heap. Jean Cocteau remembered:

> All the elements of a scandal were present. The smart audience in tails and tulle, diamonds and ospreys were interspersed with the suits and *bandeaux* of the aesthetic crowd. The latter would applaud novelty simply to show their contempt for the people in the boxes. . . . Innumerable shades of snobbery, super-snobbery and inverted snobbery were represented. . . . The audience played the role that was written for it. (Buckle 2012, 357–358)

Going into the theatre that night, the predominating sentiment was scorn. During the performance, it would turn to rage.

THE RIOT

Diaghilev knew the value of a scandal. For the premiere of *Le Sacre*, he had raised ticket prices, and his publicity blitz had insured a sold-out audience. He prepared his dancers and Pierre Monteux, his conductor, in advance for trou-

ble. "'He entreated the dancers,' said Grigoriev [the Ballets Russes *régisseur*], 'to keep calm and carry on, and asked Monteux on no account to let the orchestra cease playing. 'Whatever happens,' he said, 'the ballet must be performed to the end'" (Kelly 2000, 289). Diaghilev obviously expected something to happen.

Accounts of exactly what did happen that night vary in the details, but the overall picture is consistent. The audience was restless before the performance even started; whistling and isolated laughing seem to have begun with the very first notes of the opening bassoon solo, before the curtain rose on the dancers (Järvinen 2013, 20). Valerian Svetlov, who was there that night, later said, "To me it seems odd that the guffawing began even before the first bars of the prelude, when the audience could not yet have evaluated the work, so that the whole demonstration had the character of being prepared in advance" (Järvinen 2013, 20).

Things quickly escalated to hissing and catcalling. The different factions of the audience attacked or defended the ballet—and each other. Cocteau wrote: "The audience played the role it had to play; it immediately rebelled. It laughed, scoffed, whistled, cat-called, and perhaps might have got tired in the long run if the mob of the esthetes and a few musicians in their excessive zeal had not insulted and even jostled the people in the boxes. The uproar degenerated into a free-for-all" (Kelly 2000, 326). Sergei Grigoriev recalled: "The hubbub soon became deafening; but the dancers went on, and so did the orchestra, though scarcely a note of the music could be heard. The shouting continued even during the change of scene, for which music was provided; and now actual fighting broke out among some of the spectators; yet even this did not deter Monteux from persisting with the performance" (Kelly 2000, 317).

The members of the audience began to attack each other, first verbally and then physically. Monteux recalled, "Neighbors began to hit each other over the head with fists, canes or whatever came to hand" (Kelly 2000, 292). Romola de Pulszky, another member of the audience and a hanger-on who would join the company a few weeks later, wrote:

> One beautifully dressed lady in an orchestra box stood up and slapped the face of a young man who was hissing in the next box. Her escort rose, and cards were exchanged between the men. A duel followed next day. Another Society lady spat in the face of one of the demonstrators. The composer Florent Schmitt shouted at the boxes "*Taisez-vous, les garces du seizième!*" ["Shut up, you 16th arrondissement bitches!" refer-

ring to the wealthy neighborhood in which many of the *gratin* lived.] . . .
A woman called [composer Maurice] Ravel [who was Roman Catholic]
"a dirty Jew." (Buckle 2012, 358)

Either Astruc or Diaghilev ordered the house lights turned repeatedly on and
off to try to quiet the audience, to little avail. There are some reports that gen-
darmes were called during the interval to eject some of the loudest troublemak-
ers, but if so, that measure also failed to have any effect. When the curtain rose
on the second act, the shouting continued. Nijinsky's mother, in the audience
to see her son's work, fainted.

At the conclusion of the performance, the audience—or at least some part
of it—burst into applause. A member of the audience wrote in his diary, "At
the end of the performance . . . a frenetic burst of applause prevailed, so that
Stravinsky and Nijinsky could come out and take their curtain calls, bowing
again and again" (Scheijen 2009, 272). Afterwards, Stravinsky went to a restau-
rant with Diaghilev and Nijinsky. He later recalled, "We were excited, angry,
disgusted, and . . . happy. . . . Diaghilev's only comment was: 'Exactly what I
wanted.' He certainly looked contented" (Hill 2000, 31).

The ballet was performed four times in Paris and three times in London
that season. But although there were occasional minor disturbances, for the
most part the audience was quiet and attentive (Eksteins 1983, 241).

THE REVIEWS

The reviews make clear that the evaluation of *Le Sacre* was often about a battle
for status, using claims of good taste and philistinism—cultural capital—as
weapons. The legitimation of the cultural capital of different class factions was
in question. The Ballets Russes had made its name and become a sensation
among the well-heeled by presenting exotic spectacles filled with gorgeous
scenery and costumes, not to mention the dancers themselves. Attending a
Ballets Russes performance had been a marker of status for some class factions,
especially given the audience Diaghilev had worked so hard to cultivate. For
some, it was high culture without the boring parts: pleasantly titillating and
still refined. *Le Sacre* changed things:

> The riot that broke out . . . seems in retrospect to have been a revolt
> of the snobs; snobs who worried they had suddenly lost their claim on

being the most progressive, the most daring. The same people who flew into raptures at the sight of Mata Hari's glorified stripteases or Nijinsky's masturbating faun were now confronted with a work of art which did not exist merely to affirm the superiority of their refined decadence, but which had the audacity to be taken seriously. And that was a bridge too far. (Scheijen 2009, 270)

The reaction by the majority of the critics was negative. The recurring joke was that the ballet should have been called *Le Massacre du printemps*. Stravinsky's music and Nijinsky's choreography were both mocked and derided. Roerich's sets and costumes were treated even worse: they were mostly ignored. The discussion in the press splintered into many facets. Some commentators blasted the audience for its behavior. In *La France*, Florent Schmitt wrote:

Igor Strawinsky's [*sic*] genius could not receive a more striking confirmation than the incomprehension of the crowd and its vicious hostility. This group of what is called "worldly people" . . . unable to see, hear, and feel for themselves, these overgrown children who are overcome with gravity at the beastly and academic clownings of low boulevard theatre, could find nothing but brutal infantile laughter at these splendors, so immeasurably distant from their weak understanding. (Schmitt 1913, 314)

Gustave de Pawlowski writing in *Comoedia* blamed the disturbance on the "elites," but also on "foreigners and women": "—Where were those slobs brought up? That was the most accommodating thing that was said, among many others, in the course of this elegant and memorable evening. It describes in itself the astonishment one feels at the stupid intentional viciousness of what we are used to calling the Parisian elite, when presented with any really new and bold initiative" (Pawlowski et al. 1913, 308).

Some reviews specifically singled out women and foreigners in the audience as particularly lacking in intelligence and the ability to appreciate the art before them. Others, however, called out the artists for their pretensions, "pretentiousness" being an easy taunt to hurl at those attempting to move towards the autonomous pole. Henri Quittard in *Le Figaro* wrote:

Here is a strange spectacle, of a laborious and puerile barbarity. . . . I know perfectly well that in taking this attitude one risks seeming to be a retrograde spirit closed to any new efforts. It's a risk one needs to

know how to run. . . . *Le Sacre du Printemps* was received rather badly yesterday, and the audience could not restrain its laughter. It would have been in good taste, then, for those who thought differently—and they were not many—to spare the authors a curtain call whose comic impertinence was obvious to all. (Quittard 1913, 307–308)

Even some of the Ballets Russes admirers complained that *Le Sacre* was too intellectual and too abstruse. "Despite her loyalty to Vaslav, Lady Ottoline Morrell thought *Sacre* 'really *terrible* and intense. Too much of Idea in it to please the public. Too little grace'" (Moore 2013, 148–149).

In *Gil Blas*, Georges Pioch wrote:

I must persist in thinking what a pity it is that M. Nijinsky, who is such a good dancer and jumps better than anyone, should one day have discovered he was a genius—like everyone else in the theatre in these years of plenty. His experiments hitherto have been damaging to the Russian Ballet; and we cannot forget all the marvelous creations this company have given to us were the work of M. Fokine, who was content to be a choreographer. (Buckle 2012, 361–362)

The dominant theme of the reviews picked up on the images of the barbarians that had been part of the Ballets Russes reputation from the beginning. In *Le Figaro*, Alfred Campus used explicit metaphors of war and invasion:

This time the Russian barbarians, led by Nijinsky, "a sort of Attila of the dance," really went too far. They were booed and they reacted with surprise. It seems that they are not at all aware of the customs and practices of the country they are imposing on, and they seem ignorant of the fact that we often take energetic measures against absurd behaviour. An accord could, however, perhaps be negotiated with the Russians. Nijinsky would have to agree not to stage any more ballets which aspire to a level of beauty inaccessible to our feeble minds, and not to produce any more three-hundred-year-old "modern" women, or little boys feeding at breasts, or for that matter even breasts. In return for these concessions we would continue to assure him that he is the greatest dancer in the world, the most handsome of men, and we would prove this to him. We would then be at peace. (Eksteins 1983, 244)

Some reviewers connected Nijinsky and, especially, Stravinsky to the art forms of racial and ethnic groups whom they considered "primitive." André Levinson, for example, called Stravinsky's score "Hottentot music" (Järvinen 2013, 15). But the most extended claim of barbarianism came from Adolphe Boschot in *Echo de Paris*:

They want to show us the dances of prehistoric Russia: so they present us, to *make primitive*, dances of savages, of the Caribees and the Kanaks. . . . So be it, but it's impossible not to laugh. Imagine people decked out in the most garish colors, pointed bonnets and bathrobes, animal skins or purple tunics, gesturing like the possessed, who repeat the same gesture a hundred times: they stamp in place, they stamp, they stamp, they stamp, and they stamp. . . . Suddenly: they break in two and salute. And they stamp, they stamp, they stamp. . . . Suddenly: a little old woman falls down headfirst and shows her underskirts. . . . And they stamp, they stamp. . . . [I]n the apparent desire to *make primitive*, prehistoric, [Stravinsky] has worked to *make his music like noise*. For that, he set to work to destroy any impression of tonality. . . . And this savage music, for a half an hour, accompanied by the dances of the Caribees. (Boschot 1913, 305–306; italics in original)

Other reviewers continued the barbarian theme but saw it in a more positive light. Jacques Rivière, who had championed the Impressionists decades earlier, wrote:

By breaking up movement, by returning to the simplicity of gesture, Nijinsky has restored expressiveness to dancing. All the angularities and awkwardness of this choreography keep the feeling in. . . . At first sight it seems less skillful, less varied, less intelligent. Yet, with its wholesale displacements, its sudden turns-about, the way it comes to rest only to begin a frantic trembling on the spot, it says a thousand times more than the long-winded, facile, charming chatter of Fokine. . . . If we can but stop associating grace with symmetry and *arabesques*, we shall find it everywhere in "Le Sacre du printemps." (Buckle 2012, 355)

Another notice in *Le Figaro* said:

Le sacre du printemps . . . is the most surprising realization that the admirable troupe of M. Serge de Diaghilew [*sic*] has ever attempted. . . . One will find there the strongly stylized characteristic attitudes of the Slavic race with an awareness of the beauty of the prehistoric period. The prodigious Russian dancers were the only ones capable of expressing these stammerings of a semi-savage humanity, of composing these frenetic human clusters wrenched incessantly by the most astonishing polyrhythm ever to come from the mind of a musician. There is truly a new thrill which will surely raise passionate discussions, but which will leave all true artists with an unforgettable impression. (Kelly 2000, 263)

A few reviewers, even while negatively assessing the ballet itself, recognized that it was ahead of its time. Léon Vallas in *Revue française de musique* wrote:

M. Strawinsky's [*sic*] entire score, of a startling richness and a rare originality, seems to be the result of a wager. Carried away in the ardor of his youth, no doubt with complete sincerity, the composer with an impetuous energy has leaped forward, burned his bridges and offered us this year the music that we should hear around 1940. Heard thirty years later, his music would not have provoked in the well-intentioned amateur this resistance which, while recognizing the innovator's genius, they could not resist. So the score of *Le Sacre du Printemps* is a premature specimen of the music of the future? (Vallas 1913, 316–317)

Stravinsky himself recognized this. He wrote that summer to Maximilian Steinberg: "Nijinsky's choreography is incomparable. Everything is as I wanted it, with very few exceptions. But we must wait a long time before the public grows accustomed to our language" (Buckle 2012, 371). The social insecurities that the premiere performance of *Le Sacre* dramatized were so intense that a dispassionate appraisal of the art *as* art would have to wait. In the meantime, *Le Sacre* disappeared.

"REBELLION IS INDISPENSABLE IN ART"

Le Sacre was performed four more times in Paris that summer and then three times in London, with very little disturbance. Then the company—minus Diaghilev, who stayed behind in Paris— left for a tour of South America. With

them in the corps went a novice Hungarian dancer named Romola de Pulszky. In a move that shocked everyone, she and Nijinsky were married in Buenos Aires on 10 September 1913. When Diaghilev got the news, he fired Nijinsky and dropped all of his ballets from the company's repertoire. When the company tried to revive *Le Sacre* after World War I, no one could remember the choreography.

But the reverberations from *Le Sacre* continued for decades, establishing Nijinsky as "one of the most important choreographers in the history of ballet" (Ostwald 1991, 67) Nijinsky had captured with dance the essence of the new century. Sarah Kennel argues that "*Le Sacre* . . . rang the death knell for the 'long nineteenth century,' and declared modernism, raw in form and brutal in impact, as its successor" (2005, 4).

Nijinsky was penniless after his break from Diaghilev and country-less after the Russian Revolution. He led an itinerant life with his wife and, eventually, two daughters and was increasingly beset by mental illness—probably schizophrenia. He was first placed in a sanitarium in Switzerland in 1919 and was in and out of mental institutions until his death in 1950. He had not danced in public in thirty years by then.

Diaghilev died of diabetes in Venice in 1929, and the Ballets Russes folded up. But Stravinsky went on to a long and extraordinary career, profoundly influencing all types of music of the twentieth century:

> Jazz musicians sat up in their seats when Stravinsky's music started playing: he was speaking something close to their language. When Charlie Parker came to Paris in 1949, he marked the occasion by incorporating the first notes of the *Rite* into his solo on "Salt Peanuts." Two years later, playing Birdland in New York, the bebop master spotted Stravinsky at one of the tables and immediately incorporated a motif from *Firebird* into "Koko," causing the composer to spill his scotch in ecstasy. (Ross 2007, 92)

The Ballets Russes influence was deeply felt throughout the art world and beyond for a long time to come, not merely as an aesthetic but also as a way of being an artist—an attitude towards being in the modern world. Jean Cocteau wrote, "It was when I knew Stravinsky, and later, when I knew Picasso, that I understood that rebellion is indispensable in art, and that the creator always rebels against something if only instinctively" (Garafola 1989, 98).

The physical violence that erupted among the audience members on the night that *Le Sacre* premiered might seem disproportionate in response to a ballet, no matter how groundbreaking. Disproportionate also that a duel, that archaic and possibly deadly form of preserving honor, would be fought over it. But honor, not only of the individuals involved, but of entire factions of the society was indeed at stake. The social upheavals that are the most characteristic attribute of modernity, ushered in during the age of revolutions, existed in homologous relations with the field of art. The battle was for the right of legitimation—not only of high culture but also of high status in the larger society. Even with regard to geopolitics, the status of France among the other nations of the globe was in question. If French culture could maintain global hegemonic dominance, France could be secure in its position. With World War I looming, the place of France as a nation in the new global hierarchy was uncertain. And the connection between this ballet and the violence of war did not go unnoticed. After the end of World War I, painter Jacques-Émile Blanche wrote, "Often during the scientific, chemical 'cubist' war, on nights made terrible by air-raids, I have thought of *Sacre* . . ." (Eksteins 1983, 228).

"Damnable, Hellish Filth from the Gutter of a Human Mind"

James Joyce's Ulysses

In February 1921, the New York Court of Special Sessions ruled that portions of James Joyce's modernist novel *Ulysses* were obscene and therefore prohibited for sale or distribution. Post office officials, under the direction of John Sumner, head of the New York Society for the Suppression of Vice, then took seized copies of *The Little Review*, a small literary magazine published in Greenwich Village that was serializing *Ulysses*, to the official government incinerator and had them burned.

"OBSCENE, LEWD, OR LASCIVIOUS"

By most accounts, Joyce began seriously working on *Ulysses* in 1914. He struggled with the manuscript, having to create innovative form and language in order to express his ideas. *Ulysses* is set in Dublin on 16 June 1904. It follows Leopold Bloom, who works selling newspaper advertisements, through his day. *Ulysses* is one of the most extended uses of stream of consciousness and interior monologue in English literature. Part of Joyce's aim was to write how people actually think, refusing to draw a veil of decency over even the unsavory parts of the human consciousness.

The uncompromisingly experimental nature of Joyce's writing left many readers baffled, but led others, who were able to decode its intricacies, to see it

as a work of genius. In a long essay in *Nouvelle Revue Française*, Valéry Larbaud tried to explicate the text—or at least plead for it—to a bewildered audience:

> [T]he author has never lost sight of the humanity of his characters, of their whole composition of virtues and faults, turpitude, and greatness; man, the creature of flesh, living out his day. All this is what one finds in reading *Ulysses*. . . . His intention is neither salacious nor lewd; he simply describes and represents; and in his book the manifestations of sexual instincts do not occupy more or less place, have neither more nor less importance, than such emotions as pity or scientific curiosity. (Larbaud 1922, 261–262)

Larbaud had to assure his audience that *Ulysses* was "neither salacious nor lewd" because by the time *Ulysses* was published in book form, it had already been banned as obscene in the United States and the ban would soon extend to the entire English-speaking world.

Joyce's first major work, *Dubliners*, a set of short stories, had been published in 1914, nine years after Joyce had first sent his manuscript out. The London publishing house of Grant Richards initially agreed to publish the book but pulled out of their agreement after the printer refused to set the work in type, objecting to the use of language (like the word "bloody") and the tawdry realism of some of the stories. Joyce persisted, submitting the manuscript to publisher after publisher, only to face the same difficulties. Joyce's patron, Harriet Shaw Weaver, and his literary supporter, Ezra Pound, worked tirelessly to find printers who were willing to set Joyce's scandalous works in type. By then, Weaver had plans to publish *Ulysses*, still a work in progress, herself. But again English printers refused to set the type based on the sections that Weaver showed them. The problem was not merely one of squeamishness; it was a legal one: the Hicklin Rule.

The Hicklin Rule was based on an 1868 English court case, *Regina v. Hicklin*. In that case, Chief Justice Cockburn ruled that material could be deemed obscene, regardless of the intent of the maker, if there was a "tendency . . . to deprave and corrupt those whose minds are open to such immoral influences, and into whose hands a publication of this sort may fall" (Birmingham 2014, 168). In effect, this meant that a publication was obscene if it might possibly be corrupting to any "open" mind, especially the mind of a child, young person, or the poorly educated (such as immigrants). Claims of artistic or literary in-

tentions by the creator were ruled irrelevant. The protection of a potentially vulnerable reader was paramount.

In the United States, the Hicklin Rule was codified into the Comstock Act of 1873. The law was a sweeping one. Kevin Birmingham writes that it banned

> any "obscene, lewd, or lascivious book, pamphlet, picture, paper, print or other publication of an indecent character" as well as anything intended to prevent conception or induce abortion. And it wasn't just illegal to mail indecent things. It was illegal for anyone—even a doctor—to mail information *about* indecent things. Advertisements for condoms, for example, or instructional manuals explaining how to use a condom (or what a condom *is*) were now criminal if sent through the mail, whether in a magazine or a private letter. (Birmingham 2014, 112; italics in original)

Punishments for breaking the law included heavy fines and long prison sentences. The law was named for Anthony Comstock, an anti-vice crusader and the founder in 1873 of the New York Society for the Suppression of Vice (NYSSV). Comstock was appointed as a special inspector for the post office, charged with ferreting out any obscene literature being distributed anywhere in the United States and arresting those responsible.

His postal duties spanned the entire country, but closer to home in New York, Comstock devoted his energies to the NYSSV as a further vehicle for rooting out obscenity. The NYSSV was not just an organization, it was a crusade. The society was backed by many members of the New York upper class who believed it might be a way to control the waves of immigrants coming into New York City, whom the established elite feared as political agitators and cultural contaminants. A changing social landscape was mirrored in a changing cultural landscape.

Comstock engaged the fears of the elites that a changing culture was an attack on their ideals, their values, and—especially—their children (Beisel 1993, 156). Nicola Beisel writes, "To justify art censorship, Comstock (1887) declared that young men might fall prey to prostitutes once they had been aroused by libidinous art. Thus art, rather than symbolizing refinement of the elite, threatened its dissolution" (1993, 156). Comstock and the members of the NYSSV feared that immigrants in the rapidly growing cities spawned by the Industrial Revolution would bring with them unacceptable ideas, values, and

practices and that their own children would fall prey to these negative influences. Comstock proclaimed: "The object of the law was to protect *public morals*, especially of that class of the community whose character is not so completely formed as to be proof against the lewd effects of pictures, photographs, and publications prohibited" (Beisel 1993, 156; italics in original). By "that class of community," Comstock meant the working class, especially the immigrant working class. He imagined the immigrants as riddled with vice, most especially the vice of lust, Comstock's obsession. Obscenity, Comstock believed, incited lust, the root of all evil. It must be suppressed for the sake of the community, especially to protect women and children from its pernicious influence. But how do we decide what is obscene?

DEFINING OBSCENITY

The Comstock Act added to the list of descriptors laid out in the Hicklin Rule to include anything "obscene, lewd, lascivious, filthy, disgusting, or indecent." The welter of adjectives highlights a fundamental uncertainty at the heart of the law. Piling up long strings of words did not hide the fact that each of those words, no matter how many there were, was a subjective judgment. By what rule do we decide if something is indecent? How is that different from what is lewd? Or is it? And, more importantly, who decides on that interpretation? Judges in obscenity cases were to simply know it when they saw it.

But the Hicklin Rule and the Comstock Act further complicated this matter by decreeing that it was not the judges who would somehow feel the obscenity: it was an imagined other audience who was theoretically open to corruption.

> A single word in the Hicklin Rule . . . dramatically expanded judges' authority by making censorship a preemptive activity. Publishers, booksellers, printers and writers were liable not just for corrupted readers but for a publication's "*tendency*" to corrupt. By focusing on a book's hypothetical effects of hypothetical readers, the Hicklin Rule made an obscenity judgment a feat of the imagination—for certainly the judge himself was above such "immoral influences." Rather, it was his task to determine whether the book could deprave someone entirely unlike him. (Birmingham 2014, 169–170; italics in original)

There was an element of social sorting here. While the outrage over the Brontës' works was about who wrote them—specifically, about the genders of the authors—the Comstock Act was instead about who read it, the type of person who could form an audience for the work. The obscenity of a text, in effect, depended on who might read it. While a book might not deprave a learned and sophisticated reader, it might corrupt one who was not sufficiently prepared to encounter it by virtue of age, education, or background.

There was a decided class element in these deliberations. If children were particularly susceptible to the degenerating influences of obscenity, another group was even more worrisome—the immigrant working class:

> Comstock argued that upper-class people, having the requisite culture to appreciate the artistic merits of nudes [and other potentially obscene cultural works], saw such paintings differently. A painting might be obscene when viewed by a working class person, but was a work of art when viewed by a wealthy person. . . . High art was distinguished from obscenity solely by the "culture" (social class) of the persons who viewed it. (Beisel 1993, 151)

Censorship was bound up with social control in rapidly urbanizing societies where traditional mores no longer held sway and where diverse populations mingled more frequently. "Censorship wasn't just about sex. It was about preserving a tenuous public order" (Birmingham 2014, 174). The idea was that enforcing morality in urban life would control a population that seemed increasingly out of control. The punishment of moral transgressions would shore up the old collective conscience that would provide a foundation for social order and solidarity that seemed to be rapidly disintegrating. Lawrence Levine argues that culture in the United States beginning in the nineteenth century was enmeshed in debates about social control and public order, especially as racism around immigration mounted:

> But if order was a necessary prerequisite for culture it was also one of culture's salutary by-products. If without order there could be no pure culture, it was equally true that without culture there could be no meaningful order. In late nineteenth-century thought the two were so intricately interwoven . . . that they could not be easily distinguished. It is important to recognize the degree of tension in this relationship,

which led the arbiters of culture on the one hand to insulate themselves from the masses in order to promote and preserve pure culture, and on the other to reach out to the masses and sow the seeds of culture among them in order to ensure civilized order. (Levine 1988, 206)

This connection between the moral order and the political order in the city would play out in the NYSSV actions against *Ulysses* as waves of foreign immigrants into the major cities brought with them radical political and social ideas to add to the demographic chaos. "The Red Raids fed information to an obscure new wing of the Bureau of Investigation (the precursor to the FBI) called the General Intelligence Division. Wherever its agents went, they confiscated files, books, newspapers and magazines connecting radicals across the country in a community of words (the Communist Party alone had twenty-five newspapers). Bookshops were hubs of subversive activity" (Birmingham 2014, 156). Literature was the vector by which these unsettling ideas would spread through an already unsettled population. If bookshops were hubs of subversive activity, the "little magazines" of the era were the source that put the dangerous ideas into print.

THE LITTLE REVIEW

"Little magazines" were independently published periodicals where non-commercial art and literature could find an audience. They were the first places avant-garde writing found a home. "The little magazines of the twenties and thirties sponsored every literary movement—Dadaism, Vorticism, Surrealism, and the Revolution of the Word—and published the early work of the century's best writers. . . . These magazines served primarily as nurturers of art and secondarily as forums for the evaluation of this modern art" (Fitch 1983, 61). These were the agents pursuing subversive strategies in the literary field, sitting at the autonomous pole of art for art's sake. Their project was, at its core, to bring forth culturally revolutionary work into the public sphere.

Because the little magazines appealed only to a small and select group of readers, distribution could be problematic. In only a few cities—such as Paris and New York—were there enough interested readers concentrated in one place to make selling the little magazines at a bookstore practical. Otherwise, the magazines were distributed to their far-flung readers by post. In the United States, low postal rates for printed material made it possible, just barely, to mail

the magazines to readers and, if not turn a profit, at least not sink disastrously under the costs of distribution. This meant that distribution was at the mercy of post office regulation.

The Little Review was a little magazine produced in New York's Greenwich Village by Margaret Anderson and Jane Heap. Like other little magazines, it was not just artistically avant-garde but politically edgy as well. Specifically, *The Little Review* was a supporter of the anarchist Emma Goldman and published her writing calling for the masses to overthrow both capitalism and the U.S. government. As early as 1915, *The Little Review* had come to the attention of U.S. authorities as a subversive publication.

In late 1917, Ezra Pound sent Anderson and Heap the first three chapters of *Ulysses*, urging them to begin serial publication of Joyce's still unfinished novel in *The Little Review*. In her memoir, Anderson wrote of *Ulysses*: "'This is the most beautiful thing we'll ever have, I cried. We'll print it if it's the last effort of our lives.' James Joyce's 'Ulysses' began in the *Little Review* in March, 1918. We ran it month after month for three years and four times the issues containing it were burned by order of the United States Post Office, because of alleged obscenity" (Beja 1992, 73–74). So beginning in March 1918, portions of the still unfinished *Ulysses* began to appear in public.

While Anderson may have found it to be beautiful, others disagreed. Letters began to pour into their office. A reader from Chicago, for example, wrote:

> Damnable, hellish filth from the gutter of a human mind born and bred in contamination. There are no words I know to describe, even vaguely, how disgusted I am; not with the mire of his effusion but with all of those whose minds are so putrid that they dare allow such muck and sewage of the human mind to besmirch the world by repeating it—and in print, through which medium it may reach young minds. Oh my God, the horror of it. . . . It has done something tragic to my illusions about America. How could you? (Birmingham 2014, 189)

Scandalized Chicagoans were only one problem. *The Little Review*, like all little magazines, depended on the post office for distribution, and the Comstock Act empowered the post office to seize and burn anything it decided was obscene. The post office censors were keeping an alert eye on *The Little Review*—banning it from the mail and burning seized copies. Issues of *The Little Review* containing Joyce's writing were having an increasingly hard time making it to the reading public. Then the ax fell.

Under pressure from the NYSSV, in 1920 the New York district attorney charged Margaret Anderson and Jane Heap with obscenity. Joyce's publishers now faced the very real possibility of prison sentences.

PEOPLE V. ANDERSON AND HEAP

In January 1920, Prohibition began in the United States. It was a high point for the suppression of unsanctioned behavior of all kinds. The Palmer Raids happened that same month, aimed at rooting out political subversives (following the Russian Revolution in 1917 that stoked fears that something similar could happen in the United States). Thousands of suspected radicals, including Emma Goldman, were rounded up in cities all over the country. Many immigrants were deported.

In April 1920, two Italian immigrants with ties to anarchist circles, Nicola Sacco and Bartolomeo Vanzetti, were charged with the politically motivated murder of a Boston area paymaster. As with the Dreyfus case in France, their arrest, trial, and eventual execution would spark an international uproar over questions about the real reasons behind the charges. Moreover, the Nineteenth Amendment, guaranteeing women the vote, also became law in 1920, causing social conservatives, including John Sumner, the head of the NYSSV, to worry about deleterious effects on family life and social stability. There were clear connections between charges of obscenity and social power:

> When the Nineteenth Amendment to the U.S. Constitution seemed poised to become law in 1920, guaranteeing women the right to vote, Sumner warned that "radical feminists" wanted to establish separate, antagonistic powers. They wanted the government to legitimize children born out of wedlock, which would encourage pregnant women to remain unmarried and give birth to "promiscuous children"—the nation's home life would crumble. At the moment, such women were marginal, he said, "but they are shrewd, and one finds them writing insidious and widely read books on the freedom of the modern woman, and advocating still greater sex freedom." (Birmingham 2014, 160)

Also in January 1920, the U.S. Post Office denied mailing privileges to *The Little Review* because of the excerpt of *Ulysses* that ridiculed the late Queen Victoria and her son King Edward. Paul Vanderham writes, "Internal evidence would seem to support Jane Heap's contention that the episode was suppressed

because of Joyce's 'disrespect for Victoria and Edward'—not to mention their empire" (1998, 34). The specific passage cited pokes fun at the English monarchy in banter among the lunchtime patrons in Davy Byrne's pub:

> — And as for the Prooshians and the Hanoverians, says Joe, haven't we had enough of those sausageeating bastards on the throne from George the elector down to the German lad and the flatulent old bitch that's dead?
>
> Jesus, I had to laugh at the way he came out with that about the old one with the winkers on her, blind drunk in her royal palace every night of God, old Vic, with her jorum of mountain dew and her coachman carting her up body and bones to roll into bed and she pulling him by the whiskers and singing him old bits of songs about *Ehren on the Rhine* and come where the boose is cheaper.
>
> — Well, says J.J. We have Edward the peacemaker now.
>
> — Tell that to a fool says the citizen. There's a bloody sight more pox than pax about that boyo. Edward Guelph-Wettin!
>
> — And what do you think, says Joe, of the holy boys, the priests and bishops of Ireland doing up his room in Maynooth in His Satanic Majesty's racing colours and sticking up pictures of all the horses his jockeys rode. The earl of Dublin, no less.
>
> — They ought to have stuck up all the women he rode himself, says little Alf.
>
> And says J.J.:
>
> — Considerations of space influenced their lordships' decision. (Joyce [1922] 1986, 271)

Vanderham's analysis of the specific passages cited by prosecutors in the obscenity trials indicates that the objections to *Ulysses* were as much about politics as they were about sex:

> Hitherto unexamined US Post Office records reveal that the motives behind the postal suppressions were not only moral but political. The Post Office's "List of Periodicals, Pamphlets, Circulars, Etc., Held to Be Non-Mailable, January 18, 1918," for example, identifies *The Little Review* as "a Publication of Anarchistic tendency." . . . The presence in the Post Office's file on the October 1917 suppression of *The Little Review*—classed, incidentally, under the rubric of "Subversive Litera-

ture, WWI"—of documents pertaining to the alter suppressions of *Ulysses* suggests that government authorities must have read Joyce's novel as a supreme example of literary bolshevism. (Vanderham 1998, 6)

The confiscated copies of the issue of *The Little Review*, therefore, were duly burned.

Then in September 1920, Sumner went to the Washington Square Book Shop and bought several copies of the July–August issue of *The Little Review*. The issue contained a passage of *Ulysses* known as "Nausicaa" in which Leopold Bloom walking on the beach observes Gerty MacDowell sitting with friends, watching fireworks. Gerty, knowing that Bloom is watching her, deliberately lets him glimpse her underwear, while singing from a nearby church can be heard. Bloom surreptitiously masturbates in his pants.

Moreover, Joyce makes clear that Gerty knew all about what was happening. In fact, in Sumner's view, Gerty's lack of innocence and her teasing recognition of Bloom's attention were more troubling than any other part of the passage. Gerty, as well as Bloom, was a depraved mind and her depravity could infect the open minds of innocent readers. The NYSSV position was that Gerty was the vector of contamination into the "open" minds of the susceptible that the anti-vice crusaders feared. Just reading about her might cause young girls to become like her. The NYSSV issued a complaint that the issue was obscene. Anderson and Heap were charged with publishing obscenity and came up for trial in the Court of Special Sessions on 14 February 1921.

They were defended by a New York attorney, John Quinn. Quinn's defense of *Ulysses* rested on three intertwined arguments. The first was that only depraved minds would see the art as obscene. The second was that the writing could not be obscene because it was incomprehensible. The third was that rather than being titillating, the book was enraging. The charges against *Ulysses* were that not only was the book obscene, but it was politically subversive.

The judges ruled that expert opinions from literary scholars and critics were not admissible in *Ulysses*'s defense. The issue of morality was not one of artistic merit, but of the effect on the unsophisticated and impressionable. Excluding expert opinions delegitimated the cultural capital of scholars and critics, removing aesthetic considerations from the discussion. The trial was not fought in the field of art but in the field of morality. The autonomous pole of that field was not controlled by artists, scholars, and critics but by moral entrepreneurs. The judges' decision was not just about what evidence would be allowed, but

about in what field the battle would be fought. Given the situation, it is no wonder that Quinn lost his argument. Anderson and Heap were convicted and were each fined fifty dollars, a much larger sum then than now.

> It was understood that the publication of *Ulysses* would be discontinued, and Quinn had to certify that the *Nausicaa* episode was the worst in the book to save his clients from being sent to prison. When they had left the courtroom Quinn said, "And now for God's sake don't publish any more obscene literature." "How am I to know when it's obscene?" asked Margaret Anderson. He replied, "I'm sure I don't know, but don't do it." (Ellmann 1982, 503)

Anderson's question went straight to the point: there was no clear definition of obscenity: it rested in the eye of the beholder, a social eye that no longer shared a collective conscience. And determining from this multiplicity of eyes whose, specifically, would *legally* judge a text was a fight over whose judgments, values, and ideals would prevail in the new society. As of 21 February 1921, *Ulysses* was effectively banned from the United States.

SYLVIA BEACH

Sylvia Beach was the American expatriate owner of Shakespeare and Company, an English-language bookstore and lending library that she had opened on Paris's Left Bank in November 1919. Joyce and his family had moved to Paris in July 1920. He and Beach met at a party that same month and became friends, with Joyce coming frequently to Shakespeare and Company.

Joyce was continuing to work on the manuscript for *Ulysses* and was facing challenges not only with crafting his monumental work, but even with such supposedly mundane details as having it typed. Printers, just like the publishers and the booksellers, were liable for prosecution under the obscenity laws and could have faced prison time and hefty fines in both England and the United States. Because of the court decision in *The Little Review* trial, *Ulysses* had been declared obscene in the United States even before Joyce had finished writing it. British courts would soon follow suit. Publishers and printers pulled away from the book. Although she had no experience with publishing, Beach agreed to publish *Ulysses*, having it printed under the Shakespeare and Company label, soliciting orders before publication with the promise to mail the book to the subscribers when it came out.

Beach hired the printer Maurice Darantière, located in Dijon, to print the book. The technicians who worked for him spoke no English, which meant that there were no worries about them being scandalized by what they were setting in type. But it also meant that an extraordinarily large number of typographical errors showed up in the text. The first copies were ready on 2 February 1922. Beach's biographer described:

> Sylvia . . . placed her own copy—with its Greek blue cover and white lettering—in the window. There it was "unfurled," cheered one English resident of Paris, "like the flag of freedom on the Left Bank." Sylvia and her subscribers, who had been coaxed to pay for the book in advance of publication, knew that this was a book that would change the course of fiction. "In Sylvia Beach's bookshop," claims Cyril Connolly, "*Ulysses* lay stacked like dynamite in a revolutionary cellar." One young American in Paris confessed, "It bursted over us like an explosion in print[,] whose words and phrases fell upon us like a gift of tongues, like a less than holy Pentecostal experience." (Fitch 1983, 14)

CLASS, SEX, RELIGION, POLITICS... AND ART

Reviews were slow in coming in—not surprisingly, given the length and complexity of the text. One of the first was Sisley Huddleston's in the *Observer* on 5 March 1922. It immediately captured one of the perplexing confluences of the book: the tie between ugliness and beauty. Of Molly Bloom's final monologue, ending with the words "yes I said yes I will Yes," he wrote: "There is one chapter devoted to the reverie of a woman, and her *monologue intérieur* is, I imagine—and am bound in all honesty to say—the vilest, according to ordinary standards, in all literature. And yet its very obscenity is somehow beautiful and wrings the soul to pity. Is that not high art?" (Huddleston 1922, 216).

But many other reviewers saw only the vileness, taking exception to the obscenity not only in itself but also along specifically class-based lines. In a moderately positive review in the European edition of the *Chicago Tribune*, George Rehm echoed the ideas of the Hicklin Rule and the Comstock Act—that texts were more dangerous to some classes of readers than to others and that one's reaction to them perhaps said more about the reader than about the work in itself: "One thing to be thankful for is that the volume is a limited edition, therefore suppressed to the stenographer or high school boy" (1922, 212).

Instead of the class of the readers, the reviewer for *The Carnegie Magazine* questioned Joyce's own class background: "The book seems to us to be the output of the mind of a stableboy, trained amid the lowest habits of speech and conduct" (S. H. C. 1934, 243).

Lawrence K. Emery, writing for *Claxon,* gave a positive review that specifically defended *Ulysses* against charges of obscenity on the basis of its artistic merit ("One might as well label the Venus de Milo indecent"). But although he recognized the "genius," he felt that there were certain groups of people who should not be exposed to Joyce's particular brand of genius: "*Ulysses* is essentially a book for the male. It is impossible for a woman to stomach the egregious grossness. Through the book one hears the coarse oaths and rude jests of the corner-boy and the subtle salaciousness of the cultured" (Emery 1923, 295).

Along with class-based critiques, there were also numerous explicit connections to the supposed leftist politics of the book. In March, S. P. B. Mais wrote in the *Daily Express,* "Reading Mr. Joyce is like making an excursion into Bolshevist Russia: all standards go to the board" (Mais 1922, 191). In *The Quarterly Review,* Shane Leslie echoed, "Here we shall not be far wrong if we describe Mr. Joyce's work as literary Bolshevism. It is experimental, anti-conventional, anti-Christian, chaotic, totally unmoral" (Leslie 1922b, 207). The literary freedom that Joyce took shocked some reviewers; his rule-breaking writing seemed almost menacing. In April, John M. Murray wrote in *Nation & Athenaeum*: "He is the egocentric rebel *in excelsis,* the arch-esoteric. European! He is the man with the bomb who would blow what remains of Europe into the sky. But he is so individual that very few people will know when the bomb has exploded. His intention, so far as he has any social intention, is completely anarchic" (Murray 1922, 196).

Critics found a connection between anarchist politics and perceived anarchy of form. Over and over, reviewers complained that the book was simply incomprehensible. Implicit in many of the reviews was a sneering dismissal of the intellectual posturing that these critics suspected of Joyce. In April Arnold Bennett wrote in *Outlook*:

James Joyce sticks at nothing, literally. He forbids himself no words. He says everything—everything. The code is smashed to bits. . . . He apparently thinks there is something truly artistic and high minded in playing the lout to the innocent and defenseless reader. As a fact, there isn't. In playing the lout there is something low minded and inartistic.

Ulysses would have been a better book and a much better appreciated book, if the author had extended to his public the common courtesies of literature. After all, to comprehend *Ulysses* is not among the recognized learned professions, and nobody should give his entire existence to the job. (Bennett 1922, 220–221)

In *The Quarterly Review*, Shane Leslie decried the "deliberate bamboozlement of the reader. . . . French and possibly American critics will utter their chorus of praise in proportion to their failure to understand" (1922b, 210–221). As with the Ballets Russes, charges of pretentiousness were meant to derail agents in the cultural field as they pursued a trajectory towards the autonomous pole.

But others seemed to have no trouble understanding Joyce's writing. The meaning of the passages was clear to them, and they were outraged at the sexual content they saw. Alfred Noyes wrote in the *Sunday Chronicle*: "It is simply the foulest book that has ever found its way into print. . . . The writing of the book is bad simply as writing, and much of it is obscure through sheer disorder of the syntax. But—there is no foulness conceivable to the mind of madman or ape that has not been poured into its imbecile pages" (Noyes 1922, 274). Many critics accused Joyce of being worse than "heathen." In May, Joseph Collins wrote in the *New York Times Book Review*: "Mr. Joyce has seen fit to use words and phrases that the entire world has covenanted and people in general, cultured and uncultured, civilized and savage, believer and heathen, have agreed shall not be used, and which are base, vulgar, vicious and depraved" (1922, 223). The *Sporting Times* reviewer wrote, "The main contents of the book are enough to make a Hottentot sick" (Aramis 1922, 193).

The book was objectionable not only on the basis of its frank depictions of the vulgar, the scatological, and the sexual, but also because by making light of the church, it was perceived as blasphemous. In May, James Douglas wrote in *the Sunday Express*:

I say deliberately that it is the most infamously obscene book in ancient or modern literature. . . . All the secret sewers of vice are canalized in its flood of unimaginable thoughts, images and pornographic words. And its unclean lunacies are larded with appalling and revolting blasphemies directed against the Christian religion and against the name of Christ—blasphemies hitherto associated with the most degraded orgies of Satanism and the Black Mass. (Birmingham 2014, 219–220)

Again from *The Quarterly Review*, "From any Christian point of view this book must be proclaimed anathema, simply because it tries to pour ridicule on the most sacred themes and characters in what has been the religion of Europe for nearly two thousand years" (Leslie 1922b, 209). In the *Dublin Review*, the same critic called for the book to be banned by the Office of the Inquisition of the Catholic Church:

> In this work the spiritually offensive and the physically unclean are united. We speak advisedly when we say that though no formal condemnation has been pronounced, the Inquisition can only require its destruction or, at least, its removal from Catholic houses. . . . Having tasted and rejected the devilish drench, we most earnestly hope that this book be not only placed on the *Index Expurgatorius*, but that its reading and communication be made a reserved case. (Leslie 1922a, 201)

But others, coming to Joyce's supposed defense, declared literature itself harmless. That July, Mary Colum wrote in *Freeman*: "Some attempt is being made by admirers to absolve Joyce from accusations of obscenity in this book. Why attempt to absolve him? It is obscene, bawdy, corrupt. But it is doubtful that obscenity in literature ever really corrupted anybody" (Colum 1922, 234). This went against the very basis of the Hicklin Rule, but trivializing *Ulysses* was not Joyce's preferred defense.

Some critics worried about the influence Joyce would have on other writers, how this work would reshape the literary field. Richard Aldington, in a review entitled "The Influence of Mr. James Joyce," wrote:

> *Ulysses* is more bitter, more sordid, more ferociously satirical than anything Mr. Joyce has yet written. It is a tremendous libel on humanity. . . . [Joyce's] influence, which I dare to prophesy will be considerable, cannot be a wholly good one. He is disgusting with a reason. He is obscure and justifies his obscurity; but how many others will write mere confusion and think it sublime? How many dire absurdities will be brought forth, with *Ulysses* as midwife? (Aldington 1921, 188)

Other critics, however, saw the influence Joyce would have on literature and welcomed it. The artistic freedom that Joyce claimed for himself would now be available to others. In *The Nation*, Gilbert Seldes wrote:

I have called Joyce formidable because it is already clear that the innovations in method and the developments in structure which he has used with a skill approaching perfection are going to have incalculable effect upon the writers of the future; he is formidable because his imitators will make use of his freedom without imposing upon themselves the duties and disciplines he has suffered; I cannot see how any novelist will be able (nor why he should altogether want) entirely to escape his influence. (Seldes 1922, 238)

Many writers were enthusiastically positive and were influenced by what they read:

F. Scott Fitzgerald . . . gave Sylvia Beach a copy of *The Great Gatsby* when he met her, and inside the front cover he drew a picture of himself kneeling beside Joyce, who was rendered as a pair of oversized spectacles beneath a halo. Fitzgerald got his copy of *Ulysses* signed when he finally met Joyce in 1928, and to prove his devotion he offered to jump out of a window if Joyce would only ask. (Birmingham 2014, 222)

And Hart Crane said, "I feel like shouting EUREKA! . . . Easily the epic of the age" (Birmingham 2014, 339).

Joyce's fearlessness in depicting the hitherto unmentioned parts of human experience was seen by various sides as both the book's greatest weakness and its greatest strength. Joyce's search for total honesty of thought was an artistic triumph that left many enraged. Reactions among other writers specifically were equally extreme as those of the critics. Some were quite negative. "Edith Wharton called Joyce's book 'a turgid welter of pornography.' . . . E. M. Forster saw in *Ulysses* 'a dogged attempt to cover the universe with mud . . . a simplification of the human character in the interests of Hell'" (Birmingham 2014, 339). Despite his own experiences with the banning of his novel *The Rainbow* in 1915, "D. H. Lawrence condemned the 'Penelope' episode as 'the dirtiest, most indecent, obscene thing ever written" (Vanderham 1998, 27).

As Joyce's innovations had time to sink in and as more analysis of the book (such as Larbaud's lectures and essays about *Ulysses*) helped clarify some of the obscurities, some initially negative reviewers began to change their minds about the book. Among initially negative authors, as with critics, opinions quickly changed as they became more comfortable with Joyce's innovations. Birmingham writes: "W. B. Yeats had been reading *Ulysses* in *The Little Review*

in 1918, and his first thought was 'A mad book!' Later he confessed to a friend, 'I have made a terrible mistake. It is a work perhaps of genius'" (2014, 224).

The uproar ensured that sales of the first edition were brisk. By the end of June, the first edition had sold out.

BANNING, BURNING, AND SMUGGLING

The slowness of the reviews coming out probably worked to *Ulysses*'s advantage: customs officials were not alerted to the book's existence, and Beach was able to ship copies ordered by subscribers in the United States (where the book was banned owing to *The Little Review* court decision) disguised as either *Shakespeare's Works* or as *Merry Tales for Little Folks*. The book had not come to the attention of British authorities yet, so making it to England was no problem. But the appearance of the reviews soon alerted customs officials in both countries. In December 1922, 400 copies of the second edition were seized and burned by U.S. Customs (Bowker 2012, 315). English authorities soon followed suit, and "Thus, by 1923 Ulysses was largely banned from the English-speaking world" (Vanderham 1998, 83).

Although *Ulysses* could be purchased in France and Beach continued to have new editions printed as previous ones sold out, the scandalous notoriety of the book that made it such a successful seller also made it extremely difficult to get past border guards, who were on the lookout for the infamous novel. Ernest Hemingway, still an unknown young writer, stepped in to help by connecting Beach with a friend of his, Barnet Braverman, who lived in Detroit but worked just across the border in Windsor, Canada. He, like many other commuters, crossed the border on a daily basis and was willing to help smuggle books from Canada into the United States. He agreed to Beach's request to help smuggle copies of the book one by one across the U.S. border.

As with alcohol (which was also being surreptitiously transported across the Canadian border to the United States during Prohibition), the illicit nature of *Ulysses* only added to its appeal: "[S]imply possessing *Ulysses* was a rebellion. Bringing it through customs was a crime. Printing, selling and distributing it was punishable by prison. Officials who aided the importation of even a single copy of *Ulysses* could receive a five-thousand-dollar fine and up to ten years in prison. Risk generated devotion—your relationship to a book changes when you have to hide it from the government" (Birmingham 2014, 261). Nevertheless, the difficulty of obtaining *Ulysses* undoubtedly depressed its sales. Throughout

the 1920s, sales averaged fewer than 3,000 copies a year. The ban continued into the 1930s while critics and scholars delved more and more deeply into the intricacies of the text, its status as a modern classic growing over time. Vanderham notes that "by the time *Ulysses* made its first legal appearance in the English-speaking world, it had been preceded by seven book-length studies" (1998, 85).

The book's notoriety coupled with its prohibited legal status opened the door to piracy. Pirated versions of the book began to appear in the United States, eating into Beach and Joyce's already slim profit margin—for the book into which they have invested so much time, energy, and financial resources. It was time to challenge the ban on *Ulysses*.

In April 1933, the Nazis began burning books. The burnings were gigantic spectacles, meant to "purify" German libraries, schools, and homes of "anti-German" and "culturally destructive" literature. While many of the authors whose works were burned were Jewish, not all were. Included in the pyres were works from, among others, Karl Marx, Ernest Hemingway, Jack London, Helen Keller, Albert Einstein, H. G. Wells—and James Joyce. With the Nazis burning Joyce's works for their "culturally destructive" influences, it became uncomfortable for the Americans and the British to be doing the same.

Into this cultural milieu came American publisher Bennett Cerf of Random House. Cerf made a deal with Sylvia Beach to become the U.S. publisher of *Ulysses* if he could successfully challenge the ban in court. In 1933, he devised a plan and made his move.

UNITED STATES V. ONE BOOK CALLED "ULYSSES"

Cerf did not want a repeat of *The Little Review* trial. He hired a prominent New York civil rights attorney, Morris Ernst, to argue the case. In 1917, Ernst had cofounded the National Civil Liberties Bureau that became the American Civil Liberties Union in 1920.

In *The Little Review* trial, the opinions and testimony of scholars and critics had not been admitted to the arguments. The Hicklin Rule admitted no exceptions to obscenity on the basis of artistic merit: the issue was simply the possible effect on the "open" mind. Comstock and Sumner had long argued that since the issue of obscenity was a moral one, rather than an aesthetic one, moral watchdogs like the NYSSV rather than critics and scholars should have the power to decide questions of obscenity. That is, they argued that the proper field for debate was the field of morality, where they held the power of legiti-

mation, rather than the field of literature, where their particular store of capital was not valued.

The conflict over rights of legitimation and interpretation among different sectors of the audience was not new in the United States. Levine discusses conflicts in the nineteenth century over the authority of cultural experts versus the taste of the public, who often loudly preferred less high-flown fare than was beginning to be offered to them. Of orchestra repertoires, he writes, "The thrust of the conductors' efforts was to render audiences docile, willing to accept what the experts deemed appropriate rather than play a role themselves in determining either the repertory or the manner of presentation" (Levine 1988, 189). The difference now was that the distinction was between cultural as opposed to moral authorities. The whole trial of *Ulysses* hinged on this conflict.

Ernst planned to base his defense of the book on arguments that it was a "modern classic" and, therefore, could not be obscene. To that end, he needed critical and scholarly opinion to back him up. He wanted to bring the discussion back into a field where artistic merit was highly valued. He devised a way around the possibility that expert testimony would be ruled out, as it had been in *The Little Review* trial. A copy of *Ulysses* would be shipped from Paris to Cerf in New York. Inside the copy, Cerf had asked Paul Léon, Joyce's assistant, to paste copies of reviews and opinion pieces about the book by "prominent men." These clippings then legally became part of the book. When it was confiscated by customs upon entry into the United States, Random House would contest the confiscation of that particular copy of the book. The opinions pasted into it would then be admissible as evidence in court.

The question at stake was which group of people had the right of legitimation. Ernst planned to make prominent players in the field of literature—scholars and critics—an undeniable part of the evidence and, by forcing the court to include their opinions in its deliberations, to claim their judgments as the dominant evaluative schema. In short, he intended to force a shift of the field of battle from morality to literature.

Ernst intended to argue that *Ulysses* was a modern classic and that, as such, by definition, it could not be obscene. As a sign of the way the times had changed since the mass burnings in the early 1920s, Ernst and Cerf had a hard time getting their criticism-laden copy of *Ulysses* confiscated at all. The Random House agent sent to pick up the incoming copy had to repeatedly insist on the confiscation by a bored and blasé customs inspector, who told him, "Oh, for God's sake, everybody brings that in. We don't pay any attention

to it" (Vanderham 1998, 89). But, after further arguing, the book was finally confiscated.

In his Claimant's Memorandum, Ernst wrote: "*Webster's Collegiate Dictionary* . . . defines a classic as 'a work, especially in literature and art, of the highest class and of acknowledged excellence.' The words 'classic' and 'obscenity' represent polar extremes. They are mutually antagonistic and exclusive. That which is obscene, corrupts and depraves—it cannot be 'of the highest class and of acknowledged excellence.'" (Vanderham 1998, 98). In front of Judge John M. Woolsey in the United States District Court in New York on 25 November 1933, Ernst laid out his argument that not only could a classic not be obscene, but that the definition of obscenity had changed over time and that the mores of the day—the standards of the community—determined what was offensive. He argued that these were living standards, changing with the passage of time. Ernst cited the changing reputation of Charlotte Brontë's *Jane Eyre* as one such example (Vanderham 1998, 95). Ernst also presented evidence of *Ulysses*'s wide appeal as a testament to the way community standards had embraced it by showing a map of the large number of libraries in the United States where the book had been requested (Birmingham 2014, 324).

Following the arguments used in *The Little Review* trial, Ernst also argued that *Ulysses* was incomprehensible to most, but with a twist. Ernst claimed that the length, complexity, and form meant that it could not be pornography because it did not share the features of pornography—salacious illustrations, a need for secrecy, and brevity. *Ulysses* had none of these. Instead, he argued, that it was

> far too tedious and labyrinthine and bewildering for the untutored and
> the impressionable who might conceivably be affected by it. Such people
> would not get beyond the first dozen pages. . . . It is axiomatic that
> only something that is understandable can corrupt. The worst Chinese
> obscenity is innocuous to anyone not acquainted with the language. If
> an author's style is incomprehensible to all but a comparatively few who
> are concededly immune to what the censor calls the suggestive power
> of words, the work cannot be said to be obscene. (Vanderham 1998,
> 99–100)

Judge Woolsey asked Ernst, "Suppose that a girl of eighteen or twenty read the soliloquy of Molly Bloom, wouldn't it be apt to corrupt her?" "I don't think that is the standard we should go by," Ernst replied. "The law does not require

that adult literature be reduced to mush for infants" (Birmingham 2014, 320). In this exchange, Ernst explicitly rejected the evaluative authorities and forms of legitimation in the field of morality as being inappropriate for the field of this discussion.

In his arguments, the counsel for the government listed several passages to which the government objected. Vanderham, in his study of those passages, argues that it was their assaults on the power of the state and the church, rather than their explicitly sexual content, that was the focus of the government's objections to the text.

On 6 December 1933, Judge Woolsey handed down his decision in *United States v. One Book Called "Ulysses."* Woolsey accepted what both detractors and proponents of the book acknowledged—that *Ulysses* was a difficult book for anyone to understand, which complicates the issue of the role of audience perception in deciding obscenity. The judge wrote: "'Ulysses' is not an easy book to read or to understand. But there has been much written about it, and in order properly to approach the consideration of it it is advisable to read a number of other books which have now become its satellites. The study of 'Ulysses' is, therefore, a heavy task" (*United States v. "Ulysses"* 1933, 1). But if obscenity were in the eye of the beholder, Woolsey's was the eye that mattered. His judgment was straightforward: "But in "Ulysses," in spite of its unusual frankness, I do not detect anywhere the leer of the sensualist. I hold, therefore, that it is not pornographic" (*United States v. "Ulysses"* 1933, 2). The opinions of the scholars— even the very existence of the scholarship—had been important in Woolsey's deliberations, acknowledging the symbolic capital of the reviews and signaling a shift of venue with regard to the field.

Woolsey then went on to his own explication of Joyce's method and aims, particularly praising his uncompromising search for authenticity:

It is because Joyce has been loyal to his technique and has not funked its necessary implications, but has honestly attempted to tell fully what his characters think about, that he has been the subject of so many attacks and that his purpose has been so often misunderstood and misrepresented. For his attempt sincerely and honestly to realize his objective has required him incidentally to use certain words which are generally considered dirty words and has led at times to what many think is a too poignant preoccupation with sex in the thoughts of his characters. (*United States v. "Ulysses"* 1933, 2)

He concluded:

> I am quite aware that owing to some of its scenes "Ulysses" is a rather
> strong draught to ask some sensitive, though normal, persons to take.
> But my considered opinion, after long reflection, is that, whilst in many
> places the effect of "Ulysses" on the reader is somewhat emetic, nowhere
> does it tend to be aphrodisiac. "Ulysses" may, therefore, be admitted
> into the United States. (*United States v. "Ulysses"* 1933, 3)

The official Random House printing began the next day.

APPEAL

In December 1933, the same month Woolsey handed down his decision, the
Twenty-First Amendment to the U.S. Constitution, repealing Prohibition,
was ratified. The attempt to prohibit alcohol had been disastrous, notable
mostly for fueling the rise of organized crime in the nation. The life span of the
Volstead Act almost exactly paralleled the life span of the U.S. ban on *Ulysses*.
Like alcohol, *Ulysses* had been smuggled into the United States. And like alco-
hol, attitudes towards the ban on *Ulysses* changed dramatically over the course
of the decade.

On 16 May 1934, the U.S. government's appeal case against Judge Wool-
sey's decision began. The appeal was held before a three-judge panel: Judge
Martin Manton (presiding) and cousins Judge Learned Hand and Judge Au-
gustus Hand. Learned Hand, in his opinion, explicitly argued that obscenity
should not depend on the characteristics of the audience, but rather was a fea-
ture of the work itself, a feature that was properly tested by "approved critics"
rather than "open" minds. Birmingham noted that "following Morris Ernst,
[both Learned and Augustus Hand] would argue that the Hicklin Rule was
untenable, that the nation's reading standards couldn't be dictated by children"
(Birmingham 2014, 335). In the end, *Ulysses* carried the day. The U.S. attorney
general declined to appeal to the U.S. Supreme Court, and the ban was lifted.

POWERS OF LEGITIMATION

Ernst won his case for *Ulysses* in front of the three-judge panel in a 2–1 vote. The
dissenting judge, Manton, had written in his dissent: "No matter what may be
said on the side of letters, the effect on the community can and must be the

sole determining factor" (Vanderham 1998, 145). This differentiation between "letters" and "community" goes to the heart of the debate over obscenity and, indeed, all culture. Who has the power of legitimation? Who sets the rules and in which field? The *Ulysses* decision shifted power away from the general community feeling into the hands of a select group of experts.

Antagonism between the cultural experts and the larger community resulted from this shift as the values of one small fraction of the population usurped the authority of the previously dominant group. Those, such as the clergy and moral entrepreneurs like Comstock and the NYSSV, as representatives of the general community, were outraged at their loss of control. For many years, Comstock had held power over legitimation in the field of culture; he had defined the basis for deciding what did and did not have value. "The closer art keeps to pure morality," he had written, "the higher its grade. Artistic beauty and immorality are divergent lines. To appeal to the animal in man does not inspire the soul of man with ecstasies of the beautiful. Every canvas which bears a mixture of oil and colors on it is not a work of art. The word "art" is used as an apology for many a daub" (Beisel 1993, 153–154).

The *Ulysses* decision changed all that, relegating Comstock and others like him, including the general public, to the sidelines and heralding the rise of the expert who could dismiss out of hand their moral concerns. That loss of status, the power to legitimate, was enraging. The very incomprehensibility of *Ulysses* was the final indignity to them. It was the perfect sign that "high culture"— and all of its associated social prestige—was no longer theirs to command.

In the next chapter, we will see debates around the definition of "expert" itself. Within the field of culture, claims of the power to legitimize would come up against questions of authenticity, identity, and intersectionality.

SEVEN

"No Theme, No Message, No Thought"

Zora Neale Hurston's Their Eyes Were Watching God

In 1976, Alice Walker wrote: "*We are a people. A people do not throw their geniuses away*. If they do, it is our duty *as witnesses for the future* to collect them again for the sake of our children. If necessary, bone by bone" (1976, xviii; italics in original). The genius of whom she was speaking was Zora Neale Hurston. And the bones were lying in an unmarked grave in an overgrown Florida cemetery among the weeds, the insects, and the snakes.

EATONVILLE

Given how often Zora Neale Hurston amended her birth year in the telling of her life story in order to make herself appear younger, it is not surprising that it was up for debate. Most scholars finally settled on 1891 as the most likely year. But when she was born was not as important as where she grew up: Eatonville, Florida, the first self-governing, incorporated all-Black town in the United States.

Growing up in Eatonville had a profound effect on Hurston's sense of self. The white gaze—so often brutal and demeaning—under which most African Americans lived their lives, was absent in Eatonville. Social positions of prestige and power were held by Black people (including Hurston's father who was a preacher and served a term as town mayor), decisions about running the

township and about the ordering of public affairs were made by Black people, businesses and nice homes were owned by Black people, good schools had Black students and teachers. Whites and their influence were absent from Hurston's childhood world. As Valerie Boyd writes in her biography of Hurston, "It was a place . . . where black people were free from any indoctrination in inferiority" (2003, 144). Hurston had no deep need to make a project out of decentering whiteness in novels like *Their Eyes Were Watching God* because whites had never been centered in her world to begin with. As she would later write, "Only a few self-conscious Negroes feel tragic about their race, and make a cage for themselves. The great majority of us live our own lives and spread our jenk in our own way, unconcerned about other people. Sufficient unto ourselves" (Boyd 2003, 305).

The population of Eatonville hovered at just over a hundred people during the years that Hurston was growing up, and the social center of the small town was the front porch of Joe Clarke's store, where residents gathered in the evenings to relax, swap stories and jokes, and gossip. As fictionalized in *Their Eyes Were Watching God*: "These sitters had been tongueless, earless, eyeless conveniences all day long. Mules and other brutes had occupied their skins. But now, the sun and the bossman were gone, so the skins felt powerful and human. They became lords of sounds and lesser things. They passed nations through their mouths. They sat in judgement" (Hurston 1937, 9–10). Listening to the talk on the porch, Hurston grew up with intimate knowledge of Black folklore as it was related in Eatonville. That grounding would form the basis of much of her later work. Her Eatonville upbringing would shape Hurston's ideas, but she was not completely uncritical of it in her writings. She especially noticed that the tellers of tales on the store's front porch were inevitably, exclusively male.

ANTHROPOLOGY AND THE HARLEM RENAISSANCE

Hurston's idyllic childhood in Eatonville ended when her mother died in 1904. Her father remarried in 1905, and Hurston was sent away to boarding school. Her father soon ceased paying her fees, and she was dismissed, spending the next decade traveling from place to place, sometimes staying with family members, working a variety of mostly menial jobs. She found her way eventually to Baltimore, competed her high school education there, and, in 1918 at age twenty-seven, entered Howard University where Alain Locke was one of her professors. After Howard, Hurston moved to New York City, to Harlem,

where she was soon one of the central figures in the Harlem Renaissance. She became a student at Barnard College, the women's college of Columbia University. It was there that she began her training, along with fellow student Margaret Mead, as an anthropologist under the auspices of Franz Boas. Boas enthusiastically supported Hurston's research agenda to study Black folklore in the southern United States and the Caribbean.

Hurston believed in the beauty and power of folklore, seeing it as the wellspring of great art. This was a militant stance in the 1920s and brought Hurston into conflict with mainstream cultural arbiters, even with some of the older writers and artists of the Harlem Renaissance. Speaking of the elitism Hurston encountered at Columbia, Robert Hemenway writes:

> Zora Hurston had known firsthand a culturally different esthetic tradition. While she and her classmates revered Beethoven, she also remembered the box playing of Eatonville's Bubber Mimms. She enjoyed Keats, but recognized the poetry in her father's sermons; she read Plato, but told stories of Joe Clarke's wisdom. Her racially different folk culture was tolerated by whites as a primitive mode of apprehending experience; yet she knew that there was nothing primitive about it, that folk traditions enabled black people to survive with strength and dignity. Hurston sensed what Houston Baker has stated: that the world did not begin with Homer. Some of her fellow Harlem Renaissance artists did not realize this, but all the evidence suggests that Hurston did. She had known both written and oral traditions, had participated in American civilization at the levels of both "high" and "low" culture, and her commitment to folklore as a field of study was an inchoate challenge to the cultural imperialism that could declare these vertical judgements. (Hemenway 1977, 99–100)

Hurston was already pursuing a strategy of subversion, explicitly denying the positioning of Black folklore as subordinate to white and bourgeois forms of culture. She claimed a place for Black folklore at the very top of the cultural hierarchy and argued for this position with her fellow African American artists. Later, in an essay in an African American newspaper out of Washington, DC, Hurston would write of Blacks who revered and emulated white culture: "Fawn as you will. Spend an eternity standing awe-struck. Roll your eyes in ecstasy and ape his every move, but until we have placed something upon his

street corner that is our own, we are right back where we were when they filed our iron collar off" (Boyd 2003, 265). That something was Black folklore:

> [H]er person and her fiction exhibited the knowledge that the black masses had triumphed over their racist environment, not by becoming white and emulating bourgeois values, not by engaging in a sophisticated program of political propaganda, but by turning inward to create the blues, the folktale, the spiritual, the hyperbolic lie, the ironic joke. These forms of expression revealed a uniqueness of race spirit because they were a code of communication—interracial propaganda—that would protect the race from the psychological encroachments of racism and the physical oppression of society. (Hemenway 1977, 51)

In this stance, Hurston was joined by a group of younger Harlem artists, including Countee Cullen, Aaron Douglas, Wallace Thurman, and Langston Hughes, who became her closest friend. These younger artists often found themselves in ideological conflict with some of the older leaders, such as W. E. B. Du Bois, who seemed to the younger generation not only elitist but also overly oriented towards whites, emulating the forms of white culture at the expense of what Hurston saw as the richness and excellence of Black creativity. Du Bois and those around him saw cultural production explicitly as "propaganda" aimed at white audiences intended to show Black creators' mastery of white idioms, erasing racist assumptions of Black cultural inferiority. Hemenway explains, "To some extent, for both Locke and Du Bois, art became identified as Beauty in the service of Truth, the product of the elite artist articulating for an inarticulate race" (1977, 39).

For Du Bois and others of his generation, culture would be produced by the intellectual elite—the "talented tenth"—of Black Americans: "Rejecting the notion of art simply for art's sake, Du Bois had written in a January 1926 *Crisis* editorial: 'We want Negro writers to produce beautiful things but we stress the things rather than the beauty.' A few months later, he made his position bluntly clear: 'I do not care a damn for any art that is not used for propaganda'" (Boyd 2003, 118). Hurston strongly disagreed with this position. In the battle over what it meant to be a Black American, Hurston and Du Bois were in opposing camps within the African American intelligentsia (Carby 1990, 77). Hurston stood firmly on the side of the Black proletariat, in whose folkways she perceived a wondrous artistry. That Hurston would extol the power of the people is no accident, given her background. As Alice Walker noted:

Zora's pride in black people was so pronounced in the ersatz black twenties that it made other blacks suspicious and perhaps uncomfortable (after all, *they* were still infatuated with things European.) Zora was interested in Africa, Haiti, Jamaica, and—for a little racial diversity (Indians)—Honduras. She had a confidence in herself as an individual that few people (anyone?), black or white, understood. This was because Zora grew up in a community of black people who had enormous respect for themselves and for their ability to govern themselves. (Walker 1983, 85; italics in original)

The battle lines were drawn between the younger artists, such as Hurston and Hughes, and the older, such as Du Bois and Hurston's former Howard professor, Alain Locke. In 1926, the younger generation embarked on a project to put forward their views, a literary magazine called *Fire!!*

FIRE!!

In the summer of 1926, a core group of the younger Harlem artists including Hurston, Thurman (who headed the operation), Hughes, and others worked to produce what they envisioned would be a quarterly magazine "devoted to the younger Negro artists" (Hemenway 1977, 43). As the editors expressed their mission: "Hoping to introduce a truly Negroid note into American literature, its contributors had gone to the proletariat rather than to the bourgeoisie for characters and material, had gone to people who still retained some individual race qualities and who were not totally white American in every respect save color of skin" (Hemenway 1977, 45). In a letter to introduce *Fire!!*, they wrote: "We are primarily and intensely devoted to art. We believe that the Negro is fundamentally, essentially different from their Nordic neighbors. We are proud of that difference. We believe these differences to be greater spiritual endowment, greater sensitivity, greater power for artistic expression and appreciation" (Boyd 2003, 134). In contrast to Du Bois and Locke, the editors to *Fire!!* intended to focus purely on art for art's sake rather than on what Hurston later dismissed as "a treatise on sociology" (Hemenway 1977, 41).

Throughout the summer and fall of 1926, the editors labored on the project. The subject matter of the pieces to be included in the first issue pushed boundaries by addressing taboo subjects such as homosexuality and prostitution. The main focus was on the Black proletariat, rather than the bourgeoisie. Hurston

contributed a short story, "Sweat," which dealt with domestic violence and ret-ribution, and a play, "Color Struck," which dramatized the contentious issue of colorism in the Black community.

The financing for the project was always precarious. Each of the seven ed-itors pledged to contribute $50 to the project, with the remainder of the fi-nancing to come from patrons. In the end, though, only three of the editors contributed their share (Hurston was not among them), and only nine sponsors were found. While the aesthetic side of *Fire!!* flourished, bad luck dogged the money side. Thurman, incredibly, was mugged on the street when he was car-rying $150 he had just borrowed from the Harlem Community Church and another $150 borrowed from the Mutual League. He also signed a promissory note to the printer for almost $1,000 that would eventually take more than four years to pay back.

Only one issue of *Fire!!* was ever released, finally appearing in November 1926. Reactions to it were largely negative (West 2005, 29). "Throughout its forty-eight pages, *Fire!!* broke ranks with the Talented Tenth propagandists by celebrating jazz, blues, uninhibited sexuality, and the natural black beauty of the folk. It was, as one historian has declared, 'a flawed, folk-centered master-piece'" (Boyd 2003, 135). However, the reviews were mixed:

> A black critic in Baltimore, labeling the magazine "Effeminate Tom-myrot," began his review by snorting: "I have just tossed the first issue of *Fire!!* into the fire." . . . And, Hughes reported, "none of the older Negro intellectuals would have anything to do with *Fire!!*" A friend told Cullen that merely mentioning *Fire!!* to Du Bois hurt the redoubt-able editor's feelings so much that he fell into a sullen silence. Publicly, Du Bois refrained from commenting on *Fire!!*, but another pillar of the black establishment, literary critic Benjamin Brawley, fumed: "If Uncle Sam ever finds out about it, it will be debarred from the mails." (Boyd 2003, 135)

Du Bois and the other members of the older generation were not easy to remove from their positions at the autonomous pole of Black American culture; subversive strategies in the field may be attempted, but do not always succeed. Sales of *Fire!!* were—not surprisingly—extremely slow. The printer, hoping to help sales so that he could be paid more quickly, handed out hundreds of unpaid-for copies of the magazine to the editors with the idea that they would be able to sell them more readily if they had copies on hand, rather than taking

orders for later delivery. In an ironic denouement, the Harlem apartment house where these copies were stored caught fire, and all the remaining inventory of *Fire!!* burned. *Fire!!* did not reemerge from the ashes. Hurston's response was "I suppose that 'Fire' has gone to the ashes quite, but I still think the idea is good" (Hemenway 1977, 46).

The *Fire!!* project produced great literature but left Hurston and the others with debt instead of profits from their work. Hurston, with her unshakeable belief in the value of Black folk culture, turned back towards the American South as a source for inspiration. But lacking funds for travel and research, Hurston would need a backer.

CHARLOTTE OSGOOD MASON

Langston Hughes introduced Hurston to Charlotte Osgood Mason in 1927. Mason was a widowed white New York socialite with an interest in the "primitivism" that she assumed was authentic Black culture. The ability to define the "authentic"—a form of symbolic capital—is, of course, a type of power in the cultural field. As Rachel Blau DuPlessis notes:

> This still shows how important positional difference is to the articulation of ideas—for it is one thing for African-American writers to assume the "primitive and intuitive" as a badge of pride and common identity, and it is quite another—indeed, a form of colonization—for a white person to insist that blacks manifest these traits above all others. And to the degree that Mason's insistence that the primitive was the sole black authenticity "savagely" stereotypes heterogeneousness and compromises the individuality of African-Americans, we can only call her interest a kind of racism. (DuPlessis 1990, 100)

Hemenway writes:

> The problem with Mrs. Mason, as perhaps with all patrons, was that she expected some return on her money. In Hurston's case it was a report on the aboriginal sincerity of rural southern black folk; in Hughes's, it was the beating of tom-toms in the breast of the urban black poet. She asked Hughes to be "primitive and know and feel the intuitions of the primitive." She thought of him as Africa; eventually he replied that he could only be Cleveland and Kansas City. Louise Thompson, another

woman supported by Mrs. Mason for a time, eventually came to feel that the patron was "indulging her fantasies of Negroes," that she was in fact racist. Her black guests were either primitive, or they were not being themselves. Aaron Douglas reported similar feelings. Once Mrs. Mason even said that Locke acted too much like white folks. (Hemenway 1977, 107)

In her pursuit of the "primitive" and her desire to control the power to legitimate forms of culture that claimed authenticity, Mason supported numerous artists and writers of the Renaissance, including Langston Hughes, Claude McKay, Aaron Douglas, and even Alain Locke. Estimates are difficult, but it seems likely that Mason gave almost a million dollars in today's money to support Black writers and artists, whom she called her "godchildren" and whom she asked to address her as "Godmother" (Boyd 2003, 158).

With her belief in the value of Black folklore, Hurston was a natural fit for Mason's interests. Soon, Mason became Hurston's patron. Mason agreed to back Hurston's further research in the American South and in the Caribbean, but the contract she drew up for Hurston to sign in December 1927 did not support Hurston as a creative artist, as she had done with her male "godchildren." Instead, it made Hurston her "agent" and gave Mason complete control over how Hurston could use the material she gathered. Mason would control all Hurston's use of "music, folklore, poetry, hoodoo, conjure, manifestations of art, and kindred matters existing among the 'American negroes'" (Kaplan 2013, 228):

> In return for $200 a month, a camera, and a car, Hurston was to "faithfully perform her task, return . . . and lay before said first party [Charlotte Mason] all of said information, data, transcriptions of music, etc., which she shall have obtained." Mason maintained a special safe-deposit box for Hurston's writings and films, to which Hurston did not have keys. Then Mason made her document every penny she spent, from "string beans and canned fruit" to "colon medicine (three dollars) and sanitary napkins (sixty five cents)." (Kaplan 2013, 228)

Mason also wanted complete control of the material that Hurston found. The contract stipulated that Hurston was "not to make known to any other person, except one designated in writing by said first party [Mason], of any said data or information" (Kaplan 2013, 229), Mason was especially concerned that none of

the information be shared with any of the anthropologists, such as Franz Boas, with whom Hurston had close ties.

Mason's lack of understanding of, and devaluing of, the scope of Hurston's work is exemplified by a clause in the contract that said Mason needed Hurston's help because she was "unable because of the pressure of other matters to undertake the collecting of this information in person" (Kaplan 2013, 228), as if an elderly white woman from New York, if it had not been for her busy schedule, could have herself gathered Black folklore in the rural South with the same proficiency as Hurston. As Hemenway notes, "Hurston's folklore collections would be exclusively the *property* of her patron—not because Mrs. Mason wanted to steal the material, but because she felt arrogantly certain that Zora Neale Hurston could not be trusted to know best what to do with it" (1977, 110; italics in original).

The contract was demeaning, turning Hurston into a mere hired hand, but Hurston had few other options for funding her travel and research. Mason's financial support allowed Hurston to pursue her interests, but at a price. Mason did not just want to support the Harlem Renaissance artists, she wanted to control and dominate them. Carla Kaplan notes that Mason "now created a triangle of Locke, Hurston, and Hughes, playing them off against one another and encouraging them to jockey for primacy with her. Competition between them would keep her as their center. Or so, at least, she hoped" (2013, 224).

Mason's interest in Black culture eventually began to wane. As she began to withdraw financial support from her soon-to-be-former godchildren, their jockeying to stay in her favor and to continue to receive their "allowances" increasingly strained the bonds among the writers. In the early 1930s, a dispute over the ownership of some of Hughes's and Hurston's collaborative work, fueled by the necessity of maneuvering to stay on Mason's payroll as she was cutting down her patronage, flared up to such an intensity that the long and deep friendship between them was permanently destroyed. Moreover, Hurston's already tenuous relationship with Locke turned into real enmity when Mason used Locke as a go-between to try to control Hurston's writing. Locke and Hurston, as a result of Mason's maneuverings, became lifelong enemies.

Later, Hurston would be harshly criticized—including (hypocritically) by Hughes—for depending on patronage from white people. Even though Hurston had been deeply invested in Black folk culture long before she had ever heard of Mason, her critics would later charge that the depictions of rural

Black characters were written in an attempt to appease the dictates of racist white patrons.

Finally, in 1932, Hurston rid herself of Mason (whom she called in private letters the "Park Avenue dragon") (Kaplan 2013, 247). Freedom from Mason, unfortunately, meant that Hurston was again without funds to live on while she wrote. Thanks to Mason's interference, she was also without the support network of other Black artists that had existed during the heyday of the Harlem Renaissance. Hurston continued to seek funding from foundations to do her folklore fieldwork, enlarging her area of study to also include the Caribbean. And she continued to write, producing plays, short stories, and essays. She published her first novel, *Jonah's Gourd Vine*, in 1934 and a book of Black folklore, *Mules and Men*, in 1935. Then in 1936, while researching in Haiti, Hurston sat down and wrote *Their Eyes Were Watching God*. "It was dammed up in me," Hurston said. "I wrote it under internal pressure in seven weeks" (Awkward 1990, 1).

THEIR EYES WERE WATCHING GOD

Since 1935, Hurston, now in her mid-forties, had been involved in a romantic relationship with a younger man, Percy Punter, a graduate student at Columbia University. Following her difficult breakup with Punter, Hurston used him as the model for Tea Cake, one of the central characters of her novel. "The plot was far from the circumstances," she said, "but I tried to embalm all the tenderness of my passion for him" (Boyd 2003, 294).

Their Eyes Were Watching God is the story of Janie and her blossoming into full selfhood. Janie's grandmother, Nanny, was raped by her slave master and became pregnant. The master's wife, seeing the color of the baby, turned her viciousness on Nanny, who nevertheless managed to escape with her life and her child, Leafy. As a teenager, Leafy herself is violently raped by a schoolteacher and becomes pregnant with Janie, who then is raised by Nanny.

In an attempt to give Janie some protection from the cruelty that she herself had suffered, before she dies Nanny marries Janie off to an older, better-off man, Logan Killicks, whom she hopes will be a source of safety. Killicks feels no love for Janie and becomes increasingly threatening. Janie finally runs away from him with smooth-talking Jody Starks. Jody takes Janie with him to Eatonville, where he opens a store and eventually becomes mayor of the all-Black

town. He views Janie as an attractive trophy to enhance his status, but his jealousy over the attention that other men pay to Janie turns malevolent. Jody becomes obsessed with breaking Janie's sense of self, beating down her spirit and silencing her.

After Jody dies, Janie, now in her forties, falls in love with the happy-go-lucky Tea Cake, a younger man who values Janie for herself. The two leave Eatonville to go work "on the muck" harvesting crops on the northern edge of the Everglades. Tea Cake is by no means the perfect mate, even beating Janie on one occasion to demonstrate his possession of her. Nevertheless, Tea Cake values Janie as a person and a partner in life.

Their happiness together is destroyed when a hurricane hits and, while trying to save Janie from the floodwaters, Tea Cake is bitten by a rabid dog. As he slowly succumbs to the disease, Tea Cake goes mad and turns on Janie, who is forced to shoot him to save her own life. Janie stands trial for murder and finds that all of Tea Cake's friends turn on her, hoping for her conviction. But, on the basis of the doctor's testimony, she is acquitted and returns to Eatonville, where she tells her story to her friend Pheoby.

In writing the story of Janie's life, Hurston was also championing the lives of poor, rural Black people, imbuing them with dignity. This stance chafed against the program of the older thought leaders who sought to present Black culture in its most "refined," Europeanized forms as a way of combatting negative stereotypes of Black:

> For Hurston, these gods were to be found in the folk culture—the music, the dance, the stories—of ordinary black people. As Zora well knew, though, many of her peers were embarrassed by these uneducated masses—people who, in some ways, still seemed bound by the rusty chains of slavery. Straining to prove themselves equal to whites, some Negro intellectuals sought to distance themselves from the ignorance and squalor, the broken English and country ways of those they claimed as their "skinfolk" but not their kinfolk. Hurston, however, perceived enormous beauty in the artful lives of these common, unheralded people. And she had long ago decided to become their champion. (Boyd 2003, 238)

A battle developed between strategies of succession—practiced by the "talented tenth"— in the cultural field and Hurston's truly subversive strategy of celebrating the folk voice, of claiming African American culture not as a poor

cousin of white culture, but as superior to white culture in its creative ferment and its beauty. A key point in this conflict was Hurston's use of Black dialect for her characters. Hurston saw dialect as part of the authentic and powerful voice of the common people. For others, especially those engaged in Du Bois's program of "positive propaganda," the use of dialect was too close to minstrelsy and negative stereotypes about ignorant Blacks (West 2005, 31).

This is not an unreasonable argument. As Hemenway writes with regard to the year (1925) that Alain Locke's edited volume *The New Negro* appeared:

> Locke's editing of *The New Negro* produced a volume that gave lip ser-
> vice to pure art, but that in the end was similar in its esthetics to the
> propagandistic tradition. This should not be construed as a pejorative
> judgment. Black men and women were still be lynched in 1925, not as
> an anomaly but as a frequent event, and the Senate of the United States,
> in its collective wisdom and democratic principle, could not even pass
> a federal anti-lynching bill. One could reasonably argue that the race
> could not afford artists who subordinated the social conscience. (He-
> menway 1977, 42)

The second wave of the KKK had flourished during the 1920s and 1930s, adding cross burnings to its arsenal of terror during this era. Culturally, Al Jolson was a hit in 1927, appearing in blackface in *The Jazz Singer*, the first "talkie" motion picture. *Amos 'n Andy*, the radio show depicting racist stereotypes of two Black Harlem residents, voiced by white actors, had begun in 1928 and continued until 1960. *Gone with the Wind*, the bestselling novel by Margaret Mitchell with its pro-KKK sympathies, was published in 1936 and received a Pulitzer Prize in 1937, the same year that *Their Eyes Were Watching God* was published:

> In her attempt to transform the tools of stereotype and oppression into
> art and a medium for liberation, however, Hurston had to negotiate
> biases created by the historical uses of dialect, pathos, and humor. . . .
> The elders of the New Negro Movement "wanted to project a positive,
> even heroic, image of blacks and black life." . . . They feared "the well-
> meant but misguided enthusiasms" of "white critics and admirers of
> Afro-Americans who, as the movement progressed, seemed bent upon
> locking blacks into a new version of an old stereotype, that of the prim-
> itive" . . . , and Hurston's characters often came too close to that ste-
> reotype for racist readers to discern the difference. (West 2005, 32–35)

Genevieve West points out:

> Given her diverse readership, all readers could hardly have had the same
> responses to her fiction. Some might have seen in Hurston's folk char-
> acters the authenticity so often praised in reviews of her novels. Other
> readers might have seen the folk traditions she recorded as quaint or un-
> usual—an objectification that inevitably belittles by suggesting that folk
> traditions are rooted in ignorance and provide proof of racial inferiority.
> Still others may have been disturbed that some of her characters' behav-
> iors overlap with negative stereotypes, particularly those of black men
> as violent, lazy, and sexually promiscuous. . . . [T]he more Hurston's
> characters had in common with stereotypes, the more likely readers
> were to understand her work as confirmation of those stereotypes—
> even if she intended otherwise. (West 2005, 23–24)

But Hurston's transgression and her attempt to subvert the ordering of the
cultural field were about more than race. Race intersected with gender so that
Janie's story of coming into selfhood is very much the story of a Black woman.
As Nanny tells Janie: "'So de white man throw down de load and tell de nigger
man tuh pick it up. He pick it up because he have to, but he don't tote it. He
hand it to his womenfolks. De nigger woman is de mule uh de world so fur as
Ah can see'" (Hurston 1937, 29).

While Hurston celebrated Black folk culture, Janie's story is nevertheless
an indictment of gender roles, and the violence with which they are enforced,
within the Black community. The novel celebrates the all-Black Eatonville
where Hurston grew up, but still recognizes the gender hierarchy that pre-
vailed there. The silencing of Janie and the brutality directed towards her by
Black men were feminist issues that Hurston was pointing out to the entire
Black community. Hurston's critique, like Janie's, would be silenced and dis-
missed by the men in her own community:

> Richard Wright . . . had trouble taking [*Their Eyes Were Watching God*]
> seriously. "Miss Hurston seems to have no desire whatsoever to move
> in the direction of serious fiction," the twenty-nine-year-old upstart
> carped in his *New Masses* review. . . . A member of the Communist
> Party at the time, Wright deplored the lack of overt protest in Hurston's
> novel. That she was writing about a black woman's internal life did not
> help matters. Not known for his progressive views on women, Wright

must have seen Hurston's novel as so much female frivolity. (Boyd 2003, 306)

Janie is a poor, Black, rural woman, and the intersectionality of that positionality is woven into her story. Hurston's male critics who would accuse her of lacking engagement with important issues in her writing clearly did not see the critique of gender relations, which is the backbone of the novel, as "serious." Sarah Corse and Monica Griffin argue:

The critical paradigm of African American protest generated an "interpretive strategy" for critics that produced very specific readings of texts. Reading *Their Eyes Were Watching God* within this interpretive strategy constructed one particular set of meanings from the text and one particular set of criteria for evaluating the text. The critical paradigm of African American protest, *like all critical paradigms and interpretive strategies*, privileges certain readings of texts while discounting others. . . . The interpretive strategy most prevalent among African American critics of Hurston's time constructed *Their Eyes Were Watching God* in a manner that made the novel unacceptable. (Corse and Griffin 1997, 184–185; italics in original)

Hurston was not writing for purposes of protest. Although whites appear periodically in the novel—such as when a gang of white men come to conscript Tea Cake at gunpoint to bury the dead from the hurricane in racially segregated graves—they are largely absent and ignored. Hurston decentered whiteness. As she said in another context about her writing: "What I wanted to tell was a story about a man, and from what I had read and heard, Negroes were supposed to write about the Race Problem. I was and am thoroughly sick of the subject. My interest lies in what makes a man or a woman do such-and-so, regardless of his color" (Boyd 2003, 246). Hemenway argues:

By leaving out "the problem," by emphasizing the art in the folkloric phenomenon, Hurston implicitly told whites: Contrary to your arrogant assumptions, you have not really affected us that much; we continue to practice our own culture, which as a matter of fact is more alive, more esthetically pleasing than your own; and it is not solely a product of defensive *re*actions to your actions. She felt that black culture manifested an independent esthetic system that could be discussed without constant reference to white oppression. (Hemenway 1977, 221)

Ignoring whites was a consciously chosen element of Hurston's subversive strategy, a truly radical break with the ideas of many other Black writers and artists.

Hurston completed *Their Eyes Were Watching God* in December 1936 and sent it to her publisher, J.B. Lippincott & Company. Despite having been written in a mere seven weeks, it needed almost no revision. When Hurston returned to the United States from Haiti in March 1937, plans for its publication were well underway. It came out in September 1937.

"THE BLIGHT OF CALCULATED BURLESQUE"

Hurston had been one of the most well-regarded and popular authors to come out of the Harlem Renaissance. *Their Eyes Were Watching God*, therefore, was widely reviewed. Most white critics and many Black critics praised it. Sheila Hibben, the critic for the *New York Herald Tribune Weekly Book Review,* wrote:

> Here is an author who writes with her head as well as with her heart. . . .
> [I]it is awfully easy to write nonsense about Negroes. That Miss Hurston can write of them with simple tenderness, so that her story is filled with the ache of her own people, is, I think, due to the fact that she is not too much preoccupied with the current fetish of the primitive.
> (Hibben 1937, 2)

Recognizing the complexity and realism of the story, Ethel A. Forrest, writing in *the Journal of Negro History*, said: "Every phase of the life of the Negro in the south, like self-segregation of the Negroes themselves and the race hatred displayed by the southern white man, has been interwoven in this book. . . . It is in many respects an historical novel" (1938, 107). W. A. Hunton, in the *Journal of Negro Education*, seemed to most succinctly express Hurston's intentions, writing that Hurston "has a healthy scorn for the Negro's endeavor to pattern his life according to white bourgeois standards" (1938, 71).

Like Hibben, many of the white critics praised the novel for its humor, but these critics seem to have missed the larger story of the oppression and brutality that is so much of Janie's (and Nanny's) life. Ralph Thompson, in the *New York Times*, for example, especially praised what he called the novel's "racial gayety" (Wall 1995, 196). Herschel Brickell, at the *New York Post*, praised what he saw as a "woman's story, and the story of a complete and happy woman, the kind we hear too little about in fiction" (Wall 1995, 196). George Stevens, in *the Saturday Review of Literature*, acclaimed: "No one has ever reported the speech

of Negroes with a more accurate ear for its raciness, its rich invention, and its music. . . . 'Their Eyes Were Watching God' has much more humor in it; and paradoxically—possibly because the author is writing unselfconsciously of her own people—it is more objective" (Stevens 1937, 3).

There was a condescending tone even in many of the positive notices by white reviewers. In the *New York Times Book Review*, Lucille Tompkins wrote of the book:

> [I]t is beautiful. It is about Negroes, and a good deal of it is written in dialect, but really it is about every one, or least every one who isn't so civilized that he has lost the capacity for glory. . . . [It] is simple and beautiful and shining with humor. In case there are readers who have a chronic laziness about dialect, it should be added that the dialect here is very easy to follow, and the images it carries are irresistible. (Tompkins 1937, 29)

As Tompkins's review shows, Hurston's use of dialect cropped up again and again in the reviews, critics sometimes praising it and often reassuring readers that it would not be too taxing on their comprehension skills. Otis Ferguson, in *The New Republic*, focused much of his negative critique on precisely Hurston's use of dialect, lecturing her on how it should be done correctly; Ferguson claimed that the trained folklorist could not "grasp its first rule" and accused her of minstrelsy, the charge that would dominate the negative reviews:

> Dialect is really sloppy, in fact. Suggestion of speech difference is a difficult art, and none should practice it who can't grasp its first rule. . . . To let the really important words stand as in Webster and then consistently misspell all the eternal particles that are no more than an aspiration in any tongue, is to set up a mood of Eddie Cantor in blackface. (Ferguson 1937, 276)

The charge of literary "blackface" (Ferguson 1937, 276) was central to the scathing critiques that Hurston faced from a group of Black male writers who pummeled *Their Eyes Were Watching God*. Blackface—an inauthentic performance of racial stereotypes—became a metaphor for Hurston's refusal to fall in line with the program of positive propaganda that dominated the strategy adopted by other Black cultural producers. Ironically, Hurston may have been accused of wearing blackface precisely because she was, in Walker's words, too "black":

With her easy laughter and her Southern drawl, her belief in doing "cullud" dancing authentically, Zora seemed—among these genteel "New Negroes" of the Harlem Renaissance—*black*. No wonder her presence was always a shock. Though almost everyone agreed she was a delight, not everyone agreed such audacious black delight was permissible, or, indeed, quite the proper image for the race. Zora was before her time, in intellectual circles, in the life style she chose. (Walker 1983, 89; italics in original)

Alain Locke, her former Howard professor and one corner of the destructive competitive triangle that Charlotte Mason had set up with Hurston and Hughes, praised Hurston's writing style, but took her to task for the type of writing with which she was engaged. In a review in *Opportunity*, he wrote:

Her gift for poetic phrase, for rare dialect, and folk humor keep her flashing on the surface of her community and her characters and from diving down deep either to the inner psychology of characterization or to sharp analysis of the social background. It is folklore fiction at its best, which we gratefully accept as an overdue replacement for so much faulty local color fiction about Negroes. But when will the Negro novelist of maturity, who knows how to tell a story convincingly—which is Miss Hurston's cradle gift, come to grips with motive fiction and social document fiction? (Locke 1938, 10)

Likewise, Sterling Brown, in *The Nation*, was disturbed by the lack of "harshness" in Hurston's work: "But this is not *the* story of Miss Hurston's own people, as the foreword states, for *the* Negro novel is unachievable as the Great American Novel. Living in an all-colored town, these people escape the worst pressures of class and caste. There is little harshness, [and] there is enough money and work to go around" (Brown 1937, 410; italics in original). Although in the review Brown himself gave these two examples from *Their Eyes Were Watching God* of exactly what he said was missing from the book (the rape and threat of death from beating to Nanny and segregated burials for the hurricane victims), a sentence early in the piece was telling. Brown wrote: "Janie's Grandmother, remembering how in slavery she was used 'for a work-ox and a brood sow,' and remembering her daughter's shame, seeks Janie's security above all else" (1937, 409). What Brown called "her daughter's shame" was the brutal rape of Janie's mother by a schoolteacher and the aftermath of that rape,

something that Brown seemed to dismiss with offhand victim blaming and to discount as "little harshness." The oppression of Black women, as women, seemed to have little impact on Brown's reading of the novel. Hurston's critique of gender relations within the Black community did not enter into his review in any way.

In an extended essay titled "Recent Negro Fiction" in *the New Masses*, Ralph Ellison criticizes Hurston (whose name he consistently misspelled as Zora "Neil" Hurston) not only for supposedly ignoring the "brutalities" of Black life, but also, ironically, for ignoring both Black folklore and white literature. This seemingly contradictory critique highlights the way in which Ellison perceived Hurston as *incorrectly* writing about Blackness.

Ellison begins by praising Hurston's erstwhile close friend Langston Hughes for his knowledge of and reliance on Black folklore in his work in the 1920s, writing: "Negro fiction of the 1920's was timid of theme. . . . Except for the work of Langston Hughes it ignored the existence of Negro folklore and perceived no connection between its own and the symbols and the images of Negro folk forms" (1941, 22). This erasure of Hurston's writing is astonishing enough, but Ellison then goes on to actively mischaracterize her work:

> Aside from ignoring the folk source of all vital American Negro art, the fiction of this group [Hurston and others including Countee Cullen and Wallace Thurman] was chiefly lyrical, and for the most part was unaware of the technical experimentation and direction being taken by American writing as the result of the work—itself a product and symptom of the breakup of a world—of such writers as [James] Joyce, [Gertrude] Stein, [Sherwood] Anderson, and [Ernest] Hemingway. (Ellison 1941, 22)

Hurston, the trained anthropologist and folklorist with numerous publications about precisely this area of expertise, was, in Ellison's characterization, not only "ignoring the folk source of all vital American Negro art," she was also ignoring the white writers whose techniques should serve as a model for Black writers to imitate. At the end of the essay, Ellison returns to this theme: "It is no accident that the two most advanced American Negro writers, Hughes and Wright, have been men who have *experienced freedom of* association with advanced white writers (not because the men from whom they have learned were unique because of their whiteness, but because in the United States even the possession of Western culture is controlled on the basis of color)" (Elli-

son 1941, 25; italics in original). The old division between the advocates of the "talented tenth" who would master white cultural forms as a type of "positive propaganda" for the race and the younger writers who had put together *Fire!!* (some of whom were also derided in Ellison's essay) was still clear.

After again praising Hughes as the leader of the turn in Black literature towards championing the common people following the onset of the Great Depression, Ellison turns explicitly to *Their Eyes Were Watching God*: "In her turn Zora Neil Hurston's latest work, though possessing technical competence, retains the blight of calculated burlesque that has marred most of her writing. *Their Eyes Were Watching God* tells the story of a Southern Negro woman's love-life against the background of an all-Negro town into which the casual brutalities of the South seldom intrude" (Ellison 1941, 24). Diminishing Janie's story to "a Southern negro woman's love-life," Ellison chastises Hurston for not giving attention to the "casual brutalities" of Black life. Again, Ellison does not seem to have registered the intersectionality of race, class, and gender that Hurston addresses. Because Hurston's writing does not center issues that Ellison finds important (issues that were significant parts of the mainstream strategy in the field of culture), he labels it "calculated burlesque"— calculated to please white patrons like Charlotte Osgood Mason (whom Hurston had broken with years before) and, therefore, not authentic. After saying of Hurston's writing that "for Negro fiction it did nothing," Ellison turned to praising at length Richard Wright's *Native Son*, writing "For the Negro writer it has suggested a path which he might follow to reach maturity, clarifying and increasing his social responsibility."

Richard Wright himself had some of the harshest criticisms of Hurston in a review that appeared in *the New Masses* just two weeks after *Their Eyes Were Watching God* was released. As with the other Black male critics, Wright charged Hurston with ignoring important and serious issues, which he connected with her supposed desire to please a white audience:

> Miss Hurston seems to have no desire whatever to move in the direction of serious fiction. . . . Miss Hurston *voluntarily* continues in her novel the tradition which was forced upon the Negro in the theater, that is, the minstrel technique that makes the "white folks" laugh. . . . The sensory sweep of her novel carries no theme, no message, no thought. In the main, her novel is not addressed to the Negro, but to a white audience whose chauvinistic tastes she knows how to satisfy. She exploits

that phase of Negro life which is "quaint," the phase which evokes a piteous smile on the lips of the "superior" race. (Wright 1937, 22–24; italics in original)

Wright repeats the charge of other male critics that Hurston's work is not "serious," meaning that it does not follow the strategy of succession in the cultural field that they themselves endorsed. Lacking an emphasis on Black–white relations, having purposefully decentered whiteness in her writing, Hurston is accused of having "no theme, no message, no thought." Michael Awkward writes of this schism:

> To put the matter more succinctly, Afro-American intellectuals were involved in a battle over whether to emphasize likeness or difference, Americanness or blackness. This was a battle which, coupled with the added burden of her gender which rendered Hurston marginal to begin with, made full appreciation of her talents virtually impossible during the first half of the twentieth century. . . . [W]e must acknowledge that the male intellectuals . . . did not closely explore Hurston's texts in large part because of her gender. (Awkward 1990, 11)

Authenticity is important symbolic capital. Charges of minstrelsy undermined the authenticity of Hurston's writing in an attempt to claim the label of "authentic" for a very different type of writing:

> Put simply, if her works represent "authentic" "Negro" experiences, then what is it that W. E. B. Du Bois and Jessie Fauset represent in their fictions? Are their middle-class characters less authentic because they are not like Hurston's? For a biased reader, the answer might be "yes." Thus, the issues of who and what are authentic pose significant problems. As black reviewers repeatedly saw white reviewers praise Hurston's treatments of black life as "authentic," as if to suggest that she reveals *the* black experience, powerful black reviewers increasingly countered such assumptions and took Hurston to task for making those assumptions possible. (West 2005, 11; italics in original)

Boyd notes that Hurston "possessed a knowledge of the black South and its folkways that was unrivaled by any other Renaissance writer. (She was, in fact, the only one from the South)" (2003, 122). Her expertise in this area was unique, which left Hurston in possession of cultural capital that could not be

validated and legitimized by anyone else. Moreover, the fracturing of relation-ships among the Renaissance writers that had resulted from Charlotte Mason's meddling left Hurston without the social support (social capital) of some of her most natural allies, such as Hughes. And, finally, as a rural woman, Hurston alone stood at the intersection of race, class, and gender.

"CAN THE BLACK POET SING A SONG TO THE MORNING?"

The sneering condescension and unfair criticism of her entire body of work in these reviews deeply hurt Hurston. She responded, defending herself and attacking this group of critics, in an essay that she sent to *Opportunity*, where Alain Locke's review of *Their Eyes Were Watching God* had appeared. She called Locke's review "an example of rank dishonesty" (Boyd 2003, 308) and said of Sterling Brown that he was "free to write volumes and volumes . . . but not between the covers of my books" (Boyd 2003, 308). She further charged that Locke knew "less about Negro life than anyone in America. . . . I will send my toe-nails to debate him on what he knows about Negroes and Negro life, and I will come personally to debate him on what he knows about literature on the subject. This one who lives by quotations trying to criticize people who live by life!!" (Boyd 2003, 308). *Opportunity* did not print Hurston's essay, but she continued to privately castigate Locke in even more vehement terms:

> "I get tired of the envious picking on me," she wrote privately to James Weldon Johnson at Fisk. "And if you will admit the truth you know that Alain Leroy Locke is a malicious, spiteful little snot that thinks he ought to be the leading Negro because of his degrees. Foiled in that, he spends his time trying to cut the ground from under everybody else." (Boyd 2003, 308–309)

The following year, in an essay entitled "Art and Such," Hurston continued to make the case for the type of writing she did, arguing that although cer-tainly Black people were angry at racial injustice, "When his baby cuts a new tooth he brags as shamelessly as anyone else without once weeping over the prospect of some Klansman knocking it out when and if the child ever gets grown" (Boyd 2003, 311). Later she wrote in further response:

> "Can the black poet sing a song to the morning?" she implored. "Up springs the song to his lips but it is fought back. He says to himself, 'Ah,

this is a beautiful song inside me. I feel the morning star in my throat. I will sing of the star and the morning.'" But then Hurston's imaginary black writer realizes that other things are expected of him: "Ought I not to be singing of our sorrows?" he asks himself. "If I do not some will even call me a coward. The one subject for a Negro is the Race and its sufferings and so the song of the morning must be choked back. I will write of a lynching instead." (Boyd 2003, 311)

Hurston acknowledged, "We talk about the race problem a great deal, but go on living and laughing and striving like everybody else" (Hemenway 1977, 220–221). To a reporter who interviewed her in 1944, she said: "The answer is an over-simplification of the Negro. He is either pictured by the conservatives as happy, picking his banjo, or by the so-called liberals as low, miserable and crying. The Negro's life is neither of these. Rather, it is in-between and above and below these pictures" (Hemenway 1977, 299).

But Hurston's defense of the subject matter of her books had little impact on the broader public. *Their Eyes Were Watching God* sold fewer than 5,000 copies and then went out of print. She continued to write and produce books, but critical opinion had hardened around the lines set down by Locke, Sterling, Ellison, and Wright. Her last published novel, *Seraph on the Suwanee*, came out in 1948 and focused on white characters. By 1950, she was back in Florida, supporting herself by working as a maid to a white family who initially had no idea of her literary career.

REVIVAL

Hurston died in 1960 in a welfare home in St. Lucie County, Florida, and was buried in an unmarked grave. By then, all of her books were out of print. It seemed that her subversive strategy had failed.

The field of American literature in Hurston's lifetime was dominated—at least at the autonomous pole of "serious" literature—by white men. William Faulkner, another southerner, won the Nobel Prize in 1949; Ernest Hemingway, who died only eighteen months after Hurston, won his Nobel in 1954; Eugene O'Neill won in 1937, the year that *Their Eyes Were Watching God* was published. To be taken seriously as an author meant not only to be concerned with certain types of writing, but also to be a certain type of person. During Hurston's lifetime, however, Black American authors challenged white domi-

nance; the Harlem Renaissance was one very conscious mobilization against it.

On one hand, the assault on the bastions of "serious" literature by the writers of the Renaissance and those who followed them was a challenge to the racial hierarchy in the cultural field—and further to the larger field of power in the United States. Du Bois's "talented tenth" were to produce positive propaganda not merely to reshuffle the cultural order, but also to claim the rights of equality in a Jim Crow world of hegemonic and physical brutality towards Black people. Books Like Ellison's *Invisible Man* and Wright's *Native Son* (focusing on male protagonists) were weapons in a life-and-death struggle. They saw Hurston's work as negligible at best and traitorous at worst. Decentering whiteness, and white oppression, looked like a betrayal. On the other hand, although these agents acted in the field to reorder the hierarchy around *who* could write serious literature, they followed a strategy of succession, not subversion, when it came to ideas about defining the concept of seriousness itself. They were oblivious (if not hostile) to the intersectional critiques embedded in Hurston's work.

Not all strategies that are intended to reorder a field succeed. Timing—the artist's ability to connect with the pressure points emerging in the larger society at the appropriate moment— matters. Hurston's subversion failed, and in the last decade of her life, she was increasingly out of touch with the larger political project around racial equality and civil rights in the United States.

As Corse and Griffin (1997) argue, the rise of second wave feminism and of Afrocentric scholarship changed that. In the 1960s and 70s, a new generation of Black female writers emerged, and Black feminist scholarship gained a larger voice in the cultural conversation both inside and outside of the academy. Alice Walker's 1975 essay "Looking for Zora" (included in *In Search of Our Mothers' Gardens*) and her introduction to Robert Hemenway's biography of Hurston ("Zora Neale Hurston—A Cautionary Tale and a Partisan View") began to deconstruct and analyze some of the reasons for the negative reception of *Their Eyes Were Watching God*:

> It is interesting to note, too, that black critics as well as white, considered Miss Hurston's classic, *Their Eyes Were Watching God*, as *second* to Richard Wright's *Native Son*, written during the same period. A love story about a black man and a black woman who spend only about one-eighteenth of their time worrying about whitefolks seemed to them far less important—probably because such a story should be so entirely

normal—than a novel whose main character really had whitefolks on the brain. Wright died in honor, although in a foreign land. Hurston died in her native state a pauper and, to some degree, an outcast. (Walker 1983, 35; italics in original)

The emergence of Black women writers into positions of prominence in American literature— including (but not limited to) Alice Walker herself (who would win the Pulitzer Prize in 1983) and Toni Morrison (Nobel Prize in 1993)—had an enormous impact. With this change in the shape of the cultural field, initiated by Black feminists who gave intellectual prominence to the issues of intersectionality that Hurston had addressed, Hurston's was repositioned.

Corse and Griffin argue that a re-evaluation of *Their Eyes Were Watching God* became possible only in a context where the political and social aspects of canon formation—as opposed to supposedly pure aesthetic considerations— came under scrutiny (1997, 193). This allowed for new evaluative criteria to come into play. The rise of Black feminism meant that issues of gender and power that had been ignored during Hurston's lifetime now came into view: "The development of a Black feminist critical paradigm provided a history and context within which the novel could be situated, thus allowing scholars to read the novel as an early archetype for Black women's writing. *Their Eyes Were Watching God* is now seen as the wellspring of a tradition that is carried on today in work by Walker, Morrison, and others" (Corse and Griffin 1997, 186). Moreover, Corse and Griffin argue that within the field of culture, *Their Eyes Were Watching God* is positioned relationally with regard to writing by other Black authors as well, including the work of her Black male peers: "The critical position of *Their Eyes Were Watching God*, both in its early lower position and its later much higher position, was and is overwhelmingly dependent upon the critical position of African American literature more generally" (Corse and Griffin 1997, 192).

Subversive strategies for the repositioning of Hurston's work within the field operated "underground" throughout the 1960s before reaching the mainstream. Henry Louis Gates experienced this process firsthand:

In my own case, I recall that in the fall of 1976 an undergraduate student in a seminar at Yale demanded that I add her to our syllabus, and gave me her one dog-eared photocopy so that I could share it with our class. Mary Helen Washington has described an underground network

of sharing and exchange that banked the embers of Hurston's literary heritage until they could blaze freely. Today her works are central to the canon of African-American, American, and Women's literatures. (Last year at Yale alone, seventeen courses taught *Their Eyes Were Watching God*!) Hurston's career thus gives pause to those who would argue for the timelessness of literary judgment and taste. (Gates and Appiah 1993, xi)

In this new context, Hurston's work was read in a new way:

> *Their Eyes Were Watching God* is a protest novel in other regards as well. . . . Hurston wrote about life *within* a particular black community—not about that community's reactions to white oppression. She was interested in what black people felt and said and did after they'd banished the white man from their minds and turned their thoughts to more interesting things. In this way, *Their Eyes Were Watching God* becomes protest literature on yet another level: It protests white oppression by stripping it of its potency, by denying its all-powerfulness in black people's lives. Hurston's literary method was not confrontation but affirmation. Yet, as June Jordan has pointed out, "affirmation of black values and lifestyle within the American context is, indeed, an act of protest." (Boyd 2003, 304–306; italics in original)

Walker argued that *Their Eyes Were Watching God* was "one of the greatest novels that America has produced—though, being America, it did not realize this" (1983, 12). But decades after Hurston's death, the literary field was finally ready for her.

EIGHT

A Permanent Revolution

Art can be complex, exploratory, and multivocal. It can push social boundaries and plumb personal depths. It is not surprising that many artworks are greeted with incomprehension or indifference. Much art is merely ignored or dismissed. But some cultural productions produce outrage. This response might seem on the surface to be wildly disproportionate to the work itself: an Impressionist painting stabbed through with an umbrella, for example, or a duel fought over a ballet. Why such a strong response to something so seemingly frivolous?

Perhaps because these cultural productions were not frivolous at all. They were catalysts working together with economic and political changes to bring about the revolution of modernity in western Europe and North America. They were part of a profound change. By looking at the responses—the reviews that appeared in the press, which certain cultural productions called forth—and by placing those discussions in the context of the rapidly changing society into which they emerged, we begin to see the relevance of this art and the specific reasons for the outrage.

The time and place of these cultural productions was a world of enormous ferment. At its congresses in London in 1847, the newly named Communist League asked Karl Marx and Friedrich Engels to draft a manifesto on its behalf. "The Manifesto of the Communist Party" was published in February 1848, coinciding with the February Revolution in France. It began with the famous sentence: "A spectre is haunting Europe—the spectre of Communism." Marx and Engels were not wrong. France, Italy, Germany, Prussia, Denmark,

the Netherlands, Austria, Hungary, Switzerland—uprisings and revolutions swept over Europe.

Moreover, across the Atlantic, the first Women's Rights convention was held in July 1848 in Seneca Falls, New York, where the "Declaration of Sentiments" was written, kicking off the first wave of feminism in the United States. The technological innovations of the Industrial Revolution were changing the forms of daily life on a continuing basis. Communism was not the only specter haunting western Europe and North America. Radical change was afoot in all areas of social life. As Lawrence Levine writes with regard to the United States during this time:

> In an industrializing, urbanizing nation absorbing millions of immigrants from alien cultures and experiencing an almost incomprehensible degree of structural change and spatial mobility, with anonymous institutions becoming ever larger and more central and with populations shifting from countryside and small town to the city, from city to city, and from one urban neighborhood to another, the sense of anarchic change, of looming chaos, of fragmentation, which seemed to imperil the very basis of the traditional order, was not confined to a handful of aristocrats. (Levine 1988, 176)

The same could have been said of many parts of western Europe as well.

SIX CULTURAL BATTLES

Into the volatile social and political tumult of 1847–88, three daughters of an Anglican clergyman in the north Yorkshire moors in England published their first novels, hoping to earn some much-needed income. Aware of the sexism that pervaded the English literary world, they released their books under male-sounding pseudonyms: Currer, Ellis, and Acton Bell. But hiding their gender under pen names was not as simple as the Brontës had imagined it would be. In a world haunted by the specter of the overthrow of so many traditional hierarchies, preserving order was increasingly important to the conservative arbiters of social life, including those in the cultural field. And, unfortunately for the Brontës, their writings were filled with power, that prerogative of men.

Once the secret of their gender leaked, their usurpation of male privilege became seen as part and parcel of the 1848 revolutions. What had been interesting novels (if written by men) now (with the secret of authorship known) caused

outrage. The Brontës had, unwittingly, touched a sore spot in their society—not just about the place of women in the social hierarchy, but also about the very definition of what a woman was and could be. Could a woman write a book like *Wuthering Heights* and still be a woman? Moreover, the existence of the Brontës as authors resonated with questions about the power of women: Could women wield power outside of a narrow domestic sphere and, if they did so, what would be the consequences for the larger society? The Brontës' brief literary lives evolved from the idea of powerful women being wholly imaginary, "like the gryphon, dragon, unicorn," or absurdly inconceivable, like "a chief justice with twins," to being a reality—the reality of the Brontës themselves as authors of books that were not at all like "the weak diffusiveness, the laboured yet most feeble wordiness" that defined the writing of proper women. According to the mores of the times, like the gryphon, the Brontës could not exist. Yet they did.

And by existing, the Brontës and their novels sent shock waves into the field of culture, rewriting the rules about what type of person could be an author of powerful literature. The right of rulemaking is, by definition, held by those at the autonomous pole. The reading public may have delightedly gobbled up their novels, but the critics, as guardians of the established literary hierarchy, were having none of it. They attacked the Brontës, accusing them of dangerous political radicalism, wishing to overthrow God's will, and being sexual deviants who had forfeited, through their wantonness, "the society of their own sex."

Charlotte Brontë, unequal to defending the Brontës' subversiveness without the support of her now deceased sisters, drew back, rewriting both her sisters' histories and their books, attempting to placate the critics by denying the essential artistry of the work. The Brontës, she argued, should not be judged for the power of their work, but instead should be pitied for the lamentable lives that they had led. Regardless, the Brontës had already opened up the possibility that women could be powerful creators just as much as men.

The Impressionists never asked for pity. They were too busy trying to successfully navigate the commercial market. Thirty years after the Brontës' appearance, the world of western Europe and North America had changed again and become, if not more settled, at least somewhat more politically quiescent for a time. After the Paris Commune of 1871, radical political action in France then took a back seat to economic transformation.

The rise of consumer culture in France, with the attendant rise in conspicu-

ous consumption, meant that Parisians, especially, could for the first time display status through symbols purchased on the open market. They did not have to rely on inherited wealth. This led to fear among those traditionally at the top of the social hierarchy that social frauds could fake their way into the elite preserve. As a response to this fear, conservatives were on the alert for signs of "shoddiness" as a marker of fraudulence—the "cheap and nasty" in clothing, household goods, and other physical forms of culture ("objectified cultural capital") including art. The art of the Impressionists—with its "unfinished" sketchy look, its quick execution, its quotidian subject matter, and its ready availability for purchase to anyone willing to pay a few francs—symbolized for conservatives exactly the type of ersatz culture that was destroying the traditional foundations of French society. With its juries and its judgments, the Salon protected the collective definition of what it meant to be French. The Impressionists, by bypassing the Salon, were striking at the heart of that.

And so not only the conservative cultural arbiters, but also the more traditional factions of the general public struck back. Although occasionally physically violent towards the offending works, most of the negative response was in the realm of ridicule: laughter and charges of madness. To be outside the bounds of normal social mores was to be insane.

The Impressionists' strategy in the field was to deny the right of legitimation to the Salon jury; instead, that right, belonged to professional art critics, especially critics who favored the Impressionists' work and who themselves had an interest in the success of the new dealer-critic system. The artists and critics were partners in a strategy that would delegitimate the Académie des Beaux-Arts and install themselves as the new rule makers in the art world. In this, they joined together with the rising self-made members of the bourgeoisie, who saw that their own legitimation depended on overthrowing a status hierarchy based on inherited position and the traditional cultural capital that came with that. And the largest population of this type of art buyer eventually came from the United States, where commercial fortunes were being made on a scale not seen in other countries and where the traditionally conservative section of society was so much smaller and so much newer.

In many ways, the issue that Impressionist art brought to the fore concerned the legitimacy of tradition and the validity of traditional rules. To what extent could culture producers innovate in their creative practice—to what extent could they break all the rules—before they were beyond the bounds of

mere creativity and veered into the world of madness? And what would the label of "madness" be made to signify?

The posthumous handlers of Emily Dickinson's poetry tried to use the label of "madness"—or at least extreme eccentricity—to their advantage. After her death, Dickinson was packaged for sale by Thomas Wentworth Higginson and, especially, Mabel Loomis Todd, who saw ownership of Dickinson's persona as the key to her own upward trajectory in the field of culture, nested in the field of class relations. Todd took over Dickinson's legacy, creating a sensation through public talks in which she presented Dickinson as the reclusive tragic victim of a broken heart, as a naïve and unschooled girl who did not understand poetic forms, as (in Higginson's words) "partially cracked" (Dickinson 1958, 570). Todd packaged Dickinson the same way she packaged Dickinson's poems: between dainty white covers with a flower painting by Todd herself. She changed the poems, including giving them trite titles, to make them better conform to the expectations for quaint women's poetry. What she could not change, she erased—including the presence of Susan Gilbert Dickinson— from Emily's life story.

Although Todd's lurid tales of Dickinson made the first volume of poems a popular success, they also had the unintended effect of delegitimizing the author of a truly subversive body of work. And the critics responded with outrage that this figure whom Todd had constructed should have the temerity to dare to write as she did and present her poetry to the public. Dickinson had the effrontery to discard the traditional rules of poetry, to "set at defiance the laws of gravitation and grammar."

The parallels between Dickinson and the Impressionists are striking. Almost contemporaries, both were accused of making only "sketches" rather than finished works. Both caused outrage when they simply ignored the traditional rules of their crafts. Both were called "mad." Both eventually achieved lasting acclaim from "outsiders": the Impressionists from geographical outsiders, the Americans; Dickinson from temporal outsiders, the modernists of the 1920s.

But Dickinson and the Impressionists also differed in important ways. Dickinson, having received critical feedback from Higginson during her lifetime, simply chose to ignore both the feedback and, indeed, the entire commercial publishing world. Rather than amend her work to fit the poetic fashions of the times, Dickinson in effect self-published, sending scores of poems to

friends far and wide in letters and putting together handmade chapbooks of poems. The Impressionists, on the other hand, helped create the dealer-critic system. The system was a whole new edifice in the art world. The artists sought out publicity and gleefully joined battle with their enemies.

Rather than herself bend to the dictates of the times or try to set up new institutions more amenable to her work, Dickinson stepped outside of formal institutional structures altogether, narrowcasting her cultural productions to only that niche audience that was prepared to appreciate her revolutionary work on its own terms. She did this in letters, which were meant to be shared (as was customary at that time). In this, Dickinson was the harbinger of today's niche-marketed, social-media-driven self-publishing culture.

Le Sacre du printemps was also a harbinger of things to come. Its premiere on the eve of World War I caused a riot in the audience because the performance touched on so many contentious social issues simultaneously: the fears of invasion (not just militarily but also culturally) and the concomitant loss of unique national identity in an increasingly connected ("globalized") world; the uncertainty over the essence of masculinity in a time of changing gender roles; the loss of surety in a collective conscience that had incorporated both homophobia and anti-Semitism as unquestioned normative attitudes; the changing valuation of the role of sex and sexual pleasure in public life; and the shakiness of a social hierarchy in which the definition of elite cultural capital was undergoing such rapid change that one's possession of valued and legitimized capital was uncertain from moment to moment.

Symbolic capital is only valuable if it is recognized as such. Diaghilev, with his spectacular bluster and showmanship and with his social ties to everyone from presidents to princesses to avant-garde poets, waged an all-out assault on the shaky edifice of traditional status, intent on making it fall, as had the Campanile of San Marco. His critics charged him with being a barbarian because they correctly recognized that he wished to sack the bastion of French culture. The "innumerable shades of snobbery, super-snobbery and inverted snobbery" at the premiere of *Le Sacre* were attitudinal weapons in a battle for the autonomous pole. (The pistols used at dawn the next morning were more lethal weapons in the same battle.)

The riot on *Le Sacre*'s first night started before the dancers began because the issues at hand were boiling long before the curtain rose on this particular flash point. *Le Sacre* was outrageous before the first dance step was taken—by the fractured audience gathered for it, by the publicity, by the setting, by the

advertisements in the program, by its very existence. Diaghilev had managed to vivify a whole host of modern anxieties in one short ballet.

In redefining what ballet means as an art form, Diaghilev was also in part redefining gender roles, repositioning queerness in the social landscape, and erasing national boundaries with regard to the arts, at the very least. And *Le Sacre* itself—Nijinsky's choreography, Stravinsky's music, Roerich's costumes and sets—also engaged in redefinition. It redefined what beauty can be, what composers can ask musicians to play and audiences to listen to, what dance is. And interestingly, given its supposed setting in "pagan" Russia, it redefined what the art of the future could encompass. World War I (and Nijinsky's surprise marriage) interrupted the program of the Ballets Russes but not the continuation of the cultural battles of modernity.

While the protest of *Le Sacre* was a visceral matter, involving not only the reviews but also direct physical confrontation and violence between members of the audience, the reaction to Joyce's *Ulysses*, while no less scathing in terms of reviewers' comments, turned to the courts instead of fisticuffs to take up the matter of suppression of offensive art. While physical force or verbal acuity might have sufficed as weapons of choice in previous cultural battles, by turning to the courts to resolve these battles, Joyce and his counselors in their arguments had reframed the question into one of the power of legitimation. Who exactly had the right of legitimation? In what field of expertise should cultural battles be fought?

For the pro-Joyceans, it was the educated specialists in the field of literature, imbued with the symbolic capital of university degrees and high artworld positions, whose expertise was relevant. The moral entrepreneurs who had previously held sway over judgments about art lost their legitimacy as the uniformity of cultural feeling among the general populace could no longer be assumed. Judges could not rely on an obvious "you know it when you see it" measure of the obscene because the multiple, often contradictory views and sentiments of an increasingly diverse and fractured community now had to be acknowledged. The field of morality no longer had a single ruling vision or order, so artistic judgments became the business of specialized experts who were not beholden to the opinions of a large and unruly general audience. And the opinions of the experts that were pasted inside the copy of *Ulysses* that landed in Judge Woolsey's courtroom asserted that the book was a work of the highest aesthetic order, "a modern classic." In the United States, the ban on *Ulysses* was lifted at the same time as the ban on alcohol, another prohibi-

tion that had unsuccessfully attempted to control an increasingly diverse urban population and reanimate a moribund collective conscience.

But while the commentators on *Ulysses* whom Joyce's lawyers submitted for Judge Woolsey to read shared a unanimity of opinion, in reality the field of culture is no more monolithic in its judgments than is the field of morality. Factions fight for position, and the relational nature of the field necessitates that as some agents rise, others must fall.

In the early twentieth century, Black American authors were making an assault on the field of culture, recognizing that it is nested in the field of power. Many of them chose a strategy of succession, encouraging a "talented tenth" who would by their successes prove that they were equal to whites in cultural endeavors. Their works would also direct toward a white audience cogent critiques of the racism embedded in American society and exemplify for a Black audience the oppressions that pervaded their lives. This mostly male group of authors put concerns about gender to one side in order to concentrate on issues of race. Intersectionality as a focal concept had yet to be articulated. In this atmosphere, Zora Neale Hurston was attacked for not being "serious."

Hurston had spent a career studying Black folklore in the United States and the Caribbean. She argued for its power and claimed for it a high status as art—not merely as equal to white forms but as superior. In the hierarchical field of culture, Hurston devoted her own work to highlighting the excellence of Black cultural forms on their own terms, without reference to or regard for whites. The acrimony of the battle between the two competing visions of the correct strategy for Black artists to pursue in the cultural field was intense because everyone involved recognized the larger social ramifications of what they were doing. Because Hurston refused to follow the strategy adopted by Alain Locke and others in the Black intelligentsia, they saw her as a traitor to the race, as a "blackface minstrel."

Hurston was before her time; she had to wait for the emergence of Black second wave feminists and Afrocentric scholarship in the 1960s and 70s for the social protest in *Their Eyes Were Watching God* to be seen and understood. Only after her death did the moment arrive for her appreciation. This leads to an interesting question: What is the relationship of these once outrageous and now canonical works to the societies of their own times?

THE "APPROPRIATE" MOMENT

Not all subversive strategies succeed. Their goal is to reorder a field—to capture the autonomous pole, to supplant the agents who currently occupy that pole. To do so, the symbolic capital of subversive agents must be recognized and legitimated by others in the field. And to disrupt the unquestioned hegemonic chain between signifier and signified, the disruption must be recognized by others. Not every attempt at outrage is even noticed, much less legitimated. As Dick Hebdige writes, "In order to communicate disorder, the appropriate language must first be selected, even if it is to be subverted" (1979, 88).

Outrageous culture producers are in a reciprocal relationship with the surrounding culture, both reflecting it as well as shaping it. In order to have an impact, the artists must tap into the issues that are important to the society at that time; this timeliness is the reason that the works generate so much emotional heat in the first place. Without the social storm of the Dreyfus affair, the fact that so many backers of the Ballets Russes were Jewish might not have had such significance for Diaghilev's critics.

But these works are now canonical because they not only reflected the social concerns of their times, but also shaped their social world and, eventually, ours. As one small example, in 1854, G. H. Lewes, one of the most pointed and vociferous critics of the Brontës on the basis on their gender, began a supportive and loving relationship with George Eliot, another female novelist writing with decided power under a male pseudonym. This one personal fact exemplifies in a very small way the impact that these outrages may have had merely by bringing into question the hegemonic assumptions that lay hidden in society. Artists not only find the appropriate moment *for* their work, but they play a role in creating the moment *with* their work.

Often, the appropriate moment for this questioning is when the cultural works first appear. But sometimes, as with *Their Eyes Were Watching God* or Dickinson's poetry, thinkers at a later time will reach back into cultural history, and a forgotten work will only then find its culturally relevant moment. The appropriate moment for an outrageous work is the one in which it both reflects the pressing, but as yet perhaps unarticulated, social issues at hand and also addresses those issues in a language that is understandable and resonant for its larger audience. As Alice Walker writes about her discovery of Hurston's work, years after Hurston's death: "What I had discovered, of course, was a model.

A model, who, as it happened, provided more than . . . one of the greatest novels America had produced—though, being America, it did not realize this" (Walker 1983, 12). Critics may accuse the works of incomprehensibility because the disruption of the usual connection between signifier and signified means that the signifier no longer easily *makes* sense without its traditional signified, and the new signified is too subversive to bear contemplation. Thus, outrage. If the works were truly incomprehensible, they could merely be ignored. As Wendy Griswold writes: "A powerful work is 'original' in the restrictive aesthetic sense of the term: it locates itself within a set of conventions that it strains, plays with, perhaps inverts, but does not totally ignore. Such a work intrigues or disturbs its recipients without utterly mystifying or frustrating them" (Griswold 1987, 1105).

ATTACK ON THE SOCIAL HIERARCHY

In looking at these examples, some patterns emerge. The first is that in each case, the outrage arose when the cultural production in question communicated a specific type of disorder, an attack on a social hierarchy that had heretofore been unquestioned, but that was—at that moment, in that society—ripe for reconsideration. These works broke into the assumed natural connection between signifier (e.g., writing by women) and signified (e.g., weak and feeble). In doing so, they called into question hegemonic assumptions. The disruptions created reverberations throughout the society.

At the moment when the issue of women's rights was coming into popular consciousness, the Brontës' gender, coupled with the power of their work, became a flash point. At the moment when questions of upward social mobility and the breakdown of traditional class distinctions arose in France, the market-based approach of the Impressionists was an attack not only on the Académie des Beaux-Arts, but also on the very idea of a single traditionally superlative form of French culture. Dickinson's work raised questions about what poetry even was and, more importantly in a world rapidly shedding traditional forms of daily life, how much "rules" themselves matter, if they do at all. The Ballets Russes managed to pierce ideas of what masculinity entails just at the moment when there was great uncertainty about it on both the individual and the national level. Moreover, hegemonic ideas about not only gender, but also homophobia, anti-Semitism, and nationalism all came up for debate. The trials over *Ulysses* pushed this further by questioning who had authority

to decide these questions. There was a shift in the field of battle regarding who—specialized experts or traditional moral entrepreneurs—had the right of legitimation. And in the artistic ferment of the Harlem Renaissance and the political turmoil that accompanied the second wave of the KKK, Zora Neale Hurston chose to decenter whiteness and white oppression of American Blacks and to engage with intersectionality, a radical and disruptive choice that splits the "experts" in the cultural field so that there is no longer a unified paradigm for legitimation.

These examples of cultural productions that we now consider to be classics of the canon all caused outrage because they each hit a social sore point at the critical time and because they spoke in language that was direct and under-standable. Although, for example, the text of *Ulysses* may have been incomprehensible to many, that incomprehensibility itself made a subtext crystal clear: this author was flouting the expected rules of literature and was impudently thumbing his nose at the general public. Joyce made it obvious that he did not care about the reading pleasure of the likes of Anthony Comstock. And that, to the likes of Anthony Comstock, was infuriating in the same way that the Impressionists' snubbing of the Salon was infuriating or that Zora Neale Hurston's refusing to engage with social protest novels that centered on the concerns of her male counterparts led them to dismiss and deride her.

IDENTITY

A second pattern that we see in these outrage events is that the battles were ultimately about opening up possibilities regarding identity. The outrage around the work of the Brontës engaged with issues about what it meant to be a woman in the way that the work of the Ballets Russes engaged with issues about what it meant to be a man. Hurston brought to the fore intersectional considerations specifically about being a rural Black woman. Hurston also delved into larger discussions of social class, and the work of the Impressionists, of the Ballets Russes, and of James Joyce very clearly called forth questions about elite identity: Who is at the top of the cultural hierarchy and how does that intersect with the top of the social hierarchy? Many of these culture producers, but perhaps most especially Emily Dickinson, raised questions about who is and who is not sane. To what degree can anyone stretch the boundaries of normative behavior—break the unspoken rules of social life—and still be considered a rational human being? What worth are norms themselves, and how can we see

them functioning in society? What do we give up to follow them? In the end, all of these battles opened up greater possibilities for acceptable diversity and, more importantly, derailed the unquestioned acceptance of hegemonic ideas of constraints around personal identity.

SEPARATING TRADITIONAL MORALITY FROM ART

A third commonality is that many of these battles enhanced the degree to which moral judgments became separated from decisions regarding aesthetic quality. Critics of the Brontës, for example, recognized the high artistic quality of their work—its power—but were often torn about whether aesthetic judgment should take precedence over moral judgment—for example, should characters such as Heathcliff or Jane Eyre ever have been created, most especially by women? The artistry with which the Brontës wrote, in fact, only made matters worse. The Impressionists not only eschewed the Salon as an institution for bringing their work before the public eye, but they ignored the moral conventions of the time that said that the subjects of paintings should be "elevated themes" of national history and heroes, classical mythology, or biblical morality tales. While the Salon asked for grand visions, the Impressionists depicted everyday people, even such supposedly debased creatures as fourteen-year-old dancers. Likewise, Hurston refused to submit to moral arguments regarding the proper subject matter of her work as judged by her male counterparts, and she paid the price for that refusal. And the immorality of *Ulysses*, with its intentional exploration of the hidden recesses of the human mind, filled as it was with less-than-lofty concerns, called forth invective like "hellish filth" and questions about whether or not the Catholic Church's Office of the Inquisition should get involved. In the end, though, it was aesthetic judgments rather than moral ones that carried the day, opening up the possibility that traditional moral judgments might no longer unquestioningly hold sway, either in the cultural field or other fields as well.

These examples also show that the positive recognition of these works often came from outside the system—either socially or temporally. Both Dickinson and Hurston had to wait for later generations—which not only had concerns more in keeping with the issues raised by these works, but also had different evaluative paradigms—to recognize the true nature of their writing. The Impressionists had their first big successes in America, where buyers were not constrained by the necessity of upholding traditional French cultural norms.

And James Joyce had to fight for his work to be evaluated not by moral entrepreneurs but by outside actors: the courts. And it is not irrelevant that the people who supported his work—some even risking jail time—were all women.

PERMANENT REVOLUTION

Of the Industrial Revolution, Hobsbawm wrote, "To ask when it was 'complete' is senseless, for its essence was that henceforth revolutionary change became the norm. It is still going on" (1962, 46). The same is true of the cultural revolution. These battles continued on through the rest of the twentieth century and into the present. The outrage, for example, directed at jazz and then early rock and roll and then later at hip-hop, is well known; outrage is such a perennial feature of the cultural landscape—especially in the arena of popular music—that it is taken for granted and indeed sought out by the artists.

Some of the most spectacular instances of cultural outrage in recent history belong to the culture wars in the United States at the end of the 1980s and the early 90s. Both Steven Dubin (1992) and Dustin Kidd (2010) present analyses of the furor that erupted into public life over a wide array of art that subverted hegemonic ideas. This included works by Robert Mapplethorpe, Andres Serrano, Dread Scott, Karen Finley, Annie Sprinkle, David Wojnarowicz, among others. While there were many points of contention that intersected in these debates, including xenophobia (Dubin 1992, 19) and racism that harkens back to the issues surrounding the premiere of *Le Sacre du printemps* and sexism that reaches back to the Brontës, a central thread (in light of the Reagan and Bush administration's cruelty and indifference to the AIDS crisis) was the questioning of homophobic and heterosexist hegemonic norms so prevalent in the United States. Artists whose work critiqued or challenged these hegemonic norms faced intense backlash not only in the press, but also from the government. The fallout impacted the arts in the United States more broadly as their government funding was severely curtailed. Conservative powers clearly recognized the subversive potential of seemingly frivolous cultural productions.

The specific themes of these more recent culture wars are familiar, as are the larger social processes at play. Importantly, Kidd argues for a connection between art and the realm of politics (2010, 141). This intersection happens not only at the point of government funding for the arts, which was a prominent talking point for conservative critics of subversive art, but also at the level of ideologies, and therefore at the level of social change: "[W]e can understand

human agency not as a choice situated within social structure but rather as a set of opportunities created by the intersection of structures and the variety of meanings embedded in resources. . . . Tensions between social structures, and between competing meaning systems within social structures, result in power contests over which set of meanings will dominate" (Kidd 2010, 143).

In his model of social change, Kidd further argues that the controversies themselves play a critical role in shaping political debate: "[M]y case studies indicate that controversy is actually the process by which . . . shared language is formed. In other words, it is not necessarily developed in advance by authoritative institutions; rather, it develops through the discursive process itself" (2010, 143). This resonates with Dubin's contention that arts controversies are more likely to occur when debate moves into the public arena, especially in a community that is already fractured along social fault lines—such as, for example, with the racist Chicago politics that preceded the furor over David K. Nelson's 1988 painting *Mirth & Girth*, of deceased Mayor Harold Washington in lingerie (Dubin 1992, 26–43).

Further similarities abound. Battles over the definition of obscenity, especially with regard to Mapplethorpe's photography, mirrored the controversy over *Ulysses*, including court cases and discussions of which fields of expertise— moral or aesthetic—were relevant for judging. That different aesthetic frameworks (Kidd 2010, 55) came into play in evaluating the cultural productions of the 1980s and 90s fits with, for example, Corse and Griffin's (1997) contention that the rise of Black feminism as a paradigm provided a new way to think about *Their Eyes Were Watching God*, as well as with Griswold's (1987) larger theoretical argument that meaning emerges and is constructed in interaction with the concerns animating the larger society.

These more recent debates share features that show their lineage from the cultural battles of generations past. The works at the heart of these controversies unsettled social hierarchies, explicitly questioning hegemonic norms of unspoken domination and subordination, especially around questions of identity and possibilities to break boundaries around personal expression. That Charlotte Brontë would invite readers to look inside the private recesses of a heart was no less shocking in 1847's *Jane Eyre* than that Annie Sprinkle would invite audience members to look inside the private recesses of a body in 1990's *Public Cervix Announcement*. These more recent controversies continue the discussion—and the outrage—around separating traditional morality from the evaluation of art. Kidd argues that the ideological debates travel between the

worlds of art and politics, effectively connecting the two (2010, 141). Subversive art is about sociopolitical power and who controls it.

OUTRAGED BY THE OUTRAGE

Raymond Williams writes:

> Hegemony . . . is a whole body of practices and expectations, over the whole of living: our senses and assignments of energy, our shaping perceptions of ourselves and our world. It is a lived system of meanings and values—constitutive and constituting—which as they are experienced as practices appear as reciprocally confirming. It thus constitutes a sense of reality for most people in the society, a sense of absolute because experienced reality beyond which it is very difficult for most members of the society to move, in most areas of their lives. It is, that is to say, in the strongest sense a "culture," but a culture which also has to be seen as the lived dominance and subordination of particular classes. (Williams 1977, 110)

Moreover, Williams continues: "A lived hegemony is always a process. . . . [I]t does not just passively exist as a form of dominance. It has continually to be renewed, recreated, defended, and modified. It is also continually resisted, limited, altered, challenged by pressures not at all its own" (1977, 112).

A measure of the transformative effects of these cultural battles on the hegemonic ideas of our society is the degree to which we are now outraged at the outrage once directed at their makers. It seems to us now outrageous that Sue Dickinson would be erased from Emily Dickinson's life or that Charlotte Osgood Mason (or anyone else) would tell Zora Neale Hurston what she could and could not write. It is outrageous that Robert Southey would tell Charlotte Brontë that literature could not be the business of a woman's life. The thought that the Office of the Inquisition would be invoked in the publication of *Ulysses* is much more alarming than is the fact that James Joyce used the word "pox." The homophobia and anti-Semitism directed at the Ballets Russes are repugnant. The charges of ugliness directed at the Impressionist paintings seem incomprehensible. Today reproductions of their works reap millions in merchandise sales alone (Connelly 1999, G2). Our outrage at the outrage of previous generations is a measure of the degree to which these cultural battles were effective.

That does not mean, of course, that sexism, racism, homophobia, and other forms of bigotry no longer exist—either in society or in the field of culture. A 2019 study of the holdings of major art museums in the United States found that 85 percent of the artists represented were white and 87 percent were male (Topaz et al. 2019). Moral arbiters claim legitimacy to insert themselves as judges in the field of culture on topics ranging from the work of fine artists such as Kara Walker to the designs on paper cups at Starbucks (Carter 2012). The various sites of discrimination that pervade society are too numerous to list, and that discrimination still often takes brutally violent forms.

The culture wars discussed here did not end, nor did these battles "solve" the problems they addressed. But the weakening of the collective conscience is part of the transformation to modernity. Oppressive assumptions around what is "normal" or "acceptable" or even "valuable" and "superior" can no longer be thoughtlessly made and casually adopted. The public arena today in the media is filled with just the sort of vigorous debate that these six historical cultural battles provoked. Cultural questions are engaged with intensity and fervor because the cultural field is nested in the field of power. By questioning hegemonic assumptions, by subjecting them to challenge and resistance, hegemonic oppressions are weakened, and social space is carved out for the next battle.

References

Aldington, Richard. 1921. "'The Influence of Mr. James Joyce', *English Review*, xxxii (April 1921), 333-41." In Deming 1970, 186–189.

Aldrich, Thomas Bailey. 1892. "'*In Re* Emily Dickinson' *Atlantic Monthly* 69 (January 1892), 143-44." In Buckingham 1989, 282–284.

Aramis [pseud.]. 1922. "'The Scandal of *Ulysses*', *Sporting Times*, no. 34 (1 April 1922), 4." In Deming 1970, 192–194.

Armitage, E. 1887. "THE IMPRESSIONISTS 'Athenaeum', 23 July 1887, no. 3117, 123-4." In Flint 1984, 81–83.

Artist. 1880. "UNSIGNED REVIEW, 'Artist' 15 April 1880, i, 117." In Flint 1984, 38–41.

Artist. 1882. "UNSIGNED REVIEW, 'ARTIST' 1 April 1882, iii, 123." In Flint 1984, 44.

Assouline, Pierre. 2004. *Discovering Impressionism: The Life of Paul Durand-Ruel*. Translated by Willard Wood and Anthony Roberts. New York: Vendome Press.

Athenaeum. 1846. "Review of *Poems* from the *Athenaeum*; 4 July 1846." In Barker 1997, 151.

Atlas. 1848. "*Atlas* January 1848." In Emily Brontë [1847] 2003, 282–284.

Awkward, Michael, ed. 1990. *New Essays on Their Eyes Were Watching God*. Cambridge: Cambridge University Press.

Ballu, Roger. 1877. "*Chronique des Arts* (14 April 1877)." In Wildenstein 2015, 160.

Barker, Juliet. 1994. *The Brontës*. New York: St. Martin's Press.

Barker, Juliet. 1997. *The Brontës: A Life in Letters*. New York: Overlook Press.

Beisel, Nicola. 1993. "Morals Versus Art: Censorship, the Politics of Interpretation, and the Victorian Nude." *American Sociological Review* 58, no. 2 (April): 145–162.

Beja, Morris. 1992. *James Joyce: A Literary Life*. Columbus: Ohio State University Press.

Bell, Currer [pseud.]. 1850a. "Biographical Notice of Ellis and Acton Bell (1850)." In Emily Brontë [1847] 2003, 307–312.

Bell, Currer [pseud.]. 1850b. "Editor's Preface to the New Edition of *Wuthering Heights* (1850)." In Emily Brontë [1847] 2003, 313–316.

Bennett, Arnold. 1922. "'James Joyce's *Ulysses*', *Outlook* (London) (29 April 1922), 337–9." In Deming 1970, 219–222.

Birmingham, Kevin. 2014. *The Most Dangerous Book: The Battle for James Joyce's Ulysses*. New York: Penguin Books.

Blake, Carrie. 1891. "'Emily Dickinson.' Report of a lecture by Heloise Edwina Hersey at Wheaton Seminary (Norton, Mass.). *Rushlight* 34:4 (February 1891), 56–7." In Buckingham 1989, 110–113.

Bookman. 1892. "'American.' *Bookman* [London] 2:7 [April 1892), 10." In Buckingham 1989, 305.

Book News. 1891. "'Descriptive Price List of New Books.' *Book News* 9 (March 1891), 271." In Buckingham 1989, 119.

Boschot, Adolphe. 1913. "'Le "Sacre du printemps": Ballet de MM. Roerich, Stravinsky et Nijinsky,' *Echo de Paris*, May 30, 1913." In Kelly 2000, 305–306.

Boston Herald. 1890. "'Scraps of Verse from the Pen of Emily Dickinson.' *Boston Herald*, December 29, 1890, p. 6." In Buckingham 1989, 67–68.

Boston Saturday Evening Gazette. 1891. "'New Publications.' *Boston Saturday Evening Gazette* 89 (November 28, 1891), p. [4]." In Buckingham 1989, 248–251.

Bourdieu, Pierre. 1993. *The Field of Cultural Production*. Edited by Randal Johnson. New York: Columbia University Press.

Bourdieu, Pierre, and Loic J. D. Wacquant. 1992. *An Invitation to Reflexive Sociology*. Chicago: University of Chicago Press.

Bowker, Gordon. 2012. *James Joyce: A New Biography*. New York: Farrar, Straus and Giroux.

Boyd, Valerie. 2003. *Wrapped in Rainbows: The Life of Zora Neale Hurston*. New York: Scribner.

Britannia. 1848. "*Britannia* January 1848." In Emily Brontë [1847] 2003, 288–291.

Brontë, Anne. [1848] 2001. *The Tenant of Wildfell Hall*. Hertfordshire: Wordsworth Editions.

Brontë, Charlotte. [1847] 2001. *Jane Eyre*. Edited by Richard J. Dunn. New York: W. W. Norton.

Brontë, Charlotte. 1849. "Charlotte to G. H. Lewes; Haworth, 1 November 1849." In Barker 1997, 248.

Brontë, Charlotte. 1850. "Charlotte to William Smith Williams; Haworth, 5 September 1850." In Barker 1997, 295.

Brontë, Charlotte. 2007. *Selected Letters of Charlotte Brontë*. Edited by Margaret Smith. Oxford: Oxford University Press.

Brontë, Emily. [1847] 2003. *Wuthering Heights.* Edited by Richard J. Dunn. New York: W. W. Norton.

Brooks, Noah. 1890. "'Books of the Christmas Season.' *Book Buyer* 7 (December 1890), 521." In Buckingham 1989, 44.

Brown, Sterling A. 1937. "Luck Is a Fortune." *Nation* 144, no. 16 (October 16): 409–410.

Buckingham, Willis J., ed. 1989. *Emily Dickinson's Reception in the 1890s: A Documentary History.* Pittsburgh: University of Pittsburgh Press.

Buckle, Richard. 2012. *Nijinsky: A Life of Genius and Madness.* New York: Pegasus Books.

Burt, Ramsay. 1995. *The Male Dancer: Bodies, Spectacle, Sexualities.* London: Routledge.

Carby, Hazel V. 1990. "The Politics of Fiction, Anthropology, and the Folk: Zora Neale Hurston." In Awkward 1990, 71–93.

Cardon, Emile. 1874. "'Avant le Salon—L'Exposition des revoltés,' *La Presse* 29 April 1874." In Tucker 1995, 77.

Carter, Barry. 2012. "Censorship or Common Decency? Newark Library Covers up Controversial Artwork." *Star-Ledger* (December 2). https://www.nj.com/njv_barry_carter/2012/12/censorship_or_common_decency_n.html

Chaumelin, Marius. 1869. "*L'Art contemporain.*" In Hamilton 1969, 131–132.

Chesneau, E. 1863. "*L'Artiste.*" In Engelmann 2007, 28.

Chicago Tribune. 1891. "'Literature of the Day.' *Chicago Tribune,* February 7, 1891, p. 12." In Buckingham 1989, 116–117.

Chorley, H. F. 1847. "Athenaeum [H. F. Chorley] December 25, 1847." In Emily Brontë [1847] 2003, 281–282.

The Christian Advocate. 1891. "'Strange Poems.' *Christian Advocate* 66 (January 29, 1891), 65." In Buckingham 1989, 106–107.

The Christian Remembrancer. 1848. "Review of *Jane Eyre* from the *Christian Remembrancer,* April 1848." In Barker 1997, 192–193.

Claretie, Jules. 1876. "'L'art et les artistes français contemporains.'" In Rewald 1961, 326.

Clarke, John, Stuart Hall, Tony Jefferson, and Brian Roberts. 1976. "Subcultures, Cultures and Class: A Theoretical Overview." In Hall and Jefferson 1976, 9–74.

Collins, Joseph. 1922. "'James Joyce's Amazing Chronicle', *New York Times Book Review* (28 May 1922), 6, 17." In Deming 1970, 222–226.

Colum, Mary. 1922. "'The Confessions of James Joyce', *Freeman* no. 123 (19 July 1922), pp. 450–452." In Deming 1970, 231–234.

Connelly, Julie. 1999. "The Impressionists Sure Move the Merchandise." *New York Times* (April 21): G2.

Corse, Sarah M., and Monica D. Griffin. 1997. "Cultural Valorization and African American Literary History: Reconstructing the Canon." *Sociological Forum* 12, no. 2 (June): 173–203.

Danchev, Alex. 2012. *Cézanne: A Life.* New York: Pantheon Books.

de Chennevières, Philippe. 1880. "*Gazette des beaux-arts,* July 1, 1880." In Hamilton 1969, 234–235.

Deming, Robert H., ed. 1970. *James Joyce: The Critical Heritage, vol. 1 (1907–1927)*. London: Routledge and Kegan Paul.

de Montifaud, Marc. 1868. "*L'Artiste.*" In Hamilton 1969, 117–118.

Dickinson, Emily. 1890. *Favorite Poems of Emily Dickinson*. Edited by Mabel Loomis Todd and T. W. Higginson. New York: Avenel Books.

Dickinson, Emily. 1951. *The Complete Poems of Emily Dickinson*. Edited by Thomas H. Johnson. Boston: Little, Brown and Company.

Dickinson, Emily. 1958. *The Letters of Emily Dickinson*. Edited by Thomas H. Johnson. Cambridge, MA: The Belknap Press of Harvard University.

Diggs, Marylynne. 1995. "Romantic Friends or a 'Different Race of Creatures'? The Representation of Lesbian Pathology in Nineteenth-Century America." *Feminist Studies* 21, no. 2 (Summer): 317–340.

Distel, Anne. 1990. *Impressionism: The First Collectors*. New York: Harry N. Abrams.

Dobell, Sydney. 1850. "*Palladium* September 1850 [Sydney Dobell]." In Emily Brontë [1847] 2003, 293–298.

Dorsey, John. 1998. "Degas' 'Little Dancer' Is Still on the Point of Controversy." *Baltimore Sun* (October 11, 1998). https://www.baltimoresun.com/news/bs-xpm-1998 -10-11-1998284216-story.html

Douglas Jerrold's Weekly Newspaper. 1848. "Douglas Jerrold's Weekly Newspaper January 1848." In Emily Brontë [1847] 2003, 284–285.

Douglas, Mary. 1975. "Jokes." In Mukerji and Schudson 1991, 291–310.

Dubin, Steven C. 1992. *Arresting Images: Impolitic Art and Uncivil Actions*. New York: Routledge.

DuPlessis, Rachel Blau. 1990. "Power, Judgment, and Narrative in a Work of Zora Neale Hurston: Feminist Cultural Studies." In Awkward 1990, 95–123.

Durkheim, Emile. (1893) 1984. *The Division of Labor in Society*. Translated by W. D. Halls. New York: Free Press.

Eclectic Review. 1851. "*Eclectic Review* February 1851." In Emily Brontë [1847] 2003, 351–354.

Edelman, Murray. 1995. *From Art to Politics: How Artistic Creations Shape Political Conceptions*. Chicago: University of Chicago Press.

Edwards, Elisha Jay. 1892. "E[lisha] J[ay] Edwards. 'Emily Dickinson's Poems.' January 12, 1892." In Buckingham 1989, 289–291.

Eksteins, Modris. 1983. "The First Performance of *Le Sacre du printemps*; or, The Audience as Art." *Canadian Journal of History* 18, no. 2 (Summer): 227–245.

Eksteins, Modris. 1989. *Rites of Spring: The Great War and the Birth of the Modern Age*. Boston: Mariner Books.

Elderfield, John, Mary Morton, and Xavier Rey. 2017. *Cézanne Portraits*. London: National Portrait Gallery Publications.

Ellison, Ralph. 1941. "Recent Negro Fiction." *New Masses* 40 (August 5): 22–26.

Ellmann, Richard. 1982. *James Joyce*. Oxford: Oxford University Press.

Emery, Lawrence K. 1923. "Extract from Lawrence K. Emery, 'The *Ulysses* of Mr. James Joyce', *Claxon* (Winter 1923-4), 14-20." In Deming 1970, 292–296.

Engelmann, Ines Janet. 2007. *Impressionism*. Munich: Prestel.

Era. 1847. "Review of *Jane Eyre* from the *Era*, November 1847." In Barker 1997, 170.

Erkkila, Betsy. 1996. "Homoeroticism and Audience: Emily Dickinson's Female 'Master'." In Orzeck and Weisbuch 1996, 161–180.

Erkkila, Betsy. 2002. "The Emily Dickinson Wars." In *The Cambridge Companion to Emily Dickinson*, edited by Wendy Martin, 11–29. Cambridge: Cambridge University Press.

Ewbank, Inga-Stina. 1966. *Their Proper Sphere: A Study of the Brontë Sisters as Early-Victorian Female Novelists*. Cambridge, MA: Harvard University Press.

Examiner. 1848. "*Examiner* January 1848." In Emily Brontë [1847] 2003, 285–288.

Ferguson, Otis. 1937. "You Can't Hear Their Voices." *New Republic* (October 13): 276.

Fitch, Noel Riley. 1983. *Sylvia Beach and the Lost Generation: A History of Literary Paris in the Twenties and Thirties*. New York: W. W. Norton.

Flint, Kate, ed. 1984. *Impressionists in England: The Critical Reception*. London: Routledge.

Folkerts, Jean, and Dwight L. Teeter Jr. 1998. *Voices of a Nation: A History of Mass Media in the United States*, 3rd edition. Boston: Allyn and Bacon.

Forrest, Ethel A. 1938. "*Their Eyes Were Watching God* by Zora Neal Hurston." *Journal of Negro History* 23, no.1 (January): 106–107.

Foucault, Michel. 1965. *Madness and Civilization: A History of Insanity in the Age of Reason*. New York: Random House.

Frank, Katherine. 1990. *A Chainless Soul: A Life of Emily Brontë*. New York: Fawcett Columbine.

Franklin, R. W. 1967. *The Editing of Emily Dickinson*. Madison: University of Wisconsin Press.

Furse, Charles W. 1892. "IMPRESSIONISM—WHAT IT MEANS 'Albemarle Review', August 1892, i, 47-51." In Flint 1984, 107–112.

G. [pseud.]. 1894. "G. 'A Connecticut Valley Poet.' *Springfield* [Mass.] *Homestead* 16 (October 6, 1894), 11." In Buckingham 1989, 332–334.

Garafola, Lynn. 1989. *Diaghilev's Ballets Russes*. New York: Oxford University Press.

Garafola, Lynn. 1998. "The Sexual Iconography of the Ballets Russes." In Hall 1998, 56–65.

Garafola, Lynn. 1999. "Reconfiguring the Sexes." In Garafola and Von Norman Baer 1999, 245–268.

Garafola, Lynn, and Nancy Van Norman Baer, eds. 1999. *The Ballets Russes and Its World*. New Haven: Yale University Press.

Gaskell, Elizabeth. [1857] 1996. *The Life of Charlotte Brontë*. Oxford: Oxford University Press.

Gates Jr., Henry Louis, and K. A. Appiah, eds. 1993. *Zora Neale Hurston: Critical Perspectives Past and Present*. New York: Amistad.

Genet, Jean. [1949] 1964. *The Thief's Journal*. Translated by Bernard Frechtman. New York: Grove Press.

Gordon, Lyndall. 2010. *Lives Like Loaded Guns: Emily Dickinson and Her Family's Feuds*. New York: Penguin Books.

Griswold, Wendy. 1987. "The Fabrication of Meaning: Literary Interpretation in the United States, Great Britain, and the West Indies." *American Journal of Sociology* 92, no. 5 (March): 1077–1117.

Habegger, Alfred. 2001. *My Wars Are Laid Away in Books: The Life of Emily Dickinson*. New York: Modern Library.

Haill, Catherine. 2013. "The Pleasure of His Company." In Pritchard 2013a, 182–183.

Halifax Guardian. 1847. "Review from the *Halifax Guardian*, 7 November 1847." In Barker 1997, 172.

Hall, Stuart, and Tony Jefferson, eds. 1976. *Resistance Through Rituals: Youth Sub-Cultures in Post-War Britain*. London: Routledge.

Hall, Susan. 1998. *From Russia with Love: Costumes for the Ballets Russes 1909–1933*. Canberra: National Gallery of Australia.

Hamilton, George Heard. 1969. *Manet and His Critics*. New York: W. W. Norton.

Hanson, Lawrence, and E. M. Hanson. 1949. *The Four Brontës: The Lives and Works of Charlotte, Branwell, Emily, and Anne Brontë*. London: Oxford University Press.

Hart, Beverly. 2013. "Souvenir Programmes." In Pritchard 2013a, 124–125.

Hart, Ellen Louise, and Martha Nell Smith, eds. 1998. *Open Me Carefully: Emily Dickinson's Intimate Letters to Susan Huntington Dickinson*. Ashfield, MA: Paris Press.

Hartford Courant. 1890. "'Recent Verse and Poetry.' *Hartford Courant*, December 18, 1890, p. 3." In Buckingham 1989, 64.

Hartford Courant. 1891a. "*Hartford Courant*, October 3, 1891, p. 10." In Buckingham 1989, 201.

Hartford Courant. 1891b. "'Emily Dickinson's Second Volume.' *Hartford Courant*, November 24, 1891, p. 4." In Buckingham 1989, 247–248.

Hebdige, Dick. 1979. *Subculture: The Meaning of Style*. London: Methuen.

Hemenway, Robert E. 1977. *Zora Neale Hurston: A Literary Biography*. Urbana: University of Illinois Press.

Hibben, Sheila. 1937. "Vibrant Book Full of Nature and Salt." *New York Herald Tribune Weekly Book Review* (September 26, 1937): 2.

Higginson, Thomas Wentworth. 1890a. "'An Open Portfolio.' *Christian Union* 42 (September 25, 1890), 392–393." In Buckingham 1989, 3–9.

Higginson, Thomas Wentworth. 1890b. "Preface." In Dickinson 1890, 13–16.

Higginson, Thomas Wentworth. 1891. "[Thomas Wentworth Higginson.] 'Recent Poetry.' *Nation* 53 (October 15, 1891), 297." In Buckingham 1989, 213–215.

Hill, Peter. 2000. *Stravinsky: The Rite of Spring*. Cambridge: Cambridge University Press.

Hobsbawm, E. J. 1962. *The Age of Revolution: 1789–1848*. New York: New American Library.

Houssaye, Henry. 1882. "'Salon,' *Revue des deux mondes*, June 1, 1882." In Hamilton 1969, 253.

Howells, William Dean. 1891. "[William Dean Howells.] 'Editor's Study.' *Harper's New Monthly Magazine* 82 (January 1891), 318-21." In Buckingham 1989, 73–78.

Huddleston, Sisley. 1922. "'*Ulysses*', No. 6823 (5 March 1922), 4." In Deming 1970, 213–216.

Hunton, W. A. 1938. "The Adventures of the Brown Girl in Her Search for Life." *Journal of Negro Education* 7, no. 1 (January): 71–72.

Hurston, Zora Neale. 1937. *Their Eyes Were Watching God*. New York: J. B. Lippincott.

Järvinen, Hanna. 2009. "Critical Silence: The Unseemly Games of Love in *Jeux* (1913)." *Dance Research* 27, no. 2 (December): 199–226.

Järvinen, Hanna. 2013. "'Great Horizons Flooded with the Alien Light of the Sun': Le Sacre du Printemps in the Russian Context." *Dance Research* 31, no. 1 (January): 1–28.

Johnson, Randal. 1993. "Pierre Bourdieu on Art, Literature and Culture." In Bourdieu 1993, 1–25.

Joyce, James. [1922] 1986. *Ulysses*. New York: Random House.

Kaplan, Carla. 2013. *Miss Anne in Harlem: The White Women of the Black Renaissance*. New York: HarperCollins.

Karthas, Ilyana. 2015. *When Ballet Became French: Modern Ballet and the Cultural Politics of France, 1909–1939*. Montreal: McGill-Queen's University Press.

Kelly, Thomas Forrest. 2000. *First Nights: Five Musical Premieres*. New Haven: Yale University Press.

Kennel, Sarah. 2005. "*Le Sacre du Printemps:* Primitivism, Popular Dance, and the Parisian Avant-Garde." *Nottingham French Studies* 44, no. 3 (September): 4–23.

Kidd, Dustin. 2010. *Legislating Creativity: The Intersections of Art and Politics*. New York: Routledge.

Kolb, Alexandra. 2009. "Nijinsky's Images of Homosexuality: Three Case Studies." *Journal of European Studies* 39, no. 2 (June): 147–171.

Lang, Andrew. 1891a. "[Andrew Lang.] 'The Newest Poet.' *Daily News* [London], January 2, 1891, p. 5." In Buckingham 1989, 80–83.

Lang, Andrew. 1891b. "'A Literary Causerie.' *Speaker* [London] 3 (January 31, 1891), 135-6." In Buckingham 1989, 107–108.

Lang, Andrew. 1891c. "[Andrew Lang.] 'An American Sappho.' *London Daily News*, October 3, 1891, pp. 4-5." In Buckingham 1989, 201–204.

Larbaud, Valéry. 1922. "'James Joyce', *Nouvelle Revue Française*, xviii (April 1922), 385-405." In Deming 1970, 252–262.

The Leader. 1850. "*Leader* December 28, 1850." In Emily Brontë [1847] 2003, 348–350.

Leroy, Louis. 1864. "*Charivari*." In Hamilton 1969, 55.

Leroy, Louis. 1874. "'L'exposition des impressionnistes', *Le Charivari* (25 April 1874)." In Rewald 1961, 318–324.

Leroy, Louis. 1877. "Le Charivari, April 11, 1877." In Distel 1990, 137.

Leslie, Shane. 1922a. "'Domini Canis' (Shane Leslie), 'Ulysses'." In Deming 1970, 200–203.

Leslie, Shane. 1922b. "Extract from Shane Leslie, 'Ulysses,' *The Quarterly Review* ccxxxviii (October 1922), 219-34." In Deming 1970, 206–211.

Levine, Lawrence W. 1988. *Highbrow/Lowbrow: The Emergence of Cultural Hierarchy in America*. Cambridge, MA: Harvard University Press.

Lewes, G. H. 1850. "Currer Bell's 'Shirley.'" *Edinburgh Review* 91, no. 183 (January): 153–173.

Locke, Alain. 1938. "Jingo, Counter-Jingo and Us." *Opportunity* xvi, no.1 (January): 8–11, 27.

Lorimer, James. 1849. "Review of *Jane Eyre*." *North British Review* 19 (August): 169–170.

Mais, S. P. B. 1922. "S. P. B. Mais, 'An Irish Revel: And Some Flappers', *Daily Express* (25 March 1922), n.p." In Deming 1970, 191.

Mantz, Paul. 1863. "*Gazette des beaux-arts*." In Hamilton 1969, 39–40.

Mantz, Paul. 1881. "*Gazette des beaux-arts.*" In Dorsey 1998, https://www.baltimoresun.com/news/bs-xpm-1998-10-11-1998284216-story.html

Martin, Wendy, ed. 2002. *The Cambridge Companion to Emily Dickinson*. Cambridge: Cambridge University Press.

Marx, Karl, and Friedrich Engels. [1848] 1978. "Manifesto of the Communist Party." In *The Marx-Engels Reader*, 2nd edition, edited by Robert C. Tucker, 469–500. New York: W. W. Norton.

Masset, Claire. 2010. *Department Stores*. Oxford: Shire Publications.

Mauclair, Camille. 1903. "MONET 'The French Impressionists 1860-1900', 1903, pp. 102-11." In Flint 1984, 322–325.

Miller, Lucasta. 2001. *The Brontë Myth*. New York: Anchor Books.

Miller, Michael B. 1981. *The Bon Marche: Bourgeois Culture and the Department Store, 1869–1920*. Princeton: Princeton University Press.

Mitch, David. 2004. "Education and Skill of the British Labour Force." In *The Cambridge Economic History of Modern Britain, Vol. I: Industrialization, 1700–1860*, edited by Roderick Floud and Paul Johnson, 332–356. Cambridge: Cambridge University Press.

Moore, Lucy. 2013. *Nijinsky*. London: Profile Books.

Mourey, Gabriel. 1896. "CONTEMPORARY FRENCH ART, BY A YOUNG ART CRITIC 'Art Journal', July 1896, vol. xxxv, 216." In Flint 1984, 134–136.

Mukerji, Chandra, and Michael Schudson, eds. 1991. Rethinking Popular Culture: Contemporary Perspectives in Cultural Studies. Berkeley: University of California Press.

Murry, John M. 1922. "Review, *Nation & Athenaeum*, 22 April 1922, xxxi, 124-5." In Deming 1970, 195–198.

New York Tribune. 1891a. "'Literary Chat.' *New York Tribune*, March 15, 1891, p. 14." In Buckingham 1989, 124.

New York Tribune. 1891b. "'Literary Notes.' *New York Tribune,* January 4, 1891, sec. 2, p. 14." In Buckingham 1989, 84–85.

Noyes, Alfred. 1922. "'Rottenness in Literature', *Sunday Chronicle* (29 October 1922), 2." In Deming 1970, 274–275.

Orzeck, Martin, and Robert Weisbuch, eds. 1996. *Dickinson and Audience.* Ann Arbor: University of Michigan Press.

Ostwald, Peter. 1991. *Vaslav Nijinsky: A Leap into Madness.* New York: Lyle Stuart.

Our Lady Correspondent [pseud.]. 1881. "UNSIGNED REVIEW, 'ARTIST' 1 May 1881, ii, 153." In Flint 1984, 41–43.

Pawlowski, Gustave, Louis Vuillemin, and Louis Schneider. 1913. "'At the Théâtre des Champs-Elysées: "Le Sacre du Printemps," ballet in two acts, by M. Igor Stravinsky,' *Comoedia,* May 31, 1913." In Kelly 2000, 308–313.

Penguin [pseud.]. 1882. "'PENGUIN', 'ARTIST' 1 June 1882, iii, 186." In Flint 1984, 246.

Pritchard, Jane, ed. 2013a. *Diaghilev and the Ballets Russes, 1909–1929: When Art Danced with Music.* London: V&A Publishing.

Pritchard, Jane. 2013b. "The Transformation of Ballet." In Pritchard 2013a, 49–63.

Quammen, David. 2006. *The Reluctant Mr. Darwin.* New York: W. W. Norton.

Quittard, Henri. 1913. "'Théâtre des Champs-Elysées: *Le Sacre du printemps*: scenes of pagan Russia, in two acts, music by M. Igor Strawinsky: choreography by M. Nijinsky: sets and costumes by M. Roerich,'" *Le Figaro,* May 31, 1913." In Kelly 2000, 307–308.

Rehm, George. 1922. "George Rehm, review, *Chicago Tribune* (European edition) 13 February 1922, 2." In Deming 1970, 212–213.

Rewald, John. 1961. *The History of Impressionism,* revised and enlarged edition. New York: Museum of Modern Art.

Reynolds, David S. 2002. "Emily Dickinson and Popular Culture." In Martin 2002, 167–190.

Richardson, John. 2012. *A Life of Picasso: The Cubist Rebel, 1907–1916.* New York: Alfred A. Knopf.

Rigby, Elizabeth. 1848. "'Vanity Fair—and Jane Eyre,' *The Quarterly Review* 84: 167 (December 1848), 153-85". In Charlotte Brontë [1847] 2001, 451–453.

Roe, Sue. 2006. *The Private Lives of the Impressionists.* New York: HarperCollins.

Ross, Alex. 2007. *The Rest Is Noise: Listening to the Twentieth Century.* New York: Farrar, Straus and Giroux.

San Jose Mercury. 1891. "'Miss Dickinson's Poems.' *San Jose* [Calif.] *Mercury,* April 19, 1891, p. 7." In Buckingham 1989, 130.

Schauffler, Henry Park. 1891. "'Second Edition of Emily Dickinson's Poems.' *Amherst Literary Monthly* 6 (November 1891), 175-82." In Buckingham 1989, 224–229.

Scheijen, Sjeng. 2009. *Diaghilev: A Life.* Translated by Jane Hedley-Prôle and S. J. Leinbach. Oxford: Oxford University Press.

Scheijen, Sjeng. 2013. "Diaghilev the Man." In Pritchard 2013a, 33–45.

Schmitt, Florent. 1913. "'*Les Sacres du Printemps*, de M. Igor Strawinsky, au Théâtre des Champs-Elysées,' *La France*, June 4, 1913." In Kelly 2000, 313–315.

Schudson, Michael. 1978. *Discovering the News*. New York: Basic Books.

The Scotsman. 1891. "'New Poetry.' *Scotsman* [Edinburgh], August 10, 1891, p. 2." In Buckingham 1989, 160–161.

Scribner's Magazine. 1891. "'The Point of View.' *Scribner's Magazine* 9 (March 1891), 395-6." In Buckingham 1989, 119–120.

Seigel, Jerrold. 1986. *Bohemian Paris: Culture, Politics, and the Boundaries of Bourgeois Life, 1830–1930*. Baltimore: Johns Hopkins University Press.

Seldes, Gilbert. 1922. "Gilbert Seldes, review, *Nation* 30 August 1922, cxv, no. 2982, 211-2." In Deming 1970, 235–239.

Sharpe's London Magazine. 1848. "Review of *The Tenant of Wildfell Hall* from *Sharpe's London Magazine*; August 1848." In Barker 1997, 194.

S. H. C. [pseud.]. 1934. "Extract from S. H. C., 'Ulysses', *The Carnegie Magazine*, vii, no. 2 (February 1934), 279-81." In Deming 1970, 242–244.

Smee, Sebastian. 2016. *The Art of Rivalry: Four Friendships, Betrayals, and Breakthroughs in Modern Art*. New York: Random House.

Smith, Margaret, ed. 2004. *The Letters of Charlotte Brontë: With a Selection of Letters by Family and Friends, 1829–1847*. Vol. 1. Oxford: Clarendon Press.

Smith, Martha Nell. 1992. *Rowing in Eden: Rereading Emily Dickinson*. Austin: University of Texas Press.

Smith, Martha Nell. 2002. "Susan and Emily Dickinson: Their Lives, in Letters." In Martin 2002, 51–73.

Smith, R. McClure. 1996. "Reading Seductions: Dickinson, Rhetoric, and the Male Reader." In Orzeck and Weisbuch 1996, 105–131.

Sonner, Sarah. 2013. "Sponsorship and Funding for the Ballets Russes." In Pritchard 2013a, 94–95.

Southey, Robert. 1837. "Robert Southey, the Poet Laureate, to Charlotte; Keswick, March 1837." In Barker 1997, 46–48.

Springfield Sunday Republican. 1891. "'Books, Authors and Art.' *Springfield Sunday Republican*, September 27, 1891, p. 6." In Buckingham 1989, 178–182.

Stevens, George. 1937. "Negroes by Themselves." *Saturday Review of Literature* (September 18, 1937): 3.

St. James's Gazette. 1891. "'The Literary World.' *St. James's Gazette* [London], August 8, 1891, p. 12." In Buckingham 1989, 159–160.

Swartz, David. 1997. *Culture and Power: The Sociology of Pierre Bourdieu*. Chicago: University of Chicago Press.

The Times. 1874. "UNSIGNED REVIEW, 'THE TIMES' 27 April 1874, 14." In Flint 1984, 34–35.

Thomson, David. 1981. *Europe Since Napoleon*, 2nd edition, revised. New York: Alfred A. Knopf.

Thoreau, Henry David. 2009. *The Journal, 1837–1861.* New York: New York Review of Books.

Todd, Mabel Loomis. 1890. "'Bright Bits from Bright Books.' *Home Magazine* 3 (November 1890), 13." In Buckingham 1989, 10–12.

Todd, Mabel Loomis. 1891. "'Preface' to *Poems by Emily Dickinson, Second Series,* edited by T. W. Higginson and Mabel Loomis Todd. Boston: Roberts Brothers, 1891, pp. [3]–8." In Buckingham 1989, 236–237.

Tompkins, Lucille. 1937. "In the Florida Glades." *New York Times Book Review* (September 26, 1937): 29.

Topaz, Chad M., Bernhard Klingenberg, Daniel Turek, Brianna Heggeseth, Pamela E. Harris, Julie C. Blackwood, C. Ondine Chavoya, Steven Nelson, and Kevin M. Murphy. 2019. "Diversity of Artists in Major U.S. Museums." *PloS One* 14, no. 3 (March). https://www.ncbi.nlm.nih.gov/pmc/articles/PMC6426178/

Tucker, Paul Hayes. 1995. *Claude Monet: Life and Art.* New Haven: Yale University Press.

United States v. One Book Called "Ulysses," 5 F. Supp. 182, 183 (S.D. New York, 1933).

Vallas, Léon. 1913. "'*Le sacre du printemps,*' *La Revue Française de Musique,* June-July 1913, 601-3." In Kelly 2000, 316–317.

Vanderham, Paul. 1998. *James Joyce and Censorship: The Trials of* Ulysses. New York: New York University Press.

Veblen, Thorstein. [1899] 1994. *The Theory of the Leisure Class.* New York: Dover Publications.

Vicinus, Martha. 2004. *Intimate Friends: Women Who Loved Women, 1778–1928.* Chicago: University of Chicago Press.

Walker, Alice. 1976. "Zora Neale Hurston—A Cautionary Tale and a Partisan View." In Hemenway 1977, xi–xviii.

Walker, Alice. 1983. *In Search of Our Mother's Gardens.* New York: Harcourt, Brace, Jovanovich.

Wall, Cheryl A. 1995. *Women of the Harlem Renaissance.* Bloomington: Indiana University Press.

Watson, Peter. 1992. *From Manet to Manhattan: The Rise of the Modern Art Market.* New York: Random House.

Wechsler, Judith. 1975. *Cézanne in Perspective.* Englewood Cliffs: Prentice-Hall.

Wegg Jr., Silas [pseud.]. 1891. "*Sylvia's Home Journal* [London] 14: 167 (November 1891), 520." In Buckingham 1989, 229–230.

West, M. Genevieve. 2005. *Zora Neale Hurston and American Literary Culture.* Gainesville: University of Florida Press.

Whipple, E. P. 1848. "*North American Review* October 1848 'NOVELS OF THE SEASON' [E. P. WHIPPLE]." In Emily Brontë [1847] 2003, 298–301.

White, Barbara Ehrlich. 1988. *Renoir: His Life, Art, and Letters.* New York: Harry N. Abrams.

White, Harrison C., and Cynthia A. White. 1965. *Canvases and Careers: Institutional Change in the French Painting World*. Chicago: University of Chicago Press.

Whiting, Charles Goodrich. 1890. "[Charles Goodrich Whiting.] 'The Literary Wayside.' *Springfield Republican*, November 16, 1890, p. 4." In Buckingham 1989, 14–21.

Whiting, Lilian. 1890. "[Lilian Whiting]. 'Emily Dickinson's Poems.' *Boston Beacon*, December 13, 1890, p. 2." In Buckingham 1989, 55–56.

Wildenstein, Daniel. 2015. *Monet: The Triumph of Impressionism*. Köln: Taschen.

Williams, Raymond. 1977. *Marxism and Literature*. Oxford: Oxford University Press.

Williams, Rosalind. 1982. "The Dream World of Mass Consumption." In Mukerji and Schudson 1991, 198–235.

Wolff, Albert. 1869. *"Figaro,* 20 May 1869." In Hamilton 1969, 139.

Wolff, Albert. 1875. *"Figaro* (23 March 1875)." In White 1988, 55.

Wolff, Albert. 1876. *"Figaro* (3 April 1876)." In White 1988, 58.

Wortman, Denis. 1891. "[Denis Wortman.] 'The Reading Room.' *Christian Intelligencer* 62 (May 27, 1891), 12." In Buckingham 1989, 147.

Wright, Richard. 1937. "Between Laughter and Tears." *New Masses* (October 5, 1937): 22–24.

Yankee Blade. 1891. "'About Big Men.' *Yankee Blade*, January 10, 1891, p. [4]." In Buckingham 1989, 99.

Young, Alexander. 1890. "'Boston Letter.' *Critic*, n.s. 14 (October 11, 1890), 183-4." In Buckingham 1989, 9.

Zola, Émile. 1867. *"Édouard Manet* in *Oeuvres complètes*, edited by Maurice Le Blond, 41 (Paris, F. Bernouard, 1938), 243-79." In Hamilton 1969, 88–104.

Index

Their Eyes Were Watching God. See Hurston, Zora Neale
Theory of the Leisure Class, The, (Veblen) 49
Thurman, Wallace, 145–47, 159
Todd, Mabel Loomis, 72, 78–84, 86, 89–94, 171

Ulysses (Joyce), 119–20, 124–41, 173–74, 176–78, 180–81; banned, 129, 135–36; burned, 119, 128, 136; composition begun, 119; excerpt, 127; excerpted in *The Little Review,* 119, 125–26; first trial, 128–29; Inquisition and, 133, 178, 181; printing, 129–30; publication, 130; second trial (*United States v. One Book Called "Ulysses"*), 136–40; smuggling, 135. *See also* Joyce, James
urbanization, 9–10, 17, 27, 100, 123, 168

Vanderham, Paul, 126–28, 135–36, 138–39
Veblen, Thorstein, 49, 52, 59, 68
Venice, 95–96, 100, 117
Vicinus, Martha, 73–74, 80

Walker, Alice, 142, 145–46, 157–58, 164–66, 175–76
West, Genevieve, 147, 153–54, 161
White, Cynthia, 47, 51, 54–55
White, Harrison, 47, 51, 54–55
Williams, Raymond, 3–4, 6, 181
women's rights, 8, 10, 26, 30, 168 (*see also* feminism)
Woolsey, John M., 138–40, 173–74
World War I, 8, 101, 109, 117–18, 128, 172–73
Wright, Richard, 154, 159–61, 163–65
Wuthering Heights. See Brontë, Emily

Zola, Émile, 52–53

CPSIA information can be obtained
at www.ICGtesting.com
Printed in the USA
JSHW021919070423
40066JS00002B/2